Canon® EOS

Rebel T2i/550D

Digital Field Guide

Canon® EOS
Rebel T2i/550D
Digital Field Guide

Charlotte K. Lowrie

WILEY

Wiley Publishing, Inc.

Canon® EOS Rebel T2i/550D Digital Field Guide

Published by
Wiley Publishing, Inc.
10475 Crosspoint Boulevard
Indianapolis, IN 46256
www.wiley.com

Copyright © 2010 by Wiley Publishing, Inc., Indianapolis, Indiana

Published simultaneously in Canada

ISBN: 978-0-470-64863-6

Manufactured in the United States of America

10 9 8 7 6 5 4 3 2 1

For general information on our other products and services or to obtain technical support, please contact our Customer Care Department within the U.S. at (877) 762-2974, outside the U.S. at (317) 572-3993 or fax (317) 572-4002.

Wiley also publishes its books in a variety of electronic formats. Some content that appears in print may not be available in electronic books.

Library of Congress Control Number: 2010925700

WILEY

About the Author

Charlotte K. Lowrie is a professional photographer and award-winning writer based in the Seattle, WA area. She has more than 25 years of photography experience ranging from photojournalism and editorial photography to nature and wedding shooting. Her images have appeared in national magazines, newspapers, and on a variety of Web sites including MSN.com, www.takegreatpictures.com, and the Canon Digital Learning Center.

Charlotte currently divides her time among maintaining an active photography business, teaching photography, and writing books and magazine articles. Charlotte is the author of 14 books including the bestselling *Canon EOS 7D Digital Field Guide* and nine other Digital Field Guides, and she co-wrote *Exposure and Lighting for Digital Photographers*. In addition, she teaches monthly online photography courses at BetterPhoto.com. Visit her Web site at words andphotos.org.

Credits

Acquisitions Editor
Courtney Allen

Project Editor
Cricket Krengel

Technical Editor
Jon Canfield

Editorial Director
Robyn Siesky

Business Manager
Amy Knies

Senior Marketing Manager
Sandy Smith

Vice President and Executive Group Publisher
Richard Swadley

Vice President and Executive Publisher
Barry Pruett

Senior Project Coordinator
Kristie Rees

Graphics and Production Specialists
Nikki Gately
Brooke C. Graczyk
Andrea Hornberger
Jennifer Mayberry
Brent Savage

Quality Control Technician
Laura Albert

Proofreading and Indexing
Penny L. Stuart
BIM Indexing & Proofreading Services

I dedicate this book to my wonderful family and to God who is my constant source of inspiration.

Acknowledgments

A special thank you to Peter Burian and Cricket Krengel, both fine photographers and good friends who kindly contributed beautiful images for this book. And a big thank you to Jon Canfield as well — a fine technical editor, photographer, and friend.

Contents

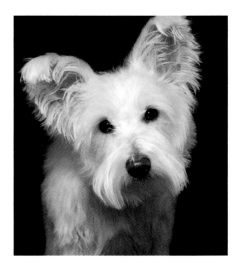

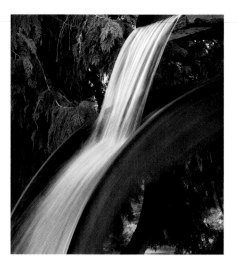

CHAPTER 9
The Elements of Exposure and Composition 187

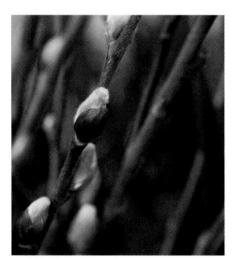

CHAPTER 10
Event and Action Photography 209

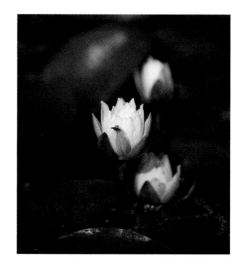

Introduction

Welcome to the *Canon EOS Rebel T2i/550D Digital Field Guide*. Whether you're new to using a digital SLR or someone with previous experience, the Rebel T2i/550D is your doorway to creating both stunning still images and movies. And this book is written to help you get the best performance and highest quality images from the Rebel.

While the Rebel offers a bridge to those moving from point-and-shoot cameras to digital SLR photography, it doesn't skimp on features that you can grow into using. The Rebel offers as little or as much creative control as you want. And that means you don't have to be an expert to begin using the camera to get great images. But as you learn and grow, the camera, and this book, will help you move to new levels of photography and enjoyment.

Most new Rebel photographers are anxious to put all that the camera has to offer to use in their everyday shooting. This book is designed to be your one-stop, "go-to" resource as you use the camera in real-life shooting. You'll learn not only what features and options the camera offers, but also when and how to use them — all without the need to refer back to the camera manual. Equally important, I've tried to include both basic approaches to photography that you can use today to get better images, but also more advanced techniques that you can use as you gain experience. In that way, this book should have "staying power." I sincerely hope that it is as useful to you next year or the year after as it is today.

This book offers practical suggestions for setting up the camera for specific subjects and scenes so that you use a full set of features in combination. You can use the suggestions as described, or you can use them as jumping off points for your specific shooting needs. Either way, putting the camera's full power to work for you makes your shooting more efficient so that you can concentrate on the creative work of exploring subjects, lighting, and composition. And if you are new to digital photography or are returning after a long hiatus, be sure to check out the introduction to photographic exposure in Chapter 9.

You may be wondering if this is the type of book where you can skip around reading chapters in random order. You can, of course, read in any order that you want, but I encourage you to read Chapters 1 through 4 sequentially. The reason to buy a book on a specific camera is to learn the camera, and these chapters provide the foundation for learning the Rebel T2i/550D, setting up a good workflow, and getting great color. From there you can explore Live View shooting, video, flash, lenses, and specific shooting specialty areas in any order that you want.

Then spend time using the camera to make pictures. The more you shoot, the more second-nature the camera controls and features become. I encourage you to take the camera and this book with you everywhere. Photography is a journey, and it's our hope that this book will be a useful guide on your journey.

Also I want to thank the many readers who have contacted me over the years. Your questions, suggestions, and ideas for previous books continue to influence the content of the books that I write today. I learn as much from you. Thank you, and keep the questions and ideas coming.

The wonderful team at Wiley and I hope that you enjoy reading and using this book as much as we enjoyed creating it for you.

Wishing you many beautiful images to come,

Charlotte

Setting Up the EOS Rebel T2i/550D

If you have any experience in photography, then you may already know that the better you know your camera, the greater the chance that you'll be able to react quickly and confidently to photographic opportunities without missing a shot. If you're new to digital SLR cameras, then the T2i/550 may seem intimidating, but, as you'll see, the camera is both easy and fun to master. This chapter is designed to help you learn the EOS Rebel T2i/550 so you know what control to use and when to use it.

In addition, this chapter helps you set up the Rebel to best suit your shooting preferences and to get the best image quality. You'll also learn different ways to review images and protect them from accidental deletion.

Backlighting as well as front lighting created the sense of this flower being lit from within. Exposure: ISO 100, f/16, 1/125 second.

Roadmap to the Rebel T2i/550D

If you've been using the Rebel T2i/550D, then you already know that the most fre-
quently used camera controls are located within finger's reach for quick adjustments
as you're shooting. Less frequently used functions are accessible from the camera
menus. The following sections will familiarize you with the T2i/550D controls and their
names — names that are used throughout the book. You can refer back to these fig-
ures as you read the book to locate the controls you need.

Front camera controls

On the front of the camera, the controls that you'll use most often are the Lens
Release button and the Depth-of-Field Preview button. And, of course, you'll use the
lens mount each time you change lenses.

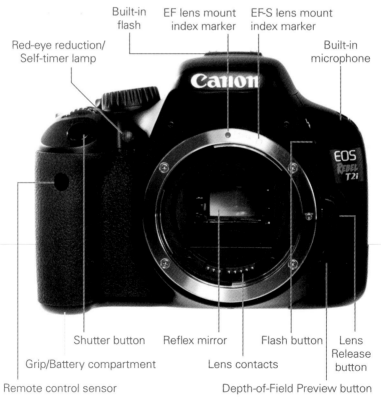

1.1 Rebel T2i/550D front camera controls

From bottom left to top right, here is a look at the front of the camera:

▶ **Grip/Battery compartment.** This is the molded area where your hand grips the camera, and it serves as the battery compartment as well.

▶ **Remote control sensor.** This sensor works with the accessory Remote Control RC-6 that can fire the camera's shutter from up to 16.4 feet (five meters) from the camera. The remote includes the options for immediate or a 2-second delay before shutter firing.

▶ **Shutter button.** Press this button halfway down to focus on the subject, and then press it completely to make the picture. In addition, when you half-press the Shutter button, the camera sets the aperture and shutter speed based on the current ISO. You'll learn more about focusing and exposure in Chapter 2.

▶ **Reflex mirror.** This mirror provides a view of the scene when you're composing the image in the viewfinder, and when you press the Shutter button completely, it flips up and out of the optical path to expose the image sensor to make the picture.

▶ **Lens contacts.** These contacts provide communication between the lens and the camera.

▶ **Lens Release button.** Press this button to release the lens from the lens mount, and then turn the lens to remove it.

▶ **Depth-of-Field Preview button.** Press this button to stop down, or adjust, the lens diaphragm to the current aperture (f-stop) so that you can preview the depth of field in the viewfinder. The larger the area of darkness in the viewfinder, the more extensive the depth of field will be. You can also use this button when shooting in Live View. While you press the Depth-of-Field Preview button, you can't change the aperture.

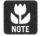

At the lens's maximum aperture, the Depth-of-Field Preview button cannot be depressed because the camera's diaphragm is fully open. The maximum aperture is the widest lens opening for the lens you're using and it varies by lens.

▶ **Flash button.** Pressing this button in P, Tv, Av, M, and A-DEP shooting modes pops up the built-in flash.

▶ **Built-in microphone.** The built-in monoaural microphone records sound when you're shooting movies.

▶ **EF and EF-S lens mount index markers.** The lens mount has a red and a white mark for two types of lenses. The white mark on the lens mount is for Canon EF-S lenses that have a white mark on the lens barrel. EF-S lenses are designed for the

smaller sensor size of the T2i/550D. The red mark on the lens mount is for Canon EF lenses. EF lenses can be used on any Canon EOS camera. Just set the lens on the lens mount and line up the white or red mark on the lens barrel with the same color mark on the lens mount, and then turn the lens to the right to attach it.

▶ **Built-in flash.** The flash provides illumination either as the main light source or as a fill flash. In Basic Zone shooting modes such as Full Auto, Portrait, and so on, the flash fires automatically. In Creative Zone shooting modes including P, Tv, Av, M, and A-DEP, you have to press the Flash pop-up button to use the built-in flash.

▶ **Red-eye reduction/Self-timer lamp.** When you have Red-eye reduction turned on, this lamp lights to help reduce the size of the subject's pupils to minimize the appearance of red-eye in the final image.

Top camera controls

Controls on the top of the camera enable you to use your thumb and index finger on your right hand to control common adjustments quickly. Here is a look at the top of the camera.

▶ **Focal plane mark.** This is the point from which the lens' minimum focusing distance is measured.

▶ **Hot shoe.** You can mount an accessory Speedlite flash unit here to provide communication between the flash and the Rebel.

▶ **Mode dial.** Turning this dial changes the shooting mode. Just line up the shooting mode you want to use with the white mark beside the dial.

▶ **Power switch.** This button switches the camera on and off.

▶ **ISO speed button.** Pressing this button displays the ISO speed screen on the LCD so that you can change the ISO setting, which determines the sensor's sensitivity to light. In P (Program AE), Tv (Shutter-Priority), Av (Aperture-Priority), M (Manual), and A-DEP shooting modes, you can select Auto ISO to have the camera automatically determine the ISO from 100 to 6400, or you can set the ISO yourself. In all automatic shooting modes such as Portrait and Landscape, the camera automatically sets the ISO between 100 and 3200. Alternately, you can set the highest ISO setting that the Auto ISO option uses. You can also turn on an additional high ISO setting, equivalent to 12800 by setting Custom Function I-2.

ISO speed button

Main dial

Shutter button

ISO

ON

OFF

Focal plane mark Hot shoe Mode dial Power switch

1.2 Rebel T2i/550D top camera controls

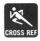 Custom Functions are detailed in Chapter 4.

▶ **Main dial.** Turning this dial selects a variety of settings and options. Turn the Main dial to manually select an AF (autofocus) point after pressing the AF-point Selection/Enlarge button; and to set the aperture (f-stop) in Av mode, the shutter speed in Tv and Manual mode, and to shift the exposure program in P mode. Additionally, you can use the Main dial to scroll among the camera menus.

▶ **Shutter button.** Pressing the Shutter button halfway sets the focus at the active AF point. Simultaneously the camera determines the aperture (f-stop) and/or shutter speed based on the current ISO setting. Pressing the Shutter button completely makes the picture. In any mode except Direct Printing, you can also half-press the Shutter button to dismiss the camera menus and image playback.

Rear camera controls

The controls on the back of the Rebel T2i/550D enable you to make quick adjustments while you're shooting. Some of the rear camera controls can be used only in P, Tv, Av, M, and A-DEP shooting modes. In automatic camera modes such as Portrait, Landscape, and Sports, the camera sets all of the settings for you, so pressing the AV, WB, and Drive mode selection buttons has no effect. But in P, Tv, Av, or M, and A-DEP shooting modes, these buttons function as described in the following list.

> **TIP** If you're shooting and press a button and nothing happens, check the Mode dial to see if you're using an automatic mode such as Portrait or Landscape. If you want to change the white balance, then turn the Mode dial to P, Tv, Av, M, or A-DEP shooting mode.

Here is a look at the back of the camera.

▶ **Menu button.** Press the Menu button to display camera menus on the LCD. To move among menu tabs, turn the Main dial or press the left or right cross keys on the back of the camera. (The cross keys are the keys surrounding the Set button.)

▶ **Display button.** Press this button to turn the LCD display and the current camera settings off and on. If you are playing back images, pressing this button one or more times changes the display to show more or less shooting information and to display one or more histograms displayed next to the image preview.

▶ **Display off sensor.** This sensor detects when you move the camera to your eye and automatically turns off the LCD display.

▶ **Dioptric adjustment knob.** Turn this knob to adjust the sharpness for your vision by -3 to +1 diopters. If you wear eyeglasses or contact lenses for shooting, be sure to wear them as you adjust the Dioptric adjustment knob. To make the adjustment, point the lens to a light-colored surface such as a white wall, and then turn the control until the AF points in the viewfinder are perfectly sharp for your vision.

▶ **Viewfinder.** Look through the viewfinder to view and compose the scene. On the Rebel T2i/550D, the viewfinder offers an approximately 95 percent view of the scene. The viewfinder uses a Precision Matte focusing screen that displays then nine autofocus (AF) points.

Live View/Movie shooting button

Viewfinder | Set button | Speaker

Display off sensor | Dioptric adjustment knob | AE lock/FE lock/Index/ Reduce button

Display button

White balance button | AF point selection/ Magnify button

Menu button

LCD monitor | Quick Control/ Direct print button | Drive mode button | Playback button | Erase button | AF mode button

Picture Style button

Aperture/Exposure Compensation button | Access lamp

1.3 Rebel T2i/550D rear camera controls

▶ **Live View/Movie shooting button.** Pressing this button enables you to begin shooting in Live View mode, or to shoot movies when the Mode dial is set to Movie shooting mode.

▶ **Aperture/Exposure Compensation button.** Press and hold this button and turn the Main dial to set Exposure Compensation in P, Tv, Av, and A-DEP shooting modes. In Manual mode, press and hold this button and turn the Main dial to set the aperture.

▶ **AE lock/FE lock/Index/Reduce button.** Pressing the Shutter button halfway, and then pressing this button enables you to lock the exposure on the point in the scene. Then you can focus on another part of the scene. If you're using the built-in flash, pressing this button locks the flash exposure in the same way. During image playback, you can press this button to display multiple images as an index, or to reduce the size of an enlarged LCD image during image playback.

▶ **AF point selection/Magnify button.** Press this button to activate the AF points displayed in the viewfinder. As you hold the button and turn the Main dial, you can select one AF point, or you can select all of the AF points to have the camera automatically select the AF point or points used to focus. During image play-back, you can press this button to enlarge the image preview to check focus.

▶ **Speaker.** Plays the audio recorded when you shoot a movie clip. You can adjust the speaker volume by turning the Main dial.

▶ **Access lamp.** Lights when images are being written to the media card. Do not open the media card door or turn off the camera when this lamp is lit.

▶ **Erase button.** During image playback, press this button to delete the currently displayed image. Or you can press the left or right cross key to move to another picture to delete.

▶ **Playback button.** Press this button to display the last image captured on the LCD. In single-image Playback, the display includes an overlay of shooting infor-mation on the preview image. Pressing the Index/Reduce button on the top-right back of the camera during playback displays a grid of 2 × 2 or 3 × 3 images that you can scroll through using the Main dial. Press the AF point Selection/Magnify button once or twice to return to single-image display.

▶ **Quick Control/Direct print button.** Press this button to display the Quick Control screen on the LCD. From the Quick Control screen, you can change exposure and other camera settings. During printing, press this button to trans-fer all or selected images from the SD card to your computer when the camera is connected to a compatible printer.

▶ **The LCD monitor.** The LCD monitor displays the camera settings, camera menus, image previews, and the Quick Control Screen.

The four buttons grouped around the Set button are collectively referred to as cross keys. The functionality of the keys or buttons changes depending on whether you're playing back images, navigating camera menus, or changing exposure settings.

During image playback, the left and right cross keys move backward and forward through the images stored on the SD/SDHC/SDXC (media) card. When you navigate through menu options, the up and down cross keys move among options.

Here is a summary of the cross key and Set button functions.

- ▶ **AF mode button.** Press this button to choose one of three autofocus modes: One-shot AF (also known as AI Focus) for still subjects, AI Focus AF for subjects that may start to move or move unpredictably such as children and wildlife, or AI Servo AF for tracking focus of moving subjects.

- ▶ **Set button.** Press this button to confirm changes you make on the camera menus, and to display submenus.

- ▶ **Picture Style button.** Press this button to display the Picture Style screen where you can choose the look of images in terms of contrast, color rendition, saturation, and sharpness. In semiautomatic and manual shooting modes, you can choose Standard, Portrait, Landscape, Neutral, Faithful, or Monochrome Picture styles, and you can customize up to three user-defined styles.

- ▶ **White Balance button.** Press this button to display the White Balance screen where you can choose among seven preset White Balance options, or choose Custom white balance.

- ▶ **Drive mode button.** Press this button to set the Drive mode. You can choose to shoot one picture at a time, to shoot continuously at 3.7 frames per second (fps), or to shoot in one of the Self-timer/Remote control modes. The maximum burst during continuous shooting is approximately 34 Large/Fine JPEG frames or six RAW frames. During image playback, press this button to move to a previous image.

Side camera controls

On the side of the T2i/550D is a set of terminals under a cover and embossed with icons that identify the terminals, which include:

- ▶ **External microphone IN terminal.** This terminal enables the connection of an external stereo microphone that you can use to record sound with videos.

- ▶ **Remote control terminal.** This terminal enables connection of an accessory Remote Switch RS-60E3.

▶ **Audio/video OUT/Digital terminal.** The AV Out terminal enables you to connect the camera to a non-high-definition (HD) television set using the AV cable supplied in the camera box to view still images and movies on the TV.

▶ **HDMI mini OUT terminal.** This terminal is used to connect the camera to an HD television using the accessory HTC-100 cable to play back still images and movies on the TV.

Lens controls

Depending on the lens you are using, the number and type of controls offered vary. For example, if you are using an Image Stabilized lens, the lens barrel has a switch to turn on Image Stabilization that helps counteract the motion of your hands as you hold the camera and lens. Some lenses offer a switch from autofocus to manual focusing.

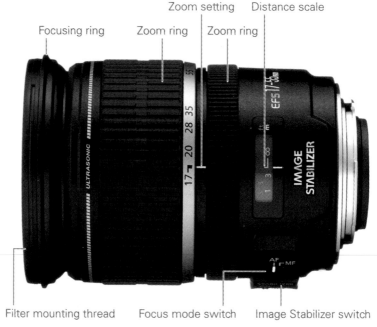

1.4 Lens controls

Many Canon lenses offer the Focus mode switch that enables you to switch between autofocus or manual focus. Image Stabilization (IS) lenses offer controls to turn stabilization on or off. Lens controls differ by lens.

Depending on the lens, additional controls may include the following:

▶ **Focusing distance range selection switch.** This switch determines and limits the range that the lens uses when seeking focus to speed up autofocusing. The focusing distance range options vary by lens.

▶ **Image Stabilizer switch.** This switch turns Optical Image Stabilization on or off. Optical Image Stabilization (IS) corrects vibrations at any angle when handholding the camera and lens. IS lenses typically allow sharp handheld images of two or more f-stops over the lens's maximum aperture.

▶ **Stabilizer mode switch.** Offered on some telephoto lenses, this switch has two modes: one mode for standard shooting and one mode for vibration correction when panning at right angles to the camera's panning movement.

▶ **Zoom ring.** The zoom ring adjusts the lens in or out to the focal lengths marked on the ring.

▶ **Focusing ring.** For lenses that have a focusing mode switch, the lens focusing ring can be used at any time regardless of focusing mode by switching to MF on the side of the lens, and then turning this ring to focus.

▶ **Distance scale and infinity compensation mark.** This shows the lens's minimum focusing distance to infinity. The infinity compensation mark compensates for shifting the infinity focus point resulting from changes in temperature. You can set the distance scale slightly past the infinity mark to compensate.

The LCD

With the T2i/550D, the 3-inch LCD not only displays captured images and current camera settings, but it also provides a live view and focusing screen with Live View and Movie mode shooting. The LCD displays 100 percent coverage of the scene.

Viewfinder display

On the Rebel T2i/550D, the optical, eye-level pentamirror viewfinder displays approximately 95 percent of the scene that the sensor captures. In addition, the viewfinder displays the AF points, a 4-percent Spot metering circle that is displayed at the center of the viewfinder, as well as information at the bottom that displays the current shooting settings, a focus confirmation light, and other settings.

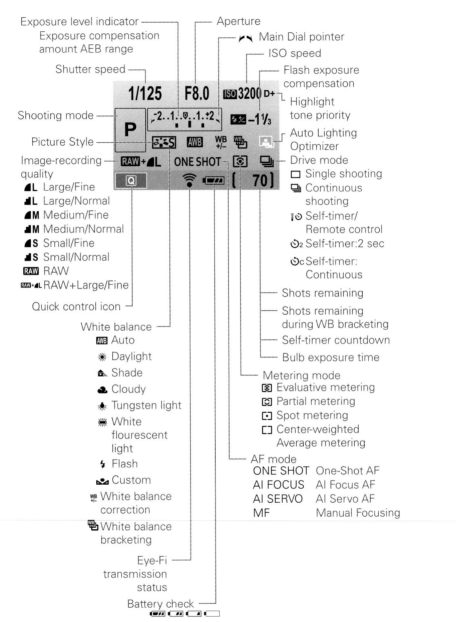

1.5 Rebel T2i/550D LCD display with the Shooting settings displayed

Nine AF points are displayed in the viewfinder. When you manually select AF points by pressing the AF-point Selection/Magnify button and turning the Main dial, the AF points display a red dot within the AF point as you cycle through them. If the camera

automatically selects the AF point or points, the selected point or points display(s) with the red dot inside the AF point in the viewfinder when you press the Shutter button halfway down.

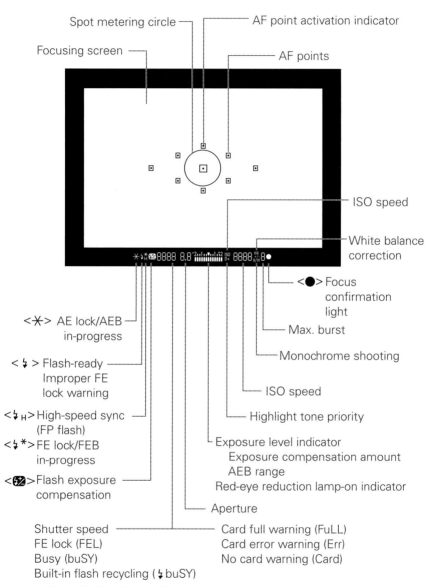

1.6 Rebel T2i/550D viewfinder display

You can verify exposure settings, focus, and more in the viewfinder before making a picture. The display changes depending on the shooting mode you're using.

Setting Up the Rebel T2i/550D

You may have already set up basic settings such as the date and time. But be sure to check through this section of the book for settings that you may have missed or want to revise. The settings that I recommend are designed to get the highest resolution images that you can print at full size to take advantage of all the high resolution that the T2i/550D offers.

Many people are afraid that changing camera settings will "mess up" the pictures that they're getting, and that they won't know how to reset the camera if they don't like the changes they've made. Canon provides a reset option, which means that you can always revert to the original settings on the Rebel T2i/550D so that you can start fresh.

To reset the camera to the original settings, follow these steps.

1. **Press the Menu button, and then press the right cross key to select the Setup 3 menu.**

2. **Press the down cross key to select Clear settings, and then press the Set button.**

3. **To reset the camera to factory settings, press the up or down cross key to select Clear all camera settings, and then press the Set button.** The Clear all camera settings confirmation screen appears.

4. **Press the right cross key to select OK.**

About Media Cards

The Rebel T2i/550D accepts SD and SDHC, or Secure Digital High Capacity, SDXC, and Eye-Fi SD media cards. Not all media cards are created equal, and the type and speed of media that you use affects the Rebel T2i/550D's response and performance times including how quickly images are written to the media card, and your ability to continue shooting during the image-writing process. Memory card speed also affects the speed at which images display on the LCD, and how quickly you can enlarge images on the LCD. And with the high-definition video capability of the Rebel, Canon recommends using a Class 6 or higher media card.

In addition, the T2i/550D accepts SDXC memory cards that offer the potential for increased storage capacity over previous SD cards. Eye-Fi SD cards have a built-in Wi-Fi transmitter and internal antenna for wireless, high-speed transfer of images and video from the camera to the computer or to online Web sites from Wi-Fi-enabled locations or from your network. Eye-Fi also supports geotagging and uploading RAW files.

At this writing, SDXC cards are not supported by all computer operating systems. If you insert the card into a computer or card reader and receive a message asking you to format the card, choose Cancel to avoid overwriting the SDXC format. For more information, visit the www.sdcard.org/developers/tech/sdxc/using_sdxc Web site.

The type of file format that you choose also affects the speed of certain tasks. For example, when writing images to the media card, JPEG image files write to the card faster than RAW or RAW + Large JPEG files. JPEG and RAW file formats are discussed in detail later in this chapter.

As you take pictures, the LCD on the Rebel T2i/550D shows the approximate number of images that remain on the media card. The number is approximate because each image varies slightly, depending on the ISO setting, the file format and resolution, the Picture Style, and the image itself (different images compress differently). And as you shoot video, the Rebel displays the recording time on the LCD. Video recording shuts off automatically when the size of the movie file reaches 4GB. For still and video shooting, an 8GB card is a good size to consider.

When you buy a new memory card, always format it in the camera and never on your computer. But first off-load all images to the computer because formatting erases images even if you've set protection on them. Also be sure to format cards that you've used in other cameras when you begin using them in the Rebel T2i/550D. Formatting a media card in the camera also cleans any image-related data freeing up space on the card, and it manages the file structure on the card so the Rebel T2i/550D and media card work properly together.

To format a card in the camera, be sure that you download all images to your computer first, and then follow these steps:

1. **Press the Menu button, and then turn the Main dial to select the Setup 1 menu.**

2. **Press the down or up cross key to select Format, and then press the Set button.** The Format screen appears asking you to confirm that you want to format the card and lose all data on the card.

 You can optionally choose the Low-level format option that erases the recordable sectors on the card. While Low-level format takes a bit longer, it can improve the performance of the card, and it ensures that all information on the card is permanently erased.

3. **To do a low-level format, press the Erase button to place a check mark next to Low level format, and then press the right cross key to select OK.**

4. **Press the Set button.** The camera formats the card, and then displays the Setup 1 menu.

It is generally a good idea to format media cards every few weeks to keep them clean.

 To avoid taking pictures when no memory card is in the camera, press the Menu button, choose the Shooting 1 menu, and then press the down cross key to select Release shutter without card. Press the Set button, press the down cross key to select Disable, and then press the Set button again. Now you cannot release the shutter unless a media card is in the camera.

Avoid Losing Images

When the camera's red access light — located on the back of the camera — is blinking, it means that the camera is recording or erasing image data. When the access light is blinking, do not open the SD card slot cover, do not attempt to remove the media card, and do not remove the camera battery. Any of these actions can result in losing images and damage to the media card. There is an audible warning to let you know that images are being written to the card, but make it a habit to watch for the access light anyway to know not to open the media card slot cover or turn off the camera.

Choosing the File Format and Quality

The file format, either JPEG or RAW, and the JPEG quality level that you choose determine not only the number of images that you can store on the media card, but also the sizes at which you can later print images from the Rebel T2i/550D.

The Rebel T2i/550D delivers very high-quality images that make beautiful prints at approximately 14.5 × 21.6 inches. Even if you don't foresee printing images any larger than 4 × 5 inches, you may get a once-in-a-lifetime shot and want to print it as large as possible. For this reason, and to take advantage of the Rebel T2i/550D's fine image detail and high resolution, you'll want to choose a high-quality setting and leave it there for all your shooting. The high image-quality settings take more space on the media card, but the price of the card is small compared to missing out on a great image that you can't print at the maximum image size.

The JPEG quality options on the Rebel T2i/550D are displayed with icons on the Quality screen that indicate the compression level of the files and the recording size. For example, a solid quarter circle and the letter "L" indicate the largest JPEG file size and the solid quarter circle indicates the lowest level of file compression for the highest image quality. Likewise, a jagged quarter circle indicates higher compression levels and relatively lower quality, and "M" indicates medium quality. File formats and compression are discussed next.

JPEG format

JPEG, an acronym for Joint Photographic Experts Group, is a popular file format for digital images that provides not only smaller file sizes than the RAW files, but it also offers the advantage of being able to display your images straight from the camera on any computer, on the Web, and in e-mail messages. To achieve the small file size, JPEG compresses images, and, in the process, it discards some data from the image — typically data that you would not easily see. This characteristic of discarding image data during compression gains JPEG its *lossy* moniker. The amount of data discarded depends on the level of JPEG compression. High compression levels discard more image data than low levels. The higher the compression level, the smaller the file size and the more images that you can store on the media card, and vice versa.

As the compression level increases to make the file size smaller, more of the original image data is discarded, and the image quality degrades. Compression also introduces defects, referred to as *artifacts*, which can create a blocky, jagged look, blurring, and diminished color fidelity in the image. At low compression levels, artifacts are minimal, but as the level increases, they become more noticeable and objectionable. You'll see the effects of high compression ratios when you enlarge the image to 100 percent in an image-editing program on the computer. To get the highest-quality images, use the lowest compression and the highest quality settings, such as Large/Fine. If space on the card is tight, then use the next lower setting, Large/Normal. If you use lower quality settings, just be aware that the image quality diminishes accordingly.

> **TIP** If you edit JPEG images in an editing program, image data continues to be discarded each time you save the file. I recommend downloading JPEG files to the computer, and then saving them as TIFF (Tagged Image File Format) or PSD (Photoshop's file format) files. TIFF and PSD, available in Adobe's Photoshop image-editing program, are lossless file formats.

When you shoot JPEG images, the camera's internal software processes, or edits, the images before storing them on the media card. This image preprocessing is an advantage if you routinely print images directly from the SD card, and if you prefer not

to edit images on the computer. And because the T2i offers a variety of Picture Styles that change the way that image contrast, saturation, sharpness, and color are rendered, you can get very nice prints with no editing on the computer.

The JPEG quality options reflect the megapixels recorded for the image. At the Large settings, images are recorded at 17.9 megapixels. The Medium quality options record 8 megapixels, while Low quality options record 4.5 megapixels.

Picture Styles are detailed in Chapter 3.

RAW format

RAW files store image data directly from the camera's sensor to the media card with a minimum of in-camera processing. Unlike JPEG images, which you can view in any image-editing program, you must view RAW files using the Canon Image Browser, Digital Photo Professional, or another RAW-compatible program such as Adobe Bridge and Camera Raw. Most operating systems, such as the Mac, provide regular updates so that you can view RAW images on your computer without first opening them in a RAW conversion program. To print and share RAW images, you must first convert them by using a program that supports the T2i/550D's RAW file format, and then save them as a TIFF or JPEG file. You can use Canon's Digital Photo Professional program or a third-party RAW-conversion program to convert RAW images.

With all these caveats, you may wonder why you'd choose RAW shooting. The answer is simple and compelling — RAW files offer the highest image quality and the ultimate flexibility in correcting and perfecting the final image. With RAW images, you can change key camera settings after you take the picture. For example, if you didn't set the correct white balance or exposure, you can change it when you convert the image on the computer.

Canon includes its Digital Photo Professional program on the disc included in the Rebel T2i/550D box, and that program enables you to convert RAW files.

In addition, you can adjust the image brightness, contrast, and color saturation — in effect, you have a second chance to correct underexposed or overexposed images, and to correct the color balance, contrast, and saturation after you take the picture. The only camera settings that the Rebel T2i/550D applies to RAW files are aperture, ISO, and shutter speed. Other settings such as White balance, Picture Style, and so on are "noted," but not applied to the file. As a result, you have a great deal of control over how image data looks when you convert a RAW image.

Because RAW is a lossless format (no loss of image data), image quality is not degraded by compression. However, RAW files are larger, so you can store fewer RAW images on the media card than JPEG images.

RAW files are denoted with a .CR2 file name extension. After converting the RAW data, you can save the image in a standard file format such as TIFF or JPEG.

RAW + JPEG

On the Rebel T2i/550D, you can also choose to capture both RAW and Large/Fine JPEG images simultaneously. The RAW+JPEG option on the image Quality screen is handy when you want the advantages that RAW files offer, and you also want a JPEG image to quickly post on a Web site or to send in e-mail. If you choose RAW+JPEG, both images are saved in the same folder with the same file number but with different file extensions. RAW files have a .CR2 extension, and JPEG files have a .JPG extension.

To set the image quality, follow these steps:

1. **Press the Menu button, and then turn the Main dial to select the Shooting 1 menu.**

2. **Press the down or up cross key to select Quality.**

3. **Press the Set button.** The Quality screen appears with the currently selected quality setting displayed along with the image dimensions in pixels and the approximate number of images you can store on the current media card in the camera.

4. **Press the right or left cross key to select the size and quality that you want.**

5. **Press the Set button.**

Changing File Numbering

When you begin shooting images, the Rebel T2i/550D automatically creates a folder on the SD/SDHC card to store the images. The folder is named 100Canon, and you see the folder when you download images from the camera to the computer. In addition, the camera numbers the images and assigns prefixes and file extensions. Both JPEG and RAW files begin with the prefix IMG_. Movie files begin with MVI_ and have a .MOV file extension.

1.7 The File numbering options screen

While much of the file management on the camera is automatic, you can choose how the camera numbers images, and your choice can help you manage images on your computer. The file numbering options are: Continuous, Auto reset, and Manual reset. Here is how each file numbering option works.

Continuous file numbering

When you begin using the T2i/550D, the camera automatically numbers images sequentially. When you replace the media card, the camera remembers the last highest image number and continues numbering from the last file number. Images are numbered sequentially using a unique, four-digit number from 0001 to 9999. The camera continues sequential numbering until you shoot image number 9999. At that point, the camera creates a new folder named 101, and images you shoot restart with number 0001.

This file-numbering sequence continues uninterrupted until you insert a memory card that already has images on it. At that point, the T2i/550D notes the highest file number on the media card, and then uses the next higher number when you take the next image — provided that the number is higher than the highest image number stored in the camera's memory. Stated another way, the camera uses the highest number that is either on the media card or that is stored in the camera's internal memory. Then the camera uses that number to continue file numbering. If it is important to you that files be numbered consecutively, then be sure to insert formatted/empty media cards into the camera.

An advantage of Continuous file numbering is that, to a point, this file-numbering option ensures unique file names, making managing and organizing images on the computer easier because there is less chance that images will have duplicate file names.

Now is a good time to create a system of image folders on your computer. I know from experience that the time spent creating a solid file system for storing images pays big dividends over time.

Auto reset

With this file-numbering option, you can have the file number restart with 0001 each time you insert a different media card. If the media card has images stored on it, then numbering continues from the highest image number stored on the card. So if you want the images to always begin at 0001 on each media card, then be sure to insert a freshly formatted media card each time you replace the card.

If you like to organize images by media card, Auto Reset is a good option. However, be aware that multiple images that you store on the computer will have the same file name. This means that you should create separate folders on the computer and follow scrupulous folder organization to avoid file name conflicts and potential overwriting of images that have the same file name.

Manual reset

If you choose Manual reset, then the camera first creates a new folder on the media card, and then it saves images to the new folder starting with file number 0001. After Manual reset, file numbering returns to Continuous or Auto reset — whichever option you used previously.

The Manual reset option is handy if you want the camera to create separate folders for images that you take over a span of several days.

On the Rebel T2i/550D, up to 999 folders can be created automatically by the camera with up to 9,999 images stored in each folder. If you reach these capacities, a message appears telling you to change the media card even if there is room remaining on it. Until you change the media card, you can't continue shooting.

To change the file-numbering method on the T2i/550D, follow these steps:

1. **Press the Menu button, and then turn the Main dial to select the Setup 1 menu.**

2. **Press the down or up cross key to select File numbering, and then press the Set button.** Three file-numbering options appear with the current setting highlighted.

3. **Press the down cross key to select Continuous, Auto reset, or Manual reset, and then press the Set button.** The option you choose remains in effect until you change it with the exception of Manual reset as noted previously.

Additional Setup Options

There are a number of handy setup options that can make your shooting easier and more efficient. You may have already set some of these options, but in case you missed some, you can check Table 1.1 and see which ones you want to set or change.

The additional setup options are typically those that you set up only once, although there are some that you may revisit in specific shooting scenarios. For example, I prefer to turn on the autofocus confirmation beep in most shooting situations. But at a wedding or event when the sound of the beep is intrusive, I turn it off.

Also, you may prefer to have vertical images automatically rotated on the LCD to the correct orientation. However, this rotation makes the LCD image smaller, so you may prefer to rotate vertical images only for computer display.

Table 1.1 provides a guide for these additional setup options. If you don't see an option listed in the table, check to see which shooting mode you've set on the Mode dial. Some options are not available in the automatic shooting modes such as Portrait, Landscape, Sports, and so on. If an option isn't available, just change the Mode dial to P, Tv, Av, M, or A-DEP to access the option. In other instances, the options are detailed in later chapters of this book.

To change these options, press the Menu button, and then follow the instructions in the subheadings in Table 1.1.

Table 1.1: Additional Setup Options

Turn the Main dial to choose this Menu tab.	Press a cross key to select this Menu option.	Press the Set button to display these Menu Sub-options on-screen.	Press a cross key to select the option you want, and then press the Set button.
Shooting 1	Beep	Enable/Disable	Choose On for audible confirmation that the camera achieved sharp focus. Choose Off for shooting scenarios where noise is intrusive or unwanted. The beep is also used for the Self-time Drive mode.
	Release shutter without card	Enable/Disable	Choose Disable to prevent inadvertently shooting when no media card is inserted. The Enable option is marginally useful, and then only when gathering Dust Delete Data.
	Image Review	Off, 2, 4, 8 sec., and Hold	Longer durations of 4 or 8 seconds to review LCD images have a negligible impact on battery life except during travel when battery power is at a premium. I use 4 sec. unless I'm reviewing images with a subject, then I choose 8 sec.

Turn the Main dial to choose this Menu tab.	Press a cross key to select this Menu option.	Press the Set button to display these Menu Sub-options on-screen.	Press a cross key to select the option you want, and then press the Set button.
Playback 1	Rotate		Choose this option to rotate vertical images to the correct orientation on the LCD only, albeit at a smaller size. You can rotate by 90 or 270 degrees. You can use this option for thumbnail Index view as well. Movies cannot be rotated. If you set the Auto rotate option (below), you do not need to use this option.
Setup 1	Auto Power off	30 sec., 1, 2, 4, 8, 15 min., Off	This setting determines when the camera turns off after you haven't used it. Shorter times conserve battery power. To turn the camera back on, lightly press the Shutter button or press the Menu, DISP., a cross key, and so on. Even if you choose the Off option, the LCD turns off automatically after 30 minutes.
	Auto rotate	On the LCD and computer, On for the computer only, or Off	Two On options let you choose to automatically rotate vertical images to the correct orientation on the LCD and computer monitors, or only on the computer monitor. If you choose the first option, the LCD preview image is displayed at a reduced size. Or choose Off for no rotation on the camera or computer.
	LCD auto off	Enable, Disable	Enable is the default that turns the LCD off as you move the camera to your eye to avoid the bright monitor interfering with seeing through the viewfinder. If you want the LCD monitor to remain on, choose Disable.
	Screen color	1, 2, 3, or 4	Choose the screen color for the Shooting settings screen.
	Eye-Fi settings	Eye-Fi Trans (Enable/Disable), and Connection info.	This menu option is available only when you're using an Eye-Fi SD card in the camera. Choose the Enable option to allow automatic wireless image or movie file transmission. Connection info. displays the access point and MAC address information as well as other error messages.

continued

Table 1.1: Additional Setup Options *(continued)*

Turn the Main dial to choose this Menu tab.	Press a cross key to select this Menu option.	Press the Set button to display these Menu Sub-options on-screen.	Press a cross key to select the option you want, and then press the Set button.
Setup 2	LCD brightness	Seven levels of brightness	Choose this menu option to display a screen on which you can select from one to seven levels of LCD brightness.
	Sensor Cleaning	Auto Cleaning (Enable/Disable), Clean now (Cancel/OK), Clean manually (Cancel/OK)	Sensor cleaning is performed when you turn on and turn off the camera. To stop automatic cleaning, choose Disable. The Clean now option enables you to manually have automatic cleaning performed when you choose this option, and select OK. Clean manually locks up the mirror and shutter so that you can clean the sensor yourself.
Setup 3	Clear Settings	Clear all camera settings Clear all Custom Func. (C.Fn.) Cancel	Choose the Clear all camera settings option to reset the camera settings back to the manufacturer's default settings. Choose Clear all Custom Func. (C.Fn.) to reset all Custom Function settings to manufacturer's original settings.
Firmware			Displays the current firmware version. Choose this option to install a newer firmware version.

Adding a Copyright to Images

Copyright identifies your ownership of images. On the T2i/550D, you can add your copyright information to the metadata that is embedded with each image that you shoot.

 To complete the copyright process, register your images with the United States Copyright Office. For more information, visit www.copyright.gov.

To enter your copyright and name on your images, follow these steps.

1. **Press the Menu button, turn the Main dial to select the Setup 3 tab, and then highlight Copyright information.**

2. **Press the Set button.** The Copyright information screen appears.

3. **Press the up or down cross key to highlight the option you want such as Enter author's name or Enter copyright details, and then press the Set button.** A screen appears where you can enter the name or details.

4. **Press the Q button to activate the keyboard portion of the screen, and then left or right cross key to move the cursor to the letter you want to enter.**

5. **Press the Set button to insert the letter in the top portion of the screen.** If you make a mistake and want to delete a character, press the Erase (trash can) button.

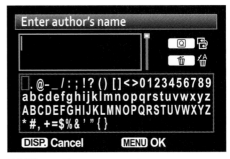

1.8 The author name entry screen

6. **Repeat step 5 until the full name is entered.**

7. **Press the Menu button to return to the previous screen where you can choose the second to enter copyright details or the author name, whichever you didn't choose in Step 3.** You can cancel entering text by pressing the Display button. To display the copyright, repeat Steps 1 and 2 above, and in Step 3, choose Display copyright info.

 If you need to delete the copyright information, choose Delete copyright information on the Copyright information screen on the Setup 3 menu.

Viewing and Finding Images

On the Rebel T2i/550D, you can not only view images after you take them, but you can also magnify images to verify that the focus is sharp, display and page through multiple images that you have stored on the media card, check the histogram and exposure information, or watch images as a slide show. The following sections describe viewing options and suggestions for using each option.

 You can also play back movies on the LCD, as detailed in Chapter 6.

Single-image playback

Single-image playback is the default playback mode where the camera displays one image at a time on the LCD. Canon sets the initial display time to 2 seconds to maximize battery life, but a longer display time of 4 seconds is more useful. And, if you are reviewing images with a friend or the subject of the picture, the 8-second option may be best. Alternately, you can choose the Hold option that displays the image until you dismiss it by lightly pressing the Shutter button.

To turn on image review, press the Playback button on the back of the camera. If you have multiple pictures on the media card, you can use the left and right cross keys to move forward and backward through the images.

If you want to change the length of time that images display on the LCD, follow these steps:

1. **Press the Menu button.**

2. **Turn the Main dial to select the Shooting 1 menu, and then press the down cross key to select Image review.**

3. **Press the Set button.** The image review time options appear.

4. **Press the down cross key to select Off, 2, 4, 8 sec., or Hold.** The numbers indicate the number of seconds that the image displays. Off disables image display, while Hold displays the image until you dismiss it by lightly pressing the Shutter button.

5. **Press the Set button.** Lightly press the Shutter button to return to shooting.

Index display

Index display shows thumbnails of four or nine images stored on the media card at a time on the LCD. This display is handy when you need to ensure that you have a picture of everyone at a party or event, or to quickly select a particular image on a card that is full of images.

To turn on the Index display, follow these steps:

1. **Press the Playback button on the back of the camera.**

2. **Press the AE/FE Lock button on the back of the camera.** This button has an asterisk displayed above it. The LCD displays the last four images stored on the media card. If you don't have four images on the card, it displays as many images as are stored on the card.

3. **Press the cross keys to move among the images.** The selected image has a border around it. You can press the AE/FE Lock button again to display an index page of nine images.

4. **To move through individual images, press a cross key, or to move to the next page of images, turn the Main dial.**

5. **Press the Magnify button one or more times to return to single-image display.**

6. **Lightly press the Shutter button to cancel the display.**

Slide show

When you want to sit back and enjoy all the pictures on the media card, the Slide show option plays a slide show of images on the card. Use this option when you want to share pictures with the people that you're photographing, or to verify that you've taken all the shots that you intended to take during a shooting session.

During the slide show, the camera does not go to sleep to interrupt the image or movie playback.

You can start a slide show by following these steps:

1. **Press the Menu button, and then turn the Main dial to select the Playback 1 menu.**

2. **Press the down or up cross key to select Slide show, and then press the Set button.** The Slide show screen appears.

3. **Press the up or down cross key to select All images, and then press the Set button.** Up and down arrow controls appear to the right of the All images text.

4. **Press the up or down cross key to select from the options: All images, Stills, Movies, or Date, and then press the Set button.** If you select Date, press the Display button, and then press the up or down cross key to select the date from the Select date screen. Then press the Set button.

5. **Press the down cross key to select Set up, and then press the Set button.** The Slide show screen appears with options to set the Display time and Repeat.

6. **Press the down cross key to select Display time, and then press the Set button.** The Play time options appear and are 1, 2, 3, 5, 10, or 20 seconds.

7. **Press the down or up cross key to select the Display time duration you want, and then press the Set button.**

8. **Press the down cross key to select Repeat, and then press the Set button.**

9. **Press the up or down cross key to select Enable or Disable for the Repeat option, and then press the Set button.**

10. **Press the Menu button, and then press the down cross key to select Start.**

11. **Press the Set button to begin the slide show.** You can pause and restart the slide show by pressing the Set button. If you're playing back movies, turn the Main dial to adjust the volume. Press the Menu button to stop the slide show and return to the Slide show screen.

Image jump

When you have a lot of images on the media card or you want to find only the movies or only the still images on the card, you can use Image jump on the Playback 2 menu. Then you can choose to move through images by 1, 10, or 100 images at a time, or find images by date, movies, or still (images).

Here is how to choose the jump method to move through images:

1. **Press the Menu button, and then turn the Main dial to select the Playback 2 menu.**

2. **Press the up or down cross key to highlight Image jump w/ [Main dial], and then press the Set button.** The Image jump with Main dial screen appears. You can choose 1, 10, 100 images, or Date, Movies, Stills (still images).

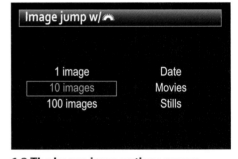

1.9 The Image jump options screen

3. **Press the up or down cross key to select the jump method, and then press the Set button.** The Playback 2 menu appears.

4. **To jump through images, press the Playback button on the back of the camera.** The most recent image is displayed on the LCD.

5. **Turn the Main dial to jump through images by the option you selected in Step 3.** The LCD displays the jump method and relative progress through the images on the card at the lower right of the LCD. You can change the jump option by pressing the up cross key.

Using the Display button

In image playback mode, you can use the Display button to sequence through different displays in Playback mode. In Single-image playback mode, press the Display button once to display basic shooting information overlaid on the image preview. Press it again to display shooting information, a small image preview, and the image brightness histogram. Press it once more to display abbreviated shooting information with the RGB and brightness histograms. Or press the Display button again to return to single-image review with minimal shooting information displayed. You can use the cross keys to move forward and backward through pictures in this display.

Displaying images on a TV

Viewing images stored on the media card on a TV is a convenient way to review images at a large size, particularly when traveling. The video cable to connect the camera to a non-HD TV is included in the T2i/550D box. If you want to view images on an HD TV, you need to buy an HDMI Cable HTC-100. Before connecting the camera to the TV, you need to set the video system format using the Setup 2 menu on the camera. The following instructions are for both HD (Hi-Definition) and non-HD TVs.

1. **Press the Menu button, and then turn the Main dial to select the Set-up 2 menu.**

2. **Press the down key to select Video system, and then press the Set button.** The camera displays the NTSC and PAL options.

NOTE NTSC is the analog television system in use in the United States, Canada, Japan, South Korea, the Philippines, Mexico, and some other countries, mostly in the Americas. PAL is a color encoding system used in TV systems in parts of South America, Africa, Europe, and other countries.

3. **Highlight the system you want, and then press the Set button.**

4. **Turn off the TV and the camera.**

5. **Attach the AV cable or the HDMI cable to the terminals detailed below.** You cannot use the camera's Video Out and HDMI Out terminals simultaneously.

 - For a non-HD TV. Attach the AV cable to the camera's A/V Out/Digital terminal, and then connect the other end of the video cable to the TV set's Video In terminal and to the audio In terminal.

- For an HD TV. Connect the HDMI cable to the camera's HDMI OUT terminal with the plug's HDMI MINI logo facing the front of the camera, connect the other end to the TV's HDMI IN port.

6. **Turn on the TV, and then switch the TV's video input to the connected port.**

7. **Turn the camera's power switch to the ON position.**

8. **Press the Playback button.** Images are displayed on the TV but not on the camera's LCD monitor. When you finish viewing images, turn off the TV and the camera before disconnecting the cables.

 You can use the previous steps to not only display images stored on the media card on the TV, but also to use the TV to display what would appear on the LCD during both general shooting and when you're shooting in Live View.

Erasing and Protecting Images

For those who keep multiple images on media cards for prolonged periods of time, it's important to use options on the T2i/550D that enable you to delete images you don't want, and to protect images you do want from accidental deletion. The following sections detail how to erase one or multiple images and how to protect images.

Erasing images

Erasing images is useful provided that you are certain that you don't want the image. From experience, I know that some images that appear to be mediocre on the LCD can very often be salvaged with judicious image editing on the computer. For that reason, I recommend erasing images with caution.

With the Rebel T2i/550D, you can choose to erase images one at a time or you can select individual images to erase, or you can erase all images on the media card. If you want to delete one image at a time, follow these steps:

1. **Press the Playback button on the back of the camera, and then press the left and right cross keys to select the picture that you want to delete.**

2. **Press the Erase button, and then press the right cross key to select Erase.**

3. **Press the Set button to erase the image.** When the access lamp stops blinking, lightly press the Shutter button to continue shooting.

To select and erase a group of individual images that you select, follow these steps:

1. **Press the Menu button, and then turn the Main dial to select the Playback 1 menu.**

2. **Press the down cross key to highlight Erase images, and then press the Set button.** The Erase images screen appears.

3. **Press the up or down cross key to highlight Select and erase images, and then press the Set button.** The last captured image appears on the LCD.

4. **Press the up or down cross key to place a check mark in the box at the top left of the screen.** This marks the image for deletion.

5. **Press the left or right cross key to move to the next image, and repeat Step 4.** Continue this process until all the images you want to delete are marked with a check mark.

6. **Press the Erase button on the back of the camera.** The Erase images screen appears with a confirmation message asking if you want to erase the selected images.

7. **Press the right cross key to select OK, and then press the Set button.** All check-marked images are erased.

Protecting images

To ensure that important images are not accidentally deleted, you can protect them. Setting protection means that no one can erase the image when using the erase images options.

 Even protected images are erased if you or someone else formats the media card.

You can protect an image by following these steps:

1. **Press the Menu button, and then turn the Main dial to select the Playback 1 menu.**

2. **Press the up or down cross key to select Protect images, and then press the Set button.** The last image taken is displayed on the LCD with a protection and a SET icon in the upper-right corner. If this isn't the image you want to protect, press the left or right cross key to display the image you want to protect.

3. **Press the Set button to protect the displayed image.** A protection icon denoted by a key appears above the thumbnail display and to the left of the image number.

4. **Press the left or right cross key to scroll to other images that you want to protect, and then press the Set button to add protection to the images.** If you want to remove protection, scroll to a protected image, and then press the Set button. Protection is removed and is indicated by the protection icon being removed.

Controlling Exposure and Focus

You're likely anxious to begin using the advanced features of the EOS T2i/550D. Fortunately, with the T2i/550D, you can begin immediately without needing to know everything there is to know about photography and without needing a bag full of lenses and accessories. And if you are upgrading from a point-and-shoot camera, then you'll enjoy the creative freedom that the Rebel T2i/550D offers.

The first step in making pictures is choosing a shooting mode. With the T2i/550D, you can switch among automated, semiautomatic, and manual shooting modes and be assured of getting great shots in almost any situation. In this chapter, you learn about image exposure and how to modify it when you face challenging scenes and subjects, as well as how to get tack-sharp focus. You also explore choosing a drive mode based on the subjects you're shooting.

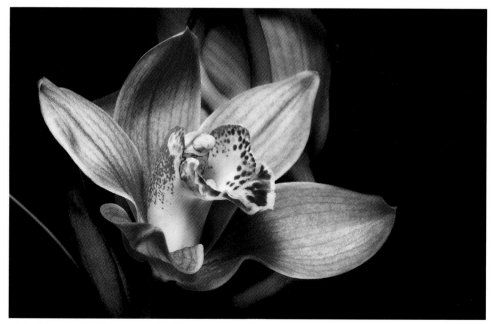

Maintaining detail in both the highlights and shadows was the key to getting a good, printable exposure in this image of an orchid. Exposure: ISO 200, f/14, 1/125 second.

Choosing a Shooting Mode

Before you begin, it's helpful to define shooting mode. A shooting mode determines the type of exposure settings that are set and whether you or the camera sets them. Exposure settings include the aperture, shutter speed, and the ISO. The T2i/550D has several automatic and semiautomatic shooting modes, as well as a manual shooting mode. Most of the automatic shooting modes control all the camera settings, much like a point-and-shoot camera. Other shooting modes are semiautomatic, giving you control over some of the exposure settings and other camera settings. And there is a fully Manual (M) shooting mode where you set all the exposure settings.

Shooting modes are shown on the Mode dial. You set a shooting mode by turning the Mode dial to line up the shooting mode you want with the white line on the camera body.

The Mode dial is roughly divided into two sections: the automatic, or Basic Zone, shooting modes, and the semiautomatic and manual modes, collectively dubbed as Creative Zone modes. Most automatic modes are denoted with icons such as a person's head to designate Portrait mode, a running person to designate Sports mode, and so on. The exceptions are Full Auto mode, designated by a green rectangle, and Creative Auto, designated with the letters CA.

In most of the Basic Zone modes, the camera sets everything automatically so that you can concentrate on capturing the moment. You can change the look of images by changing lenses and by adjusting the lens to bring the subject closer or farther to get a wider view of a scene.

Each automatic shooting mode is designed for photographing specific scenes or subjects. For example, if you're making a portrait, the camera sets the aperture (f-stop) to blur the background thus keeping background details from distracting the viewer from the subject. While the automatic Basic Zone modes are handy, when you use them, you relinquish control of not only the exposure settings, but also other important camera settings including the white balance, drive mode, and where the focus is set in the image.

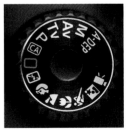

2.1 Rebel T2i/550D Mode dial and shooting zone groupings

The other half of the Mode dial groups the semiautomatic and manual, or Creative Zone, shooting modes. These modes are designated by letter abbreviations such as P for Program AE (Auto Exposure), Tv for Shutter-priority, Av for Aperture-priority, M for Manual, and A-DEP for Automatic

depth of field. If you are an experienced photographer, or if you're anxious to move beyond the automated modes to have more creative control, then the Creative Zone modes are the ticket.

Creative Zone modes give you partial or full control over some or all of the exposure settings. For example, in Aperture-priority AE (Av) mode you can set the aperture, or f-stop, and the camera automatically sets the appropriate shutter speed that's needed to make a well-exposed image. You retain control over all the camera settings including the focus, white balance, drive mode, and other camera settings.

How shooting modes relate to exposure

The shooting mode that you choose enables you to control some or all of the elements of exposure. To make a good exposure, the camera requires that the ISO (short for International Organization for Standardization), aperture, or f-stop, and shutter speed be set correctly based on the amount of light in the scene. And when the ISO, aperture, and shutter speed are set correctly, you get a well-exposed picture. Here is a brief overview of these elements:

If you are new to photography, be sure to read Chapter 9 for more detail about ISO, aperture, and shutter speed and how they work together.

▶ **ISO.** The ISO setting determines how sensitive the image sensor is to light. An ISO of 400 or higher means that the sensor is more sensitive to light and needs less light to make the exposure. A low ISO, such as 100, means that the sensor is less sensitive to light and needs more light to make the exposure.

On digital cameras, high ISO sensitivity settings amplify the output of the sensor so that less light is needed. Be aware, however, that this amplification also increases digital noise, which creates a grainy appearance as well as unwanted color flecks, particularly in the shadow areas in an image.

▶ **Aperture.** The aperture determines how much the lens diaphragm opens or closes to let more or less light into the camera. The diameter of the lens opening is determined by the aperture, or f-stop. The aperture is also a key factor in controlling depth of field, or how much of the scene is in acceptably sharp focus from front to back from the plane of sharp focus. Each change in aperture, or stop, doubles or halves the exposure.

▶ **Shutter speed.** The shutter speed determines how long the camera shutter stays open to let light into the sensor. Shutter speeds are expressed as fractions of a second, such a 1/60, 1/125, 1/250 second, and so on. On the T2i/550D,

shutter speeds are shown as decimals in the viewfinder. Controlling shutter speed is most commonly associated with the ability to control how motion is shown in an image and the ability to handhold the camera in low-light scenes. Each shutter speed change either doubles or halves the exposure.

To make a well-exposed picture, all the exposure elements must be set in the correct proportion. If one element such as the f-stop changes, then the shutter speed must change proportionally assuming that the ISO remains the same. But you have a lot of latitude in making changes to the aperture and shutter speed because many different combinations of f-stop and shutter speed produce an equivalent and correct exposure, assuming the same ISO setting.

For example, at the same ISO setting, f/11 at 1/15 second is equivalent to f/4 at 1/125 second. In other words, both of these exposures let the same amount of light into the camera. However the resulting pictures look very different. With a narrow aperture, or large f-stop number, such as f/11, the scene will have sharper detail from front to back than it will with a wide aperture, or small f-stop number of f/4. In photographic terms, f/11 provides an extensive depth of field where detail is rendered in acceptably sharp focus from back to front in the image in most cases. F/4 creates a shallow depth of field where detail behind and in front of the plane of sharp focus is shown as a soft blur.

2.2 In this image taken at f/8, the background shows moderate sharpness so that you can see some of the details. Exposure: ISO 200, f/8, 1/30 second.

While it's helpful to know about exposure settings, you don't have to master them immediately to use even the semiautomatic shooting modes, except perhaps M (Manual) mode. Even in P, Tv, and Av shooting modes, you can set the setting that you want to control, and the Rebel automatically sets the other exposure element. For example, if you choose Av mode, you set the f-stop, and the camera automatically sets the correct shutter speed. This makes it easy to use the Rebel's creative controls immediately, and it helps you learn about them as you shoot.

Keep this exposure summary in mind as you read about shooting modes. It will help you understand what types of control you have and what to expect with each mode.

Basic Zone shooting modes

The automatic, or Basic Zone, shooting modes are grouped together on one side of the Mode dial. Most of these shooting modes are denoted by pictorial icons, except for Full auto that is denoted with a green rectangle and Creative Auto that is denoted by the letters CA. In the scene shooting modes such as Landscape, Portrait, and so on, you simply choose the shooting mode that matches the type of scene you're shooting. For example, if you're photographing a landscape, then you can use the shooting mode with the mountain icon. Landscape images traditionally show the scene with all areas of the

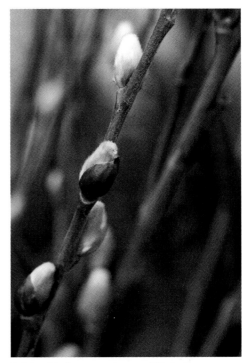

2.3 In this image taken at f/5.6, the background details are almost completely blurred because the wide aperture (f-stop) creates a shallow depth of field. Exposure: ISO 200, f/5.6, 1/60 second.

image in acceptably sharp focus, called extensive depth of field. So in this mode, the T2i/550D sets as narrow of an aperture (large f-stop number such as f/11 or f/16) as possible given the amount of light in the scene. Each of the other Basic Zone modes except CA and Full Auto make similar adjustments to give you a classic photographic result for each type of scene.

In Basic Zone modes, the camera automatically sets all the exposure settings — ISO, aperture, and shutter speed — as well as the focus, drive mode, white balance, and other camera settings. With the exception of Full Auto mode and CA shooting modes, the only control you have is to specify the type of scene that you're shooting by selecting the shooting mode on the Mode dial and by using lenses creatively.

Basic Zone modes can be a good choice for quick shots. For example, if you're making a portrait, select Portrait mode, which sets a wide aperture (f-stop) to blur the background, creating a shallow depth of field. Conversely, if you are shooting a football game and you want the motion of the players to be crisp and without blur, then choose Sports mode, which sets as fast a shutter speed as possible given the light in the scene.

The primary downside of using automatic modes is that you cannot control where the sharp focus is set in the image. In a portrait, the camera may decide to focus on the subject's nose or teeth rather than on the subject's eyes, and the subject's eyes are where the sharp focus should always be in a portrait. Another disadvantage is that the flash fires automatically in many of the automatic modes. While the T2i/550D flash output is well controlled for natural-looking results, you cannot turn the flash off if you want a natural-light picture and still use the exposure settings for a particular scene mode.

In addition to setting the ISO, f-stop, and shutter speed, the Rebel T2i/550D also automatically sets:

▶ Automatic (Auto) white balance

▶ Auto Lighting Optimizer, an automatic adjustment that lightens images that are too dark and increases the contrast in low-contrast images

▶ Long Exposure Noise Reduction to reduce digital noise when the exposure time is 1 second or longer

▶ The AF point or points

▶ The light-metering mode, which is set to Evaluative

▶ The drive mode that determines how many images the Rebel T2i/550D takes when you press and hold the Shutter button. The drive mode changes depending on the automatic shooting mode you choose.

▶ Use of the built-in flash that's used in some Basic Zone modes, which is detailed later in the book

▶ The sRGB (standard Red, Green, Blue) color space. Color spaces are detailed in Chapter 3.

In most Basic Zone modes, you cannot change the settings that the camera chooses.

Creative Auto mode

The first shooting mode that loosely falls within the automatic shooting mode category is Creative Auto, denoted as CA on the camera Mode dial. If you're new to using a dSLR, and you want to get the creative effects that are commonly associated with dSLR shooting, then CA mode is a good shooting mode to choose. CA shooting mode displays visuals and text on the LCD to help you understand the results you get from making various adjustments. This shooting mode also offers more control than the other automatic modes, but it offers less control than the Creative Zone shooting modes (detailed later in this chapter).

To use CA mode, follow these steps:

1. **Turn the Mode dial to CA.** The CA screen appears on the LCD.

2. **Press the Q button, and then press a cross key to select the function you want to change.**

3. **Turn the Main dial to adjust the setting.** If you want to return to the initial CA screen, press the Shutter button halfway down.

In CA shooting mode, you can adjust the following settings:

2.4 The Creative Auto screen offers a visual gateway to make exposure and other camera setting changes without needing to understand photographic exposure concepts. As you select each option on the screen, descriptive text identifies it.

▶ **Flash control.** With this control, you can have the built-in flash fire automatically when the light is too low to handhold the camera and get a sharp image; choose to have the flash fire with every image, or choose to turn off the flash completely. If you choose to turn off the flash in low-light scenes, be sure to stabilize the camera on a tripod or on a solid surface.

▶ **Background control.** You can adjust this control to blur the background or render it with more sharpness. Just adjust the marker to the left to blur the background or to the right to increase background sharpness. As discussed earlier, the relative blurring or sharpening of the background is referred to as depth of field, and it's controlled in large part by the f-stop. Thus this control enables you to change the aperture.

▶ **Exposure (Brightness) control.** As the name implies, this control enables you to modify the image so that it is brighter or darker by moving the mark to the right or left respectively. This control is combined with Auto Lighting Optimizer (detailed later in this chapter) that automatically brightens images that are too dark and adjusts the contrast if necessary.

▶ **Picture Style.** You can choose from four of the six Picture Styles. Picture Styles are a collection of preset adjustments that determine the level of sharpness, contrast, saturation, and color tone of images. In CA mode, you can choose Standard, Portrait, Landscape, or Monochrome Picture Styles.

▶ **Image recording quality.** By activating this control, you can change the image recording to any of the JPEG, RAW, or RAW+JPEG quality options.

▶ **Shooting speed (drive mode).** The speed, or number of images the camera takes with each press of the Shutter button, is determined by the drive mode. This control enables you to choose Continuous shooting mode at 3.7 frames per second (fps), Self-timer/Remote control mode with a 10-second delay before the image is made or making the image with a remote control, a 2-second delay, or Self-timer Continuous mode that takes the number of images that you choose from two to ten images at 10-second intervals.

The remaining Basic Zone modes or automatic modes are designed to provide point-and-shoot functionality so that the camera sets all camera and exposure settings.

Full Auto mode

In the Full Auto shooting mode, the Rebel T2i/550D automatically selects all exposure and camera settings. This shooting mode can be good for quick snapshots, and you can enhance your creative options with the lens you choose. However, keep in mind that the camera defaults to using the built-in flash in low-light scenes, although you may not want or need to use the flash.

In Full Auto mode, the camera is set to AI Focus AF mode, which means that if the subject begins moving, the camera automatically switches to another autofocus mode called AI Servo AF mode. In this mode the Rebel tracks focus on the subject as the subject moves. Autofocus modes are detailed later in this chapter.

The camera also automatically selects the AF point or points. It may choose one or multiple AF points that are typically determined by what is closest to the lens and/or that has the most readable contrast in the scene. The camera displays the selected AF points with a red dot inside the AF point that is displayed in the viewfinder so that you can see where the camera will set the point of sharpest focus.

TIP If the camera doesn't set the point of sharpest focus where you want, you can try to force it to choose a different AF point by moving the camera position slightly. If you want to control where the point of sharpest focus is set in the image, then it is better to switch to P, Av, or Tv shooting mode and set the AF point manually (which is explained later in this chapter).

In Full Auto mode, the camera automatically sets:

▶ Standard Picture Style

▶ Single-shot (one image at a time) drive mode with the option to set 10-second Self-timer/Remote control mode or Self-timer Continuous drive mode

▶ Automatic flash with the option to turn on Red-Eye Reduction mode

 Picture Styles are detailed in Chapter 3.

Flash-off mode

In Flash-off mode, the Rebel T2i/550D does not fire the built-in flash or an external Canon Speedlite, regardless of how low the scene light is. If you use Flash-off shooting mode in low-light scenes, be sure to use a tripod and ensure that the subject remains completely still.

In Flash-off mode, the camera automatically sets:

▶ Standard Picture Style

▶ AI Focus AF autofocus mode with automatic AF-point selection. This means that the camera uses One-shot AF designed for still subjects, but it automatically switches to the focus-tracking mode AI Servo AF if the subject begins to move. The camera automatically selects the AF point.

▶ Single-shot drive mode

Portrait mode

In Portrait mode, the T2i/550D sets a wide aperture (small f-stop number) providing a shallow depth of field to blur background details and prevent them from distracting from the subject. The T2i/550D also uses the Portrait Picture Style, which is designed to enhance the skin tones. Obviously, Portrait mode is great for people portraits, but it can also be used for taking pet portraits, indoor and outdoor still-life shots, and nature shots. However, if you use Portrait mode for nature shoots, the Portrait Picture Style that is used automatically in this shooting mode may render the color less vivid than if you use other modes that use other Picture Styles.

In Portrait mode, the camera automatically sets:

▶ Portrait Picture Style

▶ One-shot autofocus mode and automatic AF-point selection

▶ Continuous drive mode so that you can shoot at 3.7 frames per second (fps) up to 34 Large JPEG images in a burst. Alternately, you can choose to use the 10-second Self-timer/Remote control or the Self-timer Continuous drive mode.

▶ Automatic flash with the option to turn on Red-Eye Reduction mode

To enhance the effect that Portrait mode provides in blurring the background, use a telephoto lens and move the subject several feet away from the background.

In Portrait mode, the camera automatically selects the AF point or points. When the camera chooses the AF point, it looks for points in the scene where lines are well defined, for the object that is closest to the lens, and/or for points of strong contrast. In a portrait, the point of sharpest focus should be on the subject's eye. But the subject's eye may not fit the camera's criteria for setting focus. As a result, the camera often focuses on the subject's nose, mouth, or clothing. So as you shoot, watch in the viewfinder to see which AF points the camera chooses when you half-press the Shutter button. If the AF point or points aren't on the eyes, then shift your shooting position slightly to try to force the camera to reset the AF point to the eyes. If you can't force the camera to refocus on the eyes, then switch to Av mode, set a wide aperture such as f/5.6, and then manually select the AF point that is over the subject's eyes. Manually selecting an AF point is detailed later in this chapter.

Landscape mode

In Landscape mode, the T2i/550D sets the exposure so that both background and foreground details are acceptably sharp for extensive depth of field. To do this, the camera sets a narrow aperture (large f-stop number). Also in Landscape mode, the camera gives you the fastest shutter speed possible given the amount of light in the scene. The fast shutter speed helps ensure sharp handheld images.

In lower light, however, the Rebel T2i/550D tries to maintain as narrow an aperture as possible, and in low light, the shutter speed will be slower, or the camera will increase the ISO, or both. So as the light fades, be sure to monitor the shutter speed in the viewfinder. If the shutter speed is 1/30 second or slower, or if you're using a telephoto lens, then steady the camera on a solid surface or use a tripod for shooting. As it does in all Basic Zone modes, the camera uses Evaluative metering (described later in this chapter) to measure the light in the scene to determine the exposure settings. This mode works well not only for landscapes but also for cityscapes and portraits of large groups of people.

In Landscape mode, the camera automatically sets:

▶ Landscape Picture Style

▶ One-shot autofocus mode and automatic AF-point selection

▶ Single-shot drive mode with the option to set 10-second Self-timer/Remote control or Self-timer Continuous drive mode

▶ The flash does not fire

Close-up mode

In Close-up mode, the Rebel T2i/550D allows a close focusing distance, and it sets a wide aperture (small f-stop number) to create a shallow depth of field that blurs background details. It also sets as fast a shutter speed as possible given the light. This mode produces much the same type of rendering as Portrait mode. In Close-up shooting mode, the camera uses the Standard Picture Style. You can further enhance the close-up effect by using a macro lens. If you're using a zoom lens, zoom to the telephoto end of the lens.

 All lenses have a minimum focusing distance that varies by lens. This means that you can't focus at distances closer than the minimum focusing distance of the lens. You know that the camera has achieved good focus — and thus, you're not closer than the minimum focusing distance — when you hear the autofocus confirmation beep from the camera and when the focus indicator light in the viewfinder burns steadily.

In Close-up mode, the camera automatically sets:

▶ Standard Picture Style

▶ One-shot autofocus mode with automatic AF-point selection

▶ Single-shot drive mode with the option to set 10-second Self-timer/Remote control or the Self-timer Continuous drive mode

▶ Automatic flash with the option to turn on Red-Eye Reduction mode

Sports mode

In Sports mode, the Rebel T2i/550D sets a fast shutter speed to freeze subject motion. This mode is good for capturing athletes in midair, a player sliding toward a base, or the antics of pets and children.

In this mode, when you half-press the Shutter button, the camera focuses and automatically tracks focus on the moving subject. The focus is locked at the moment you fully press the Shutter button. And if you're shooting a burst of images, you can continue to hold the Shutter button down, and the camera maintains focus. In Sports mode, the camera automatically sets:

▶ Standard Picture Style

▶ AI Servo AF autofocus mode with automatic AF-point selection

▶ Continuous drive mode. Continuous drive mode enables you to shoot at 3.7 fps for a maximum burst rate of 34 Large/Fine JPEG images or 6 RAW images. You also have the option to use the 10-second Self-timer/Remote control or Self-timer Continuous drive mode.

▶ The flash does not fire

Night Portrait mode

In Night Portrait mode, the Rebel T2i/550D combines flash with a slow shutter speed so that both the subject and the background are correctly exposed. This combination prevents the subject from being very bright against a very dark background. However, this mode uses a longer exposure to properly expose a dark background, so it's important that the subject remain still during the entire exposure to avoid blur. Be sure to use a tripod or set the camera on a solid surface to take night portraits.

You should use this mode when people are in the picture, rather than for general night shots, because the camera blurs the background similar to the way it does in Portrait mode. For night scenes without people, use Landscape mode or a Creative Zone mode and a tripod.

In Night Portrait mode, the camera automatically sets:

▶ Standard Picture Style

▶ One-shot autofocus mode with automatic AF-point selection

▶ Single-shot drive mode with the option to set 10-second Self-timer/Remote control or Self-timer Continuous drive mode

▶ Automatic flash with the option to turn on Red-Eye Reduction mode

To use a Basic Zone mode, follow these steps.

1. **Turn the Mode dial so that one of the Basic Zone modes lines up with the white mark on the camera.**

2. **Press the Shutter button halfway down to focus, and press it completely to make the picture.** As you hold the camera, stabilize the elbow of the arm that's holding the camera by pressing it into your body and stand with your feet apart so that you form a sort of tripod with your body.

Movie mode

Movie mode enables you to capture full high-definition (full HD) quality video clips with control over the exposure. You can then play back the movies on a television, computer, or on the Rebel's LCD screen.

Because shooting with Movie mode differs significantly from the other Rebel shooting modes, I've devoted Chapter 6 to using Movie mode.

Creative Zone shooting modes

When you want creative control over your images, the semiautomatic and manual, collectively dubbed as the Creative Zone, shooting modes put part or all of the exposure control in your hands. Fortunately, you don't have to be a photography expert to use these shooting modes. Rather, you can choose a shooting mode based on the exposure element that's most important for you to control in a particular scene or with a particular subject.

For example, when you want to control how blurred or sharp the background details appear, then Av shooting mode is the best choice. In Av mode, you can blur the background by choosing a wide aperture of f/5.6 or f/4, or you can show the background with acceptably sharp detail by choosing a narrow aperture of f/8, f/11, or f/16. But when you want to control how the motion of the subject appears, then Tv mode is the best choice. In Tv mode, you can set a fast shutter speed to freeze the motion of a player in mid-jump or mid-run or choose a very slow shutter speed to show the motion of water as a silky blur. In each case, the camera sets the other settings for you automatically.

The following sections offer a summary of each Creative Zone shooting mode.

P mode

Program AE, shown as P on the Mode dial, is a semiautomatic but shiftable mode. Shiftable means that you can change the camera's suggested exposure by changing or shifting to an equivalent exposure just by turning the Main dial.

Here is how shifting the exposure works. When you press the Shutter button halfway, the camera shows you its ideal exposure settings in the viewfinder. Say that the camera recommends using f/4 at 1/400 second. That's fine, but you want more sharpness in the background details (a more extensive depth of field) than f/4 provides. Just turn the Main dial to the right until you get to f/8 or f/11 — apertures that provide more extensive depth of field. As you turn the Main dial, the Rebel automatically changes the shutter speed to give you an equivalent exposure.

But there is a catch. When you change the exposure in P mode, it is maintained for only one shot. Then the T2i/550D reverts to the camera's original exposure. Also if you don't take the shot at your modified settings within 2 or 3 seconds, the camera reverts to the initial settings. Thus P mode is handy when you want to quickly change the depth of field and shutter speed for one shot while making a minimum of camera adjustments.

 If you're using the built-in flash, you can't shift, or change from the camera's recommended exposure in P mode.

And P mode is an excellent mode to use if you're just beginning to use a digital SLR. You can not only experiment by changing the exposure for a single shot, but you can also control where the focus is set, as well as controlling other important settings on the Rebel.

 If you change the exposure settings in P mode and see 30 and the maximum lens aperture, or 4000 and the minimum lens aperture blinking in the viewfinder, it indicates the image will be underexposed and overexposed, respectively. In these instances, you can increase or decrease the ISO until the blinking stops.

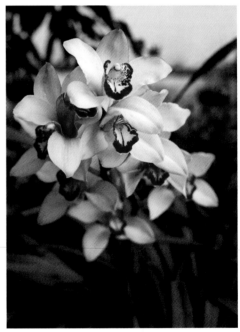

2.5 The camera originally set the aperture at f/5.6. In P mode, I turned the Main dial to set the aperture to f/2.8 to get a shallow depth of field through the background. Exposure: ISO 100, f/2.8, 1/1000 second.

To use P mode:

1. **Turn the Mode dial to line up P with the white mark on the camera, and then press the Shutter button halfway.** The T2i/550D displays its ideal suggested exposure settings in the viewfinder.

2. **To change the camera's recommended exposure, turn the Main dial until the aperture or**

shutter speed that you want is displayed in the viewfinder. As you turn the Main dial, both the aperture and shutter speed change simultaneously because the camera automatically calculates the equivalent aperture and shutter speed as you move the Main dial. But if you're using the flash, you cannot shift the program.

Why Use Program Mode Instead of Full Auto Mode?

Full Auto and Program shooting modes seem similar, but they vary greatly in the amount of control you have. In Full Auto mode, the camera sets all the camera settings automatically and you cannot change them. However, in P mode, you can temporarily change the camera's suggested shutter speed and aperture settings giving you creative control. Equally important, P mode enables you to control the autofocus point as well as all other camera functions — none of which you can control in Full Auto mode. Here is a look at the settings you can control in P mode, but that you can't control in Full Auto mode.

▶ **Shooting settings.** AF mode and AF-point selection, drive mode, metering mode, aperture, shutter speed, ISO, Exposure Compensation, Auto Exposure Bracketing, AE Lock, Custom Functions, and others.

▶ **Image settings.** White balance, Custom white balance, White balance correction, White balance bracketing, Color Space, and Picture Style.

Tv mode

Shutter-priority AE mode, shown as Tv on the Mode dial, is the semiautomatic mode where you set the shutter speed and the camera automatically sets the aperture. This is the mode to choose when you want to control how motion appears in the image, either as frozen in mid-motion or blurred. For example, where you want to show a skateboarder in midair with no motion blur, you can set a fast shutter speed of 1/500 second or faster. But if you want to show the motion of a waterfall as a silky blur, then set a slow shutter speed of 1/2 second to several seconds.

Tv mode is also helpful when you want to ensure that the shutter speed is fast enough for you to handhold the camera and get a sharp image. For example, if you're shooting an indoor sports event and don't want the shutter speed to go below, say, 1/60 second, you can set 1/60 second in Tv mode and the camera will maintain that shutter speed. The camera will also alert you if the light is too low for the shutter speed you've chosen (based on the maximum, or widest, aperture of the lens you're using).

2.6 This image was taken in Tv mode using a moderately fast 1/125-second shutter speed that stopped the motion of the splashing water. Exposure: ISO 200, f/5.6, 1/125 second.

Now is a good time to talk about how fast a shutter speed is necessary to avoid camera shake from handholding the camera. If you're not using an Image Stabilization (IS) lens, or a monopod or tripod, then the general rule is that you can handhold the camera and get a sharp image at the reciprocal of the focal length: 1/[focal length]. Thus if you're using a non-IS zoom lens zoomed to 200mm, then 1/200 second – 1 over the zoom setting of the lens at 200mm -- is the slowest shutter speed at which you can handhold the lens and not get image blur from camera shake.

For details on different types of lenses, see Chapter 8.

In Tv mode, you have full control over camera settings including being able to set the AF mode, AF point, metering and drive modes, Picture Style, and using the built-in flash. The shutter speeds that you can choose depend on the light in the scene. In low-light scenes without a flash, you may not be able to get a fast enough shutter speed to freeze the action. In Tv mode, the shutter speeds range from 1/4000 to 30 seconds, and Bulb. Shutter speed increments can be changed from the default 1/3-stop to 1/2-stop increments using Custom Function (C.Fn) I-1. Flash sync speed is 1/200 second or slower. To use Tv mode:

1. **Turn the Mode dial to line up Tv with the white mark on the camera.**

2. **Turn the Main dial to the shutter speed that you want.** As you turn the Main dial to set the shutter speed, the camera automatically sets the aperture. At the default settings, shutter speed values display in the viewfinder and on the LCD in 1/3-stop increments. And fractional shutter speeds show only the denominator. For example, 125 indicates 1/125 second, "0"6" indicates 0.6 seconds, and ""20"" indicates 20 seconds. If the f-stop blinks in the viewfinder, it means that a suitable aperture is not available at that shutter speed under the existing light. In these cases, you can switch to a higher ISO or to a slower shutter speed.

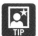 If you find the shutter speed display in the viewfinder confusing, take the camera away from your eye, press the Q button to display the Quick Control screen, and then select the shutter speed control. Then turn the Main dial to change the shutter speed. The Quick Control screen shows the faster shutter speeds as fractions rather than just showing the denominator of the fractional shutter speed.

Av mode

Av mode is another semiautomatic shooting mode, but in Av mode you set the aperture (f-stop) and the camera automatically sets the correct shutter speed. Aperture-priority AE mode is shown on the camera Mode dial as Av.

Aperture is the primary factor that controls the depth of field. A wide aperture, such as f/5.6, f/3.5, or f/2.8 creates a shallow depth of field with a softly blurred background. A narrow aperture, such as f/8, f/11, f/16, and narrower, creates an extensive depth of field with both foreground and background elements displaying good, or "acceptable," sharpness.

Unless you're shooting action, Av mode is a good everyday shooting mode because in many scenes, you want to control the depth of field. And in Av mode, you can quickly change the aperture to do so. The apertures you can choose depend on the lens you're using. And some lenses have what are called "variable apertures." For example, if you're using the Canon EF-S 18-55mm f/3.5-5.6 IS lens with the lens set to 18mm, then you can select f/3.5 as an aperture. But if the lens is set to 55mm, the widest aperture you can choose is f/5.6. For more details on lenses, see Chapter 8.

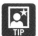 If you want larger aperture changes than the default 1/3-stop, then you can change to 1/2-stop increments using C.Fn I-1, Option 1.

In addition to providing quick control over depth of field, you may want to use Av mode to set and maintain the aperture at the sweet spot of the lens that you're using. The sweet spot is the aperture at which the lens provides the best detail, contrast, and sharpness, and it varies by lens. In low-light scenes where you know that you need to shoot consistently at the largest (widest) aperture, Av mode maintains the aperture.

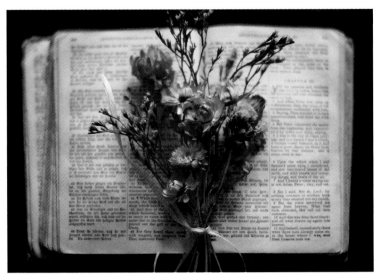

2.7 This image was taken in Av mode at a wide aperture creating the shallow depth of field that I wanted so that the text in the distance would blur. Exposure: ISO 200, f/1.2, 1/25 second.

In Av mode, you have control over all the camera settings including the AF mode, AF point, drive and metering modes, white balance, Picture Style, and use of the built-in flash.

 You can preview the depth of field for an image by pressing the Depth-of-Field Preview button on the front of the camera. When you press the button, the lens diaphragm closes to the aperture that you've set so that you can see how much of the scene will be in acceptably sharp focus.

If you use Av mode, be sure to monitor the shutter speed in the viewfinder; if it is 1/30 second or slower on a non-Image Stabilized lens, use a tripod. Or you can use the handholding rule provided earlier in the Tv section.

 For details on setting Custom Functions, see Chapter 4.

To change to Av mode, follow these steps:

1. **Turn the Mode dial to line up Av with the white mark on the camera.**

2. **Turn the Main dial to the aperture that you want.** The camera automatically sets the shutter speed. At the default settings, aperture values display in the viewfinder and LCD in 1/3-stop increments, such as 5.6, 6.3, 7.1, and so on. The higher the f-number, such as f/8, f/16, and so on, the smaller, or narrower, the aperture and the more extensive the depth of field. The smaller the f-number, such as f/5.6, f/4.0, and so on, the larger, or wider, the aperture and the shallower the depth of field.

 For more on apertures, see Chapter 9.

M mode

Manual mode, indicated by an M on the Mode dial, enables you to set both the aperture and the shutter speed (and the ISO) manually. But first, you have to know what exposure to use. Sometimes, you already know the exposure such as when a friend recommends the ISO, shutter speed, and aperture for shooting fireworks.

 Metering modes are detailed later in this chapter. The advanced exposure technique of using a gray card to determine exposure settings is detailed in Chapter 11.

M mode is also helpful in difficult lighting situations when you want to override the camera's recommended exposure, and in situations where you want consistent exposures across a series of photos, such as for a panoramic series. M mode is also used for fireworks and other low-light and night scenes where you know in advance the exposure that you want to use.

In M mode, you can control all camera settings including AF mode, AF point, drive and metering modes, white balance, Picture Style, and use of the built-in flash.

To use Manual mode, follow these steps.

1. **With the Mode dial set to M, press the Shutter button halfway down.** Watch the Exposure Level Index displayed at the bottom of the viewfinder and on the LCD. It has a tick mark that indicates how far the current exposure is from the camera's ideal or suggested exposure.

2.8 This image of fireworks was shot in Manual mode with the camera on a tripod. Exposure: ISO 100, f/11, 1/8 second.

2. **Adjust the shutter speed and/or aperture until the tick mark is at the center of the Exposure Level Index by**

 - Turning the Main dial to set the shutter speed, and,

 - Pressing and holding the Aperture/Exposure Compensation (AV) button on the back of the camera and turning the Main dial to adjust the aperture.

 You can also set the exposure above (to overexpose) or below (to underexpose) from the metered exposure. If the amount of under or overexposure is +/2 Exposure Values (EV) or f-stops, the Exposure Level Index bar blinks to show the amount of plus or minus EV in the viewfinder. You can then adjust either the aperture or shutter speed until the exposure level you want is displayed.

3. **Compose the image, press the Shutter button to focus, and then press the Shutter button completely to make the picture.**

A-DEP mode

A-DEP, or Automatic Depth of Field, mode automatically calculates the optimum, or maximum, depth of field between near and far subjects in the scene. As a result, both near and far elements will be in acceptably sharp focus. To do this, A-DEP mode uses the camera's nine AF points to detect near and far subject distances, and then calculates the aperture needed to keep the subjects in sharp focus.

While the automatic depth-of-field calculation is handy, getting the maximum depth of field typically means that the camera must set a narrow aperture, and that can result in a slow shutter speed. If the shutter speed is too slow for handholding, then use a tripod or monopod to avoid getting a blurry picture, or increase the ISO sensitivity setting. For non-IS telephoto lenses, see the handholding guideline in the Tv shooting mode section.

In A-DEP shooting mode, you cannot control the aperture, shutter speed, or AF points. While you can use the built-in flash in this mode, the maximum depth of field is sacrificed and A-DEP mode performs more like P mode.

To change to A-DEP mode, follow these steps:

1. **Turn the Mode dial to line up A-DEP with the white mark on the camera.**

2. **Focus on the subject.** In the viewfinder, verify that the AF points displayed in red cover the subject(s), and then take the picture. If the AF points aren't on the elements in the scene that you want, shift your shooting position slightly and refocus. Also, if the aperture blinks, it means the camera can't get the maximum depth of field. Move back or switch to a wide-angle lens or zoom setting.

2.9 This image was taken using A-DEP mode to provide the optimum depth of field in the near and far elements of the home and surroundings. Exposure: ISO 100, f/18, 1/100 second.

Setting the ISO Sensitivity

Along with aperture and shutter speed, the ISO setting is one of the elements of photographic exposure. In general terms, the ISO setting determines the sensitivity of the image sensor to light. The higher the ISO, the less light the sensor needs to make the picture, and the faster the shutter speed you'll get in low-light scenes, and vice versa. The following sections explore ISO in more detail.

About ISO settings

The Rebel T2i/550D has a wide 100 to 6400 ISO range, and it offers the ability to expand the range setting to 12800 in P, Tv, Av, M, and A-DEP shooting modes. That ability is great for allowing you to shoot in very low light; however, as you move to higher ISO settings, the output of the sensor is also amplified and that increases the digital noise in images. Digital noise appears as unwanted colorful flecks and as grain that most commonly appears in shadow areas, but at high ISO settings, it may also appear in lighter tones within the image. So while you have the option of increasing the ISO sensitivity at any point in shooting, the trade-off is an increase in digital noise from the increased amplification or the accumulation of an excessive charge on the pixels. And depending on the appearance and severity, the result of digital noise is an overall loss of resolution and image quality. .

As a result, you have to weigh the ability to use high ISO settings to get shots in low-light scenes against the resulting digital noise. It is worthwhile to test the camera by using all the ISO settings, and then comparing the images. To compare the results, view the images at 100 percent enlargement in an image-editing program, and then examine the shadow areas. If you see grain and colorful pixels where the tones should be continuous and of the same color, then you're seeing digital noise.

The most compelling benchmark in evaluating digital noise is the quality of the image at the final print size. And in the printed image, if the digital noise is visible and objectionable in an 8 × 10-inch or 11 × 14-inch print when viewed at a standard viewing distance, then the digital noise degraded the quality to an unacceptable level.

The Rebel T2i/550D offers two useful Custom Functions that help counteract noise: C.Fn II-4: Long-exposure noise reduction, and C.Fn II-5 High ISO speed noise reduction.

See Chapter 4 for details on each of these Custom Functions and how to set them.

The Rebel T2i/550D offers Auto ISO, a setting where the Rebel automatically sets the ISO from 100 to 6400 in P, Tv Av, M, and A-DEP shooting modes. In Basic Zone modes such as Portrait, Landscape, and so on, the automatic ISO range is 100 to 3200. When you're using Auto ISO, you can also set a limit on the highest ISO that the camera can set.

 The ISO sensitivity setting affects the effective range of the built-in flash, and **NOTE** the range depends on the lens that you're using. In general, the higher the ISO speed, the greater the effective flash range.

To change the ISO sensitivity setting, follow these steps.

1. **Set the camera to P, Tv, Av, M, or A-DEP shooting mode, and then press the ISO button on the top of the camera.** The ISO speed is displayed in the viewfinder and on the LCD. If the ISO screen doesn't appear on the LCD, press the Display button to display the shooting information on the LCD, and then press the ISO button again.

2. **To change the ISO setting turn the Main dial to the setting you want.** If you've enabled the expanded ISO setting, then you can also choose ISO 12800. The ISO option you select remains in effect until you change it or switch to a Basic Zone shooting mode. The current ISO is displayed in the viewfinder and on the LCD during shooting.

 You can quickly change the ISO on the Quick Control screen displayed on the **TIP** LCD. Just press the Q button to activate the screen, and then press a cross key to highlight the ISO setting. Then turn the Main dial to set the ISO setting that you want.

To set the limit on the highest ISO setting that the camera uses for Auto ISO, follow these steps.

1. **Set the camera to P, Tv, Av, M, or A-DEP shooting mode, and then press the Menu button.**

2. **Turn the Main dial to highlight the Shooting 3 tab, and then press the down cross key to select ISO Auto.**

3. **Press the Set button, and then press the up or down cross key to select the maximum ISO setting to use when you're shooting with Auto ISO.** You can choose a maximum ISO setting of 400, 800, 1600, 3200, or 6400.

If you tested the high ISO settings as suggested earlier, your test results will help you determine the maximum ISO setting to choose. Alternately, you can opt out of using Auto ISO and set the ISO based on the scene you are shooting. This approach gives you much more control over the final image quality.

Expanded ISO settings

The Rebel T2i/550D offers the ability to expand the ISO range to ISO 12800, which is denoted as H on the camera's displays. With the excellent noise performance of the T2i/550D, these settings are useful in low-light scenes when you might not otherwise be able to take a sharp image.

To access these two expanded ISO settings, you have to turn on C.Fn I-2 ISO expansion. While Custom Functions are detailed in Chapter 4, the steps are included here for convenience.

To enable the expanded ISO range, follow these steps.

1. **Set the camera to P, Tv, Av, M, or A-DEP shooting mode.**

2. **Press the Menu button and then turn the Main dial to select the Setup 3 menu.**

3. **Press the down or up cross key to highlight Custom Functions (C.Fn), and then press the Set button.** The C.Fn I: Exposure screen appears, or the last accessed Custom Function screen appears.

4. **Press the left or right cross key until the number 2 appears in the box at the top right of the screen, and then press the Set button. The options on the ISO expansion screen are activated.**

5. **Press the down cross key to highlight Option 1: On, and then press the Set button.** The expanded ISO setting remains available until you repeat these steps and choose Off to turn off the expanded settings.

Because the lowest ISO provides the best image quality, my philosophy for selecting an ISO setting is to always use the lowest possible setting for the conditions in which I'm shooting. If that means that I have to use a tripod, then that's what I do. With that as background, here are my general recommendations for selecting ISO settings.

▶ **In bright to moderately bright daylight, set the ISO to 100.** ISO 100 always gives you the least amount of digital noise, as well as the best color and contrast, and the highest level of fine image detail.

▶ **At sunset and dusk and in overcast light, set the ISO from 100 to 400.** At this time of day, shadows are deep, and keeping the ISO as low as possible helps minimize digital noise that is inherent in shadow areas. You may need to use a tripod or monopod as the light fades, especially if you're not using an IS lens.

▶ **Indoors (including gymnasiums, recital halls, and night concerts), and for night shooting, set the ISO from 400 to 3200.** If the ISO is at a high setting, and if you're not shooting action, then consider using C.Fn II-5, High ISO speed noise reduction, and set it to Option 2: Strong. I would use ISO 6400 and the expanded ISO 12800 setting only if there was no other way to get the image.

Metering Light to Determine Exposure Settings

All photographic exposures are based on the amount or intensity of light in the scene. Before the camera can give you its recommended exposure, it must first measure the amount of light in the scene. The Rebel T2i/550D features Canon's new Intelligent Focus Color Luminosity metering, or IFCL for short. Normally, camera light meters are colorblind. But with IFCL, the T2i/550D has a color-sensitive exposure sensor inside the camera that has two separate layers; one sensitive to Blue/Green, and the other sensitive to Green/Red light. When calculating exposure, the camera compares the level of each layer, and then adjusts the meter reading. This color information improves exposure accuracy for all exposures, and in particular for exposures where the subject color is predominantly on one or the other end of the color spectrum.

The new exposure system segments the viewfinder into 63 zones that align with autofocus zones so that the camera can evaluate information such as the subject distance provided by the active autofocus point as well as the areas surrounding it. Thus the T2i/550D can weight exposure for the subject and surrounding areas at approximately the same distance. The final result is that the T2i/550 delivers consistently excellent exposures that are based upon more information than with previous models of the camera.

To measure the light in the scene, the T2i/550D uses a built-in reflective light meter. After the camera measures the light in the scene, it factors in the current ISO and calculates the aperture and shutter-speed combinations that are necessary to make a good exposure.

 A reflective light meter measures the amount of light that's reflected from the subject back to the camera. Other types of light meters measure the light falling on the subject.

Because the light in various scenes differs, there are times when you want the camera to measure the light and base the exposure settings on the entire scene, with emphasis on the main subject. But in other scenes, such as when the background light is much brighter than the light on the subject, you want the camera to bias the exposure settings toward the subject to ensure that the subject is exposed properly. In the final image, the background may be very bright, but the subject will be exposed properly, and ultimately that is what you care about most — proper subject exposure. So as you can see, there are times when you want more or less of the overall scene light to be factored into the overall image exposure settings.

The different modes enable you to control how the camera meters light for the variety of different scenes and subjects. With these different modes, you have the flexibility to choose the metering mode that best suits your needs. To use the metering modes successfully, it's helpful to first understand more about how light meters work and what you can expect from the Rebel's onboard light meter.

How the Rebel T2i/550D meters light

The reflective light meter used on the Rebel T2i/550D generally assumes that all scenes are "average." An average scene is one with a mix of light, medium, and dark tones that, when averaged together, result in medium, or 18 percent, gray. Light meters see only in black-and-white and gray brightness levels or luminosity although the T2i/550D's meter is now more sensitive to light in color as well.

However, some scenes do not have average tonality; for example, a snow scene has predominantly light/white tones, while a scene where a black train engine fills most of the frame has predominantly dark/black tones. Left to its own devices, the camera will still try to get the average middle gray tonality from these scenes, and the final exposures render these scenes medium gray. And this explains why pictures of snow scenes come out with gray instead of white snow. And it explains how a solid black train engine, or a black tuxedo, is gray instead of solid black.

In other scenes, the subject may be positioned against a very dark or very light or bright background, and that's when you may want the camera to weight the light meter reading for the subject light (or reflectance) regardless of the light or dark background. That's where different metering modes and exposure modification techniques come into play.

 Canon's venerable Evaluative metering mode, which is the default mode, does an admirable job in virtually all of the scenes you'll photograph. So if you're just starting out, read about the different metering modes, and then you'll know that you can use them as you develop your photographic skills.

Four metering modes

The T2i/550D offers four metering modes that are differentiated by assigning a bias or weighting to different regions in the scene, and the regions with the most weight factor more into calculating the camera's recommended aperture and shutter speed settings (based on the current ISO).

 In P, Tv, Av, M, or A-DEP shooting modes, you can choose any of the four metering modes. But in the automatic shooting modes, such as Full Auto, Portrait, Landscape, CA, and so on, you cannot change the metering modes. The Rebel T2i/550D uses only Evaluative metering in these modes.

The following sections offer a look at the four metering modes.

Evaluative metering mode

Evaluative metering mode partitions the entire viewfinder into 63 zones to evaluate light throughout the scene. But in this metering mode, the camera biases the meter reading based on the subject position. The camera determines the subject position based on what AF point or points are active. (Active AF points are those that light with a red dot in the viewfinder when you half-press the Shutter button.) The Rebel also takes into account the scene or subject brightness, subject distance and nearby object distances, the background, as well as back and front lighting. Evaluative metering mode works well in many different types of scenes as well as in backlit scenes, and in scenes with reflective surfaces such as glass or water.

 Auto Lighting Optimizer is turned on by default, and it corrects exposure on images that are underexposed or lack contrast. If you want to see the image without this automatic correction, then turn off Auto Lighting Optimizer on the Shooting 2 camera menu.

Partial metering mode

This metering mode hones in on a much smaller area of the scene -- approximately 9 percent of the scene at the center of the viewfinder. By concentrating the meter reading

more to a small area of the scene, this mode gives good exposures for a small area of the scene such as a small subject that you want to be perfectly exposed.

In everyday shooting, partial metering is a good choice for backlit portraits so that the subject is properly exposed against the bright background rather than appearing in full or partial silhouette. Partial metering is also a good choice for high-contrast subjects, and when the background is much darker than the subject. Again, this metering mode assumes that the subject is in the center of the frame. If the subject isn't in the center, then you can take a meter reading using the center AF point, lock in the exposure settings using Auto Exposure Lock (AE Lock is detailed later in this chapter), recompose, focus, and shoot. Alternately, it may be easier to use Manual shooting mode to set the Partial metering aperture and shutter speed values.

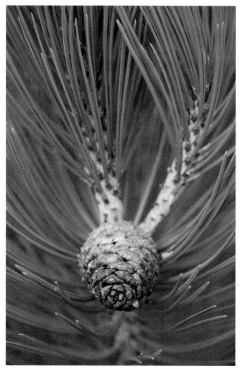 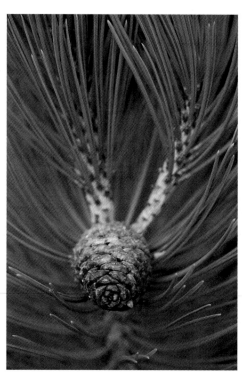

2.10 **This image was made using Evaluative metering mode. This mode evaluates the entire scene light with a bias toward the active autofocus point. Here the exposure is lighter than in figure 2.11 where I used Partial metering mode. Exposure: ISO 200, f/5.6, 1/125 second.**

2.11 **By way of comparison to figure 2.10, this image was taken using Partial metering mode. I used the center autofocus point to meter on the center of the pinecone. Exposure: ISO 200, f/5.6, 1/160 second.**

 While Partial and Spot metering modes can be considered as advanced modes, don't be afraid to experiment with them. Trying these modes on appropriate subjects is one of the best ways to learn the camera and expand your creative options.

 The T2i/550D's exposure meter is sensitive to stray light that can enter through the viewfinder. If you don't have your eye against the viewfinder, then use the viewfinder eyepiece cover that is attached to the camera strap, or cover the viewfinder with your hand.

Spot metering mode

In Spot metering mode, the metering concentrates on a small, approximately 4 percent area at the center of the viewfinder — the circle that's displayed in the center of the viewfinder. This advanced metering mode is great for exposure techniques where you meter from a middle-gray area in the scene or from a photographic gray card to calculate the exposure settings described in a sidebar in Chapter 11.

The Spot meter reading is taken at the center AF point. If that's not where you want to set the focus, then you can use Manual shooting mode to meter with the center AF point and set the aperture and shutter values from the meter reading. Then you can recompose and focus using an off-center AF point.

Center-weighted Average metering mode

This metering mode weights exposure calculation for the center of the viewfinder, while evaluating light from the rest of the viewfinder to get an average for the entire scene. The center area encompasses an area larger than the 9 percent Partial metering area. As the name implies,

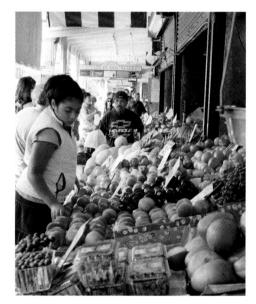

2.12 This scene was partially backlit and side-lit while the woman and vendor were in shadowy light. I took a Spot meter reading on the woman's face knowing that the vendor's face was in approximately the same light. The background and left side of the scene go very light, but the exposure on the woman's and man's faces is acceptable thanks to the Spot meter reading. Exposure: ISO 100, f/9, 1/25 second.

the camera expects that the subject will be in the center of the viewfinder, and it gives approximately 75 percent of the exposure bias to a circle bounded by the seven center AF points in the viewfinder.

Center-weighted Average metering mode is useful in scenes where the sky is brighter than a darker landscape. And provided that the subject is in the center of the frame, then Center-weighted Average metering mode is effective for backlit subjects and subjects against a bright background such as bright white sand on a beach.

NOTE
There are nine AF points, but in Center-weighted metering not all the AF points are used — only the seven AF points in the center; hence the name, Center-weighted.

To change to a different metering mode, follow these steps.

1. **Set the Mode dial to P, Tv, Av, M, or A-DEP, and then press the Menu button.**

2. **Turn the Main dial to select the Shooting 2 menu.**

3. **Press the up or down cross key to highlight Metering mode, and then press the Set button.** The Metering mode screen appears on the LCD with text and icons identifying the four metering mode options.

4. **Press the left or right cross key to select the metering mode you want.** The mode you choose remains in effect until you change it. If you switch to an automatic Basic Zone mode such as CA, Portrait, Landscape, and so on, then the camera automatically uses Evaluative metering mode.

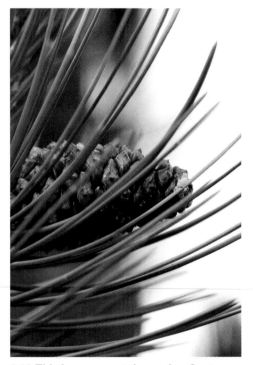

2.13 **This image was taken using Center-weighted Average metering. Exposure: ISO 200, f/5.6, 1/80 second.**

Evaluating and Modifying Exposure

The goal of shooting is to get the best exposure possible in the camera. Now that you know how to control exposure using shooting modes, set the ISO, and use metering modes, it's important to know how to evaluate exposures and adjust the ones that are not spot-on accurate.

But first, it's helpful to define what good exposure is. Aesthetically, you might say that a great exposure is one that captures and expresses the scene as you saw and envisioned it. Technically — and assuming skillful composition — a great exposure has several characteristics including:

▶ **Highlights that maintain detail either throughout the image, or at least within the subject.** Highlights that do not retain detail go completely white, and they are referred to as being "blown out" or "blown." Particularly with JPEG capture, if you don't retain detail in the highlights, that detail is gone forever.

▶ **Shadows that show detail.** If the shadows go dark too quickly, they are referred to as being "blocked up." For example, if you're photographing a groom in a black tuxedo, a good exposure shows detail within the shadowy folds of the coat or slacks.

▶ **Visually pleasing contrast, accurate color, good saturation.** I would add another characteristic that isn't related to the aperture, shutter speed, and ISO. And that, of course, is tack-sharp focus.

While the fundamental goal is to capture a good exposure, there are times when your creative vision will override these technical goals. More often, however, the dynamics of the scene itself may simply not allow you to achieve all these goals. For example, in a scene where the range from highlight to shadow is beyond the capability of the Rebel T2i/550D to maintain detail in both the highlights and shadows, then one or another technical characteristic must be sacrificed. In those situations, your aim is to get a proper and pleasing exposure on the subject.

With that as an introduction, the next sections show you how to evaluate exposures as you're shooting, and how to modify exposures when necessary.

Evaluating exposure

After you take a picture, you can best evaluate the image exposure by studying the histogram. A histogram is a graph that shows either the brightness levels in the image — from black (level 0) to white (level 255) for an 8-bit image — or the Red, Green, Blue (RGB) brightness levels, along the bottom. The vertical axis displays the

number of pixels at each location. The T2i/550D offers both types of histograms, a brightness (or luminance) histogram, and RGB (Red, Green, and Blue color channel) histograms.

The histograms are the most useful tools that you can use in the field, especially if you're shooting JPEG images, to ensure that highlights are not blown, and that shadows are not blocked up. The following sections offer an overview of each type of histogram.

 Although the Rebel T2i/550D captures 14-bit RAW images, the image preview and histogram are based on an 8-bit JPEG rendering of the RAW file.

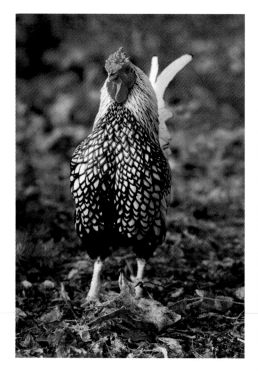

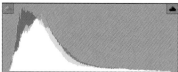 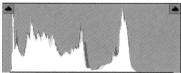

2.14 The histogram inset in this picture shows that the tones are distributed across the full range of levels. The highlights retain detail and the shadows are open showing good detail. Exposure: ISO 200, f/3.5, 1/125 second.

2.15 This image is underexposed as the histogram shows with the pixels falling short of reaching or nearly reaching the right edge of the graph. Exposure: ISO 800, f/6.3, 1/30 second.

Brightness histogram

A brightness histogram shows grayscale brightness values in the image along the horizontal axis of the graph. The values range from black (level 0 on the left of the graph) to white (level 255 on the right of the graph) for an 8-bit JPEG image. This histogram shows you the exposure bias and the way that tones are distributed in the image.

The subject you're photographing affects the histogram, of course. For example, in an image of a black train engine, more pixels shift toward the left, shadow, side of the graph. In an image of a white lily, more pixels are on the right, highlight, side of the graph. However, if pixels crowd against the far-right edge of the graph forming a spike, then some highlights in the image are blown out; in other words, they are totally white with no detail, or at 255. If pixels spike on the left edge of the graph, then some shadows are blocked up and go to black too quickly.

In a proverbial average scene, good exposure is shown with pixels spread across the graph from side to side and with no spikes on the left or right edges of the histogram.

2.16 This image has blown highlights as shown by the spike of pixels on the right edge of the histogram. While the shadows are stacked up on the left side, they do not block up and show good detail in the full-size image. Exposure: ISO 800, f/6.3, 1/30 second.

RGB histogram

An RGB histogram shows the distribution of brightness levels for each of the three color channels — Red, Green, and Blue. Each color channel is shown in a separate graph so you can evaluate the color channel's saturation, gradation, and color bias. The horizontal axis shows how many pixels exist for each color brightness level, while the vertical axis shows how many pixels exist at that level. More pixels to the left indicate that the color is darker and more prominent, while more pixels to the right indicate that the color is brighter and less dense. If pixels are spiked on the left or right side, then color information is either lacking or oversaturated with no detail, respectively. If you're shooting a scene where color reproduction is critical, the RGB histogram is likely most useful.

The histogram is a very accurate tool to use in evaluating JPEG captures. If, however, you shoot RAW capture, the histogram is based on the JPEG conversion of the image. So if you shoot RAW, remember that the histogram is showing a less robust version of the image than you get during image conversion. To set the type of histogram displayed during image playback, follow these steps:

1. **Press the Menu button, and then turn the Main dial to highlight the Playback 2 menu.**

2. **Press the up or down cross key to highlight Histogram, and then press the Set button.** Two histogram options appear.

3. **Press the up or down cross key to select either Brightness or RGB, and then press the Set button.**

To display the histogram during image playback, follow these steps:

1. **Press the Playback button on the back of the camera.** The most recent image appears on the LCD.

2. **Press the Display button on the back of the camera two or more times to display the Brightness histogram, or the RGB and Brightness histograms.** As you press the Display button, the preview cycles through four image displays: Single-image, single image with basic shooting information, small image with the Brightness histogram and detailed shooting information, and small image with the RGB and Brightness histograms displays and less detailed shooting information.

During image playback, the display option with the histograms displayed shows blown highlights as blinking areas on the image. That display provides a quick way to know if you should reshoot with the modified exposure options detailed later in this chapter.

Differences in Exposing JPEG and RAW Images

When you shoot JPEG images, it's important to expose the image so that highlight detail within the subject is retained. If you don't capture detail in the highlights, it's gone forever. To ensure that images retain detail in the brightest highlights, you can use one of the exposure techniques described in this chapter such as AE Lock or Exposure Compensation.

With RAW capture, you have more exposure latitude because some highlights can be recovered during RAW image conversion in Canon's Digital Photo Professional or Adobe Lightroom or Camera Raw. Without going into detail, it's important to know that fully half of the total image data is contained in the first f-stop of the image. This underscores the importance of capturing the first f-stop of image data and of not underexposing the image. In everyday shooting, this means biasing the exposure slightly toward the right side of the histogram, resulting in a histogram in which highlight pixels just touch or almost touch, but are not crowded against, the right edge of the histogram.

With this type of exposure, the image preview on the LCD may look a bit light, but in a RAW conversion program, you can bring the exposure back slightly. So for RAW exposure, expose with a slight bias toward the right side of the histogram to ensure that you capture the full first f-stop of image data.

Now that you know more about evaluating exposure, the next question is what should you do if the exposure needs adjustment? The Rebel T2i/550D includes several ways to modify the camera's recommended exposure and automatic exposure corrections, all of which are detailed in the following sections.

Auto Lighting Optimizer

Auto Lighting Optimizer is an image-correction feature that boosts contrast and brightens images that are too dark. This is one of the goof-proof features that can be useful if you print images directly from the media card. However, if you edit images on the computer and if you care about controlling the exposure yourself, then you will likely

prefer to see the image without automatic corrections. Auto Lighting Optimizer is turned on for all shooting modes. In Basic Zone modes such as Portrait, Landscape, Sports mode, and so on, the optimization can't be turned off, and the level of correction is set to Standard. In P, Tv, Av, M, and A-DEP shooting modes, you can turn off optimization or set the level for Low, Standard or Strong. And if you shoot RAW capture, you can apply Auto Lighting Optimizer in Canon's supplied Digital Photo Professional program.

While automatic brightening may seem handy, it also tends to reveal any digital noise in the image. Digital noise appears with a grainy look and as multicolored flecks, particularly in the shadow areas of the image. Also, by using Auto Lighting Optimizer, the effect of exposure modification may not be evident depending on the level of optimization chosen. For example, if you set negative Exposure Compensation (detailed later

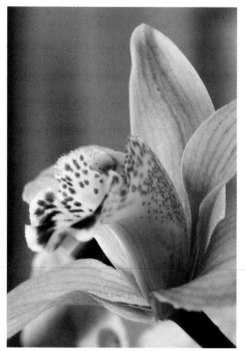

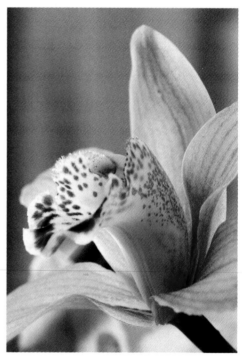

2.17 This image was taken without using Auto Lighting Optimizer. Exposure: ISO 200, f/8, 1/5 second.

2.18 This image was taken using Auto Lighting Optimizer at the Standard setting. The brightness increased overall and most noticeably in the background. It's a good idea to test the three settings for the optimization before you use it on a routine basis. Exposure: ISO 200, f/8, 1/6 second.

in this section), then Auto Lighting Optimizer automatically brightens the image and the effect of compensation is masked. The same happens for other exposure modifications such as AEB and AE Lock. If you prefer to see the effect of exposure modifications, then you can turn off Auto Lighting Optimizer, but only for Creative Zone shooting modes.

To adjust the level of or to turn off Auto Lighting Optimizer for Creative Zone shooting modes, follow these steps:

1. **Set the Mode dial to P, Tv, Av, or A-DEP shooting mode.**

2. **Press the Menu button, and turn the Main dial until the Shooting 2 menu is displayed.**

3. **Press the up or down cross key to highlight Auto Lighting Optimizer, and then press the Set button.** The Auto Lighting Optimizer screen appears.

4. **Press the right or left cross key to select the level you want, and then press the Set button.** You can choose Disable, Low, Standard, or Strong. The option you choose remains in effect until you change it.

Highlight Tone Priority

Highlight Tone Priority is designed to improve or maintain highlight detail helping to reduce the incidence of blown highlights. It does this by extending the range between 18 percent middle gray to the maximum highlights, thus effectively increasing the dynamic range, or the range of highlight to shadow tones as measured in f-stops in a scene. In addition, the gradation between grays and highlights is finer. Using Highlight Tone Priority, however, limits the ISO range from 200 to 6400, or 12800 with extended ISO enabled.

For those with experience working with tonal ranges and curves, the more technical explanation is that Highlight Tone Priority helps ensure that the pixel wells on the image sensor do not fill, or saturate, causing blown highlights. Also with the Rebel's 14-bit images, the camera sets a tone curve that is relatively flat at the top in the highlight area to compress highlight data. The trade-off, however, is a more abrupt move from deep shadows to black, which increases shadow noise. The result is an increase in dynamic range, disregarding, of course, the potential for increased shadow noise.

Highlight Tone Priority is turned off by default. You can turn on Highlight Tone Priority by following these steps:

1. **Set the Mode dial to P, Tv, Av, M, or A-DEP shooting mode.**

2. **Press the Menu button, and then turn the Main dial until the Setup 3 menu is displayed.**

3. **If necessary, press the up or down cross key to highlight Custom Functions (C.Fn), and then press the Set button.** The Custom Functions screen appears.

4. **Press the right or left cross key until the number "6" is displayed in the box at the top right of the screen, and then press the Set button.** The Custom Function option control is activated and the option that is currently in effect is highlighted.

5. **Press the down cross key to highlight 1: Enable, and then press the Set button.** This turns on Highlight Tone Priority in Creative Zone shooting modes. Lightly press the Shutter button to return to shooting.

As a reminder that Highlight Tone Priority is enabled, a "D+" designation is displayed in the viewfinder and on the LCD. In addition, the ISO range begins at 200 rather than 100.

Exposure Compensation

There are times when you need to change the camera's recommended exposure to lighten or darken the overall image. Common scenarios include scenes with a pre-dominance of light or dark tones. For example, in scenes with large expanses of snow, the camera will often darken the snow. This happens because the camera expects a scene where all the tones average to 18% reflectance, as discussed in the previous sections of this chapter. However, snow scenes are not average because they have a predominance of light tones. The same is true for scenes with large expanses of dark tones such as a large body of water or a group of men in black tuxedos.

In these types of scenes, the camera's reflective meter averages light or dark scenes to 18 percent gray to render large expanses of whites as gray and large expanses of black as gray. To avoid this, you need to use exposure compensation. For a snow scene, set a +1- to +2-stop Exposure Compensation to render snow as white instead of gray. A scene with predominately dark tones might require -1 to -2 stops of Exposure Compensation to get true dark renderings.

 The Rebel T2i/550D is set to make exposure changes by 1/3 f-stops by default. If you want larger changes, then you can set C.Fn I-1 to Option 1: 1/2-stop increments.

In addition, you can use exposure compensation to modify the camera's recom-mended exposure if the histogram shows that highlights are blown or that shadows are blocked.

Here are some things that you should know about Exposure Compensation:

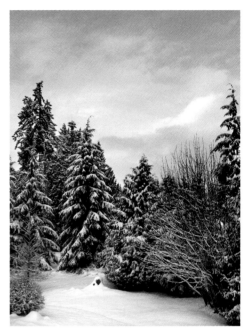

▶ Exposure Compensation works in P, Tv, Av, and A-DEP shooting modes, but it does not work in Manual mode or during Bulb exposures. In Tv shooting mode, Exposure Compensation changes the aperture by the specified amount of compensation. In Av shooting mode, it changes the shutter speed. In P mode, compensation changes both the shutter speed and aperture by the exposure amount you set.

▶ You can set Exposure Compensation up to plus/minus 5 stops, or Exposure Values (EV), although the scale shown in the viewfinder can only show plus/minus 2 EV. You can also combine Exposure Compensation with plus/minus 2 EV of Auto Exposure Bracketing (AEB).

2.19 To get true whites in the snow, I used a +1.33 Exposure Compensation setting. Exposure: ISO 100, f/8, 1/40 second.

▶ The amount of Exposure Compensation you set remains in effect until you reset it. This applies whether you turn the camera off and back on, change the media card, or change the battery. So remember to set the compensation back to zero when you finish shooting in scenes where you need compensation.

NOTE Bulb is an exposure where the shutter remains open as long as you press the Shutter button. Bulb exposures are used for some fireworks and astral photography. You can set Bulb using M shooting mode. When you set the shutter speed in M mode, turn the Main dial to the left until Bulb appears as an option. Of course, always use a tripod for Bulb exposures.

You can set Exposure Compensation by following these steps:

1. **With the Mode dial set to P, Tv, Av, or A-DEP, press the Q button to display the Quick Control screen on the LCD.**

2. **Press a cross key to highlight the Exposure Level Indicator.** The Exposure Level Indicator, the scale at the upper left of the LCD, is highlighted.

3. **Turn the Main dial to the left to set negative Exposure Compensation or to the right to set positive compensation.** Although the scale initially displays only a +/- 2 stops of compensation, you can continue turning the Main dial to display the full +/- 5 stops of compensation.

To turn off Exposure Compensation when you finish shooting, repeat these steps, but in Step 3, turn the Main dial until the tick mark is at the center of the exposure level meter that's displayed on the Quick Control screen.

Alternately, you can set Exposure Compensation and combine it with Auto Exposure Bracketing on the Shooting 2 menu. This approach is useful if you shoot a series of images at different exposures to combine into a high-dynamic range image.

Auto Exposure Bracketing

While not directly modifying the camera's recommended exposure, Auto Exposure Bracketing (AEB) fits in the category of exposure modification because it enables you to capture a series of three images each at different exposures: one at the camera's recommended exposure, one picture at an increased (lighter) exposure, and another picture at a decreased (darker) exposure. This ensures that one of the three exposures will be acceptable, particularly in challenging lighting. While bracketing isn't necessary in all scenes, it's a good technique to use in scenes that are difficult to set up or that can't be reproduced. It is also useful in scenes with contrasty lighting such as a landscape with a dark foreground and a much lighter sky.

The camera is initially set to 1/3 f-stop increment exposure changes. If you want a greater level of exposure difference, you can set C.Fn I-1 to Option 1: 1/2-stop. With either setting, you can bracket image series up to +/2 f-stops. Here are some things to know about AEB:

▶ You can't use AEB with the built-in or an accessory flash or when the shutter is set to Bulb. If you set AEB, and then pop up the built-in flash or pop it up while you're making one of the three bracketed images, the AEB settings are automatically and immediately cancelled.

▶ The order of bracketed exposures begins with the standard exposure followed by decreased (darker) and increased (lighter) exposures.

▶ You can use AEB in combination with Exposure Compensation for a total of plus/minus 7EV. If you combine AEB with Exposure Compensation, the shots are taken based on the compensation amount.

▶ If Auto Lighting Optimizer is turned on, the effects of AEB may not be evident in the darker image because the camera automatically lightens dark images. You can turn off Auto Lighting Optimizer as described previously in this chapter.

The T2i/550D offers the added flexibility of enabling you to shift the entire bracketing range to below or above zero on the meter. As a result, you can set all three bracketed exposures to be brighter or darker than the camera's recommended exposure and skip capturing the camera's standard exposure. Here's how AEB works in the different drive modes:

▶ In Continuous and Self-timer modes, pressing the Shutter button once automatically takes three bracketed exposures. In the Self-timer drive modes, the three bracketed shots are taken in succession each after the timer interval has elapsed.

▶ In Single-shot drive mode, you have to press the Shutter button three times to get the three bracketed exposures.

▶ If C.Fn III-8 is set for Mirror Lockup, and you're using AEB and Continuous drive mode, only one of the bracketed shots is taken at a time. You press the Shutter button once to lock up the mirror and again to make the first bracketed exposure. The Exposure Level Indicator in the viewfinder flashes after each exposure until all three bracketed images have been made.

AEB settings are cancelled if you pop up the built-in flash or mount an accessory flash, or turn off the camera.

You can set AEB by following these steps:

1. **With the Mode dial set to P, Tv, Av, or A-DEP, press the Q button to display the Quick Control screen on the LCD.**

2. **Press a cross key to activate the Exposure Level Indicator.** The Exposure Level Indicator, the scale at the upper left of the LCD, is highlighted.

3. **Hold down the Av button on the back of the camera as you turn the Main dial to the right to set the bracketing amount.** Markers that show increased and decreased exposure settings are displayed on the bracketing scale. You can set bracketing up to +/2 EV.

If you want to shift the bracketed exposures so they all are in the negative or positive range, then release the Av button, and turn the Main dial to the left to set negative exposure bracketing, or to the right to set positive exposure bracketing.

4. **If you're in One-shot drive mode, press the Shutter button to focus, and then press it completely to take the picture.** Continue pressing the Shutter button two more times to take all three bracketed shots. In Continuous or a Self-timer mode, the three shots are taken by pressing the Shutter button once. In Self-timer modes, the three bracketed shots are taken automatically.

Auto Exposure Lock

Many times you don't want to set or bias the exposure metering at the same point where you set the focus. For example, if you're taking a portrait, you may want to set or bias the exposure for the person's skin so that it's properly exposed while having the camera ignore a bright background. While the light on the skin is critical to getting a good exposure, you then want to focus on the person's eyes.

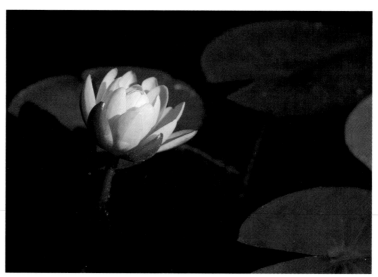

2.20 For this image, I used Partial metering mode and metered on the bright flower so that the camera would not factor in the dark background, and then I locked that exposure using AE Lock. Exposure: ISO 100, f/8, 1/125 second.

To meter on one area of the scene or subject and focus on another area, you can use Auto Exposure Lock (AE Lock). Just press the Shutter button halfway down to meter and set the exposure on the area you want, and then press the AE Lock button to

have the T2i/550D retain the exposure. Now you can move the camera to recompose the scene and focus on a different area of the scene. You can also use AE Lock to meter on a gray card or a middle-gray area in the scene, to help prevent blown high-lights, to ensure proper exposure for a backlit subject, and any time you want to ensure correct exposure of a critical area in the scene. The camera maintains the locked exposure for a couple of seconds, and then releases it. As long as the asterisk is displayed in the viewfinder, AE Lock is still in effect.

 You cannot use AE Lock in the automatic Basic Zone shooting modes such as Portrait, Landscape, Close-up, and so on.

Table 2.1 shows how AE Lock works with each metering mode and AF-point selection method and with manual focus.

Table 2.1: AE Lock Behavior with Metering Mode and AF-Point Selection

Metering Mode	Manual AF-Point Selection	Automatic AF-Point Selection	Manual Focus (Lens switch is set to MF)
Evaluative metering mode	AE Lock is set at the selected AF point	AE Lock is set at the AF point that achieves focus	AE Lock is set at the center AF point
Partial, Spot, and Center-weighted Average metering modes	AE Lock is set at the center AF point		

You can use AE Lock by following these steps:

1. **Set the Mode dial to P, Tv, Av, or A-DEP shooting mode, set the metering mode you want, and then manually select the AF point that you want to use.** Note that in A-DEP mode, the camera automatically selects the AF points. If you want to use Partial, Spot, or Centered-weighted Average metering modes, then AE Lock is set at the center AF point.

2. **If you are using Evaluative metering mode, point the AF point you selected on the part of the scene where you want to set the exposure, and then press the Shutter button halfway down.** If you are using Spot, Partial, or Center-weighted Average metering, or if you are focusing manually, then point the center AF point over the area of the scene where you want to meter. The exposure settings are displayed in the viewfinder.

3. **Continue to hold the Shutter button halfway down as you press the AE Lock button.** The AE Lock button has an asterisk icon above it on the camera. When you press this button, an asterisk icon appears in the viewfinder to indicate that AE Lock is activated.

4. **Release the AE Lock button, and move the camera to compose the shot, focus by half-pressing the Shutter button, and then press the Shutter button completely to make the picture.** As long as you see the asterisk in the viewfinder, you can take additional pictures using the locked exposure.

Getting Tack-Sharp Focus

Whether you're shooting one image at a time or you are blasting out a burst of images during a soccer match, the Rebel T2i/550D's quick focus can keep up and provide tack-sharp focus. The camera provides three autofocus modes that are suited to different types of shooting. In addition, you can choose any of the nine AF points, or you can have the camera automatically choose the AF points.

The following sections help you get the best performance from the Rebel T2i/550D's autofocus system.

Choosing an autofocus mode

Three autofocus modes are designed to help you achieve sharp focus based on the type of subject you're photographing. In P, Tv, Av, M, and A-DEP shooting modes, you can select from among these AF modes. In Basic Zone modes, the camera automatically chooses the autofocus mode.

In any of these autofocus modes, you can manually select an AF point or have the camera automatically select the AF point(s). Selecting an autofocus point is detailed later in this chapter.

The following list is a brief summary of the autofocus modes and when to use them.

▶ **One-shot AF.** This mode is designed for photographing stationary subjects that are still and will remain still. Choose this mode when you're shooting landscapes, macro subjects, architecture, interiors, and portraits of adults. Unless you're shooting sports or action, One-shot AF is the mode of choice for everyday shooting. In this autofocus mode, the camera won't allow you to make the picture until the camera achieves sharp focus. Sharp focus is confirmed when the focus confirmation light in the viewfinder is lit and when the beeper sounds if you have the beeper turned on.

▶ **AF Focus AF**. This mode is designed for photographing still subjects that may begin moving. This mode starts out in One-shot AF mode, but it automatically switches to AI Servo AF, detailed next, if the subject begins moving. Then the camera tracks focus on the moving subject. When the switch happens, a soft beep alerts you that the camera is shifting to AI Servo AF, and the focus confirmation light in the viewfinder is no longer lit. (The beeper beeps only if you have turned on the beep on the Shooting 1 camera menu.) This is the mode to choose when you shoot wildlife, children, or athletes who alternate between stationary positions and motion.

▶ **AI Servo AF.** This mode is designed for photographing action subjects. The T2i/550D tracks focus on the subject regardless of the changes in focusing distance from side to side or approaching or moving away from the camera. The camera sets both the focus and the exposure at the moment the image is made. In this mode, you can press the Shutter button completely even if the focus hasn't been confirmed. You can use a manually selected AF point in this mode although it may not be the AF point that ultimately achieves sharp focus. Or if you use automatic AF selection where the camera automatically selects the AF points, the camera starts focus tracking using the center AF point and tracks movement as long as the subject remains within the other eight AF points in the viewfinder.

If you routinely set focus and then keep the Shutter button pressed halfway down, you should know that this shortens battery life. To maximize power, anticipate the shot and press the Shutter button halfway down just before making the picture.

To change AF modes in Creative Zone modes, ensure that the lens switch is set to AF (autofocus), and then follow these steps:

1. **With the camera set to P, Tv, Av, M, or A-DEP shooting mode, press the AF (right cross key) button on the back of the camera.** The AF mode screen appears. If the screen doesn't appear, press the Display button, and then press the AF button again.

2. **Press the right or left cross key to change the AF mode, and then press the Set button.** The mode you choose remains in effect for P, Tv, Av, and M shooting modes until you change it.

 If you're using a lens that offers manual focusing, you can switch to manual focus at any time by setting the switch on the side of the lens to the MF (Manual Focus) setting. Then just turn the focusing ring on the lens to focus on the subject.

Does Focus-Lock and Recompose Work?

Some suggest that you can use the standard point-and-shoot technique of focus-lock and recompose with the Rebel T2i/550D. This is the technique where you lock focus on the subject, and then move the camera to recompose the image. In my experience, however, the focus shifts slightly during the recompose step regardless of which AF point is selected. As a result, focus is not tack sharp.

Some Canon documents note that at distances within 15 feet of the camera and when shooting with large apertures, the focus-lock-and-recompose technique increases the chances of *back-focusing*. Back-focusing is when the camera focuses behind where you set the AF point. Either way, the downside of not using the focus-lock-and-recompose technique is that you're restricted to composing images using the nine AF points in the viewfinder. The placement of the nine AF points isn't the most flexible arrangement for composing images. But manually selecting one AF point, locking focus, and then not moving the camera is the best way that I know to ensure tack-sharp focus in One-shot AF mode.

Selecting a single autofocus point

One of the requirements for a successful picture is getting tack-sharp focus. When you're shooting in P, Tv, Av, and M modes, you can manually choose one of the nine AF points shown in the viewfinder. Alternately, you can have the camera automatically select the AF points used for focusing.

In the automatic Basic Zone and in A-DEP shooting modes, the camera automatically selects the AF point or points for you.

Having the camera automatically choose the AF points may or may not set sharp focus where it should be in the scene, and here's why. When the camera chooses the AF points, it focuses on whatever is nearest the lens or has the most readable contrast. This may or may not be the area that should have the point of sharpest focus.

Improving Autofocus Accuracy and Performance

Autofocus speed depends on factors including the size and design of the lens, the speed of the lens-focusing motor, the speed of the AF sensor in the camera, the amount of light in the scene, and the level of subject contrast. Given these variables, it's helpful to know how to get the speediest and sharpest focusing. Here are some tips for improving overall autofocus performance.

▶ **Light.** In low-light scenes, the autofocus performance depends in part on the lens speed and design. In general, the faster the lens or the larger the maximum aperture of the lens, such as f/2.8, the faster the autofocus performance. But regardless of the lens, the lower the light, the longer it takes for the system to focus.

Low-contrast subjects and/or subjects in low light slow down focusing speed and can cause autofocus failure. In low light, consider using the built-in flash or an accessory EX Speedlite's AF-assist beam as a focusing aid. By default, the Rebel T2i/550D is set to use the AF-assist beam for focusing. This is controlled by C.Fn III-7.

▶ **Focal length.** The longer the lens, the longer the time to focus. This is true because telephoto lenses go farther into defocus range than normal or wide-angle lenses. You can improve the focus time by manually setting the lens in the general focusing range and then using autofocus to set the sharp focus.

▶ **AF-point selection.** Manually selecting a single AF point provides faster autofocus performance than using automatic AF-point selection because the camera doesn't have to determine and select the AF point or points to use first.

▶ **Subject contrast.** Focusing on low-contrast subjects is slower than on high-contrast subjects. If the camera can't focus, shift the camera position to an area of the subject that has higher contrast, such as a higher contrast edge.

▶ **EF Extenders.** Using an EF Extender reduces the speed of the lens-focusing drive.

▶ **Wide-angle lenses and small apertures.** Sharpness can be degraded by diffraction when you use small apertures with wide-angle or wide-angle zoom lenses. Diffraction happens when light waves pass around the edges of an object and enter the shadow area of the subject producing softening of fine detail. To avoid diffraction, avoid using apertures smaller than f/16. Because sharp focus at the proper place in the subject or scene is critical to the success of any image, you will have the best success if you manually select a single AF point and use it to focus.

You can manually select the AF point by following these steps:

1. **Set the Mode dial to P, Tv, Av, or M mode.** In A-DEP shooting mode, the camera automatically sets the AF point or points for you.

2. **Press the AF-Point Selection/ Magnify button on the back upper-right corner of the camera.** The AF-Point Selection button has a magnifying glass with

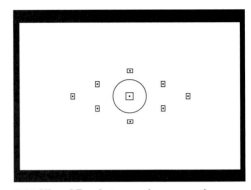

2.21 Nine AF points are shown on the focusing screen on the Rebel T2i/550D.

a plus sign in its icon below the button. The currently selected AF point displays a red dot in the center of the AF point in the viewfinder. On the LCD the selected AF point is displayed as a rectangle with a white border.

3. **As you look in the viewfinder or watch the LCD, turn the Main dial until the AF point that you want to use is highlighted.** You can also use the cross keys to select an AF point. If you select the option where all the AF points are high- lighted, then the camera automatically selects the AF point or points. If you want to control the point of sharpest focus in the image, then do not choose this option. Rather, choose an option where only one AF point — the one that is on top of the part of the subject where you want sharp focus — is highlighted. To quickly move to the center AF point, press the Set button once.

4. **Move the camera so that the AF point you selected is over the point in the scene that should have sharp focus, press the Shutter button halfway down to focus on the subject, and then press it fully to make the picture.**

You can verify image sharpness by pressing the Playback button, and then pressing and holding the AF-Point Selection/Magnify button on the back of the camera.

Selecting a Drive Mode

A drive mode determines how many shots the camera takes at a time, or, in a Self- timer mode, it sets the camera to fire the shutter automatically after a 10- or 2-second delay. The Rebel T2i/550D offers three drive modes for different shooting situations: Single-shot, Continuous, and three Self-timer modes. If you're shooting one image at a time, then the 3.7 fps speed applies. But if you're shooting in Continuous drive mode, then you can fire off a burst of up to 34 Large/Fine JPEG images or 6 RAW images.

In Basic Zone modes, the camera automatically chooses the drive mode. In CA shooting mode, you can choose the drive mode, and you can select the drive mode in P, Tv, Av, M, and A-DEP modes.

Single-shot drive mode

As the name implies, Single-shot means that the T2i/550D takes one picture each time you press the Shutter button. In this mode, you can shoot 3.7 fps, depending on shutter speed for the image you're shooting. This is the default mode on the camera in P, Tv, Av, M, and A-DEP modes. In the automatic Basic Zone modes, Single-shot drive mode is used for all except Portrait and Sports shooting modes. In CA mode, you can choose Single-shot, Continuous, and two of the Self-timer drive modes.

Continuous drive mode

In Continuous drive mode, you can shoot at 3.7 fps, or, if you press and hold the Shutter button, you shoot a continuous burst of 34 or more JPEG Large images, 6 RAW, or 4 RAW+JPEG Large images. This is the mode to choose for sports shooting or for other moving subjects such as children, pets, and wildlife.

 In AI Servo AF mode, the burst rate may be less, depending on factors including the lens and the subject.

When you're shooting a burst of images and the buffer fills up, you can't shoot until some of the images are offloaded to the media card. With smart-buffering capability, you don't have to wait for the buffer to empty all the images to the media card before you can continue shooting. After a continuous burst sequence, the camera begins offloading pictures from the buffer to the card. As offloading progresses, the camera indicates in the viewfinder when there is enough buffer space to continue shooting. When the buffer is full, a "busy" message appears in the viewfinder, but if you keep the Shutter button pressed, the number of pictures that you can take is updated in the viewfinder. This is where it is useful to have a fast media card, which speeds up image offloading from the buffer. You can use the flash with Continuous mode, but due to the flash recycle time, shooting will be slower than without the flash.

 If the AF mode is set to AI Servo AF, the T2i/550D focuses continually during continuous shooting. However, in One-shot AF mode, the camera only focuses once during the burst.

Self-timer drive modes

In Self-timer drive modes, the camera delays making the picture for 10 or 2 seconds after the Shutter button is fully depressed. In addition, you can use the 10-second delay plus Continuous shooting. For self-timer shots, be sure to use the eyepiece cover included with the camera to prevent stray light from entering through the viewfinder.

Here is a summary of the self-timer modes:

▶ **Self-timer/Remote control.** In this mode, the camera waits 10 seconds before the shutter is fired giving you time to get into the picture. In addition, you can use the accessory wireless Remote Controller RC-6 that trips the shutter immediately or after 2 seconds, or a corded Remote Switch RS-60E3 with this mode. This mode is useful when you want to be in the picture with others, and for nature, landscape, and close-up shooting. It can be combined with Mirror Lockup (C.Fn III-8). With this combination, you have to press the Shutter button once to lock the mirror, and again to make the exposure.

▶ **Self-timer: 2-second.** In this mode, the camera waits for 2 seconds before firing the shutter. This is a good choice when you're photographing documents or artwork. If you use the 2-second self-timer with Mirror Lockup, the mirror locks up when you press the Shutter button completely, and then the image is made after the 2-second delay.

▶ **Self-timer: Continuous.** In this mode, you can choose to have the camera take two to ten shots in sequence, each with a 10-second delay.

To change the drive mode, follow these steps:

1. **Set the Mode dial to P, Tv, Av, M, or A-DEP shooting mode, and then press the Drive mode button on the back of the camera.** The Drive mode button is the left cross key. You can also set the Mode dial to CA.

2. **Press the left or right cross key to select the drive mode you want, and then press the Set button.** Text identifying each drive mode icon is displayed as you make your selection. You can also turn the Main dial to select the mode you want.

Getting Great Color

On the Rebel T2i/550D, a variety of easy-to-use options help ensure that your images will have excellent color regardless of the type of light. Getting great color begins during shooting by selecting a white balance and Picture Style. In addition, you can choose a color space that best matches your printing needs. In this chapter, you learn how each option is useful in different shooting scenarios as well as learning some techniques for ensuring accurate color. But before we talk about camera controls and options that ensure accurate color, it's important to understand the concepts of light and its colors.

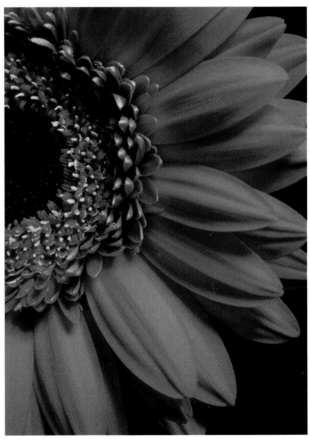

Delivering true-to-life vibrant color is one of the primary strengths of the T2i/550D. Exposure: ISO 100, f/19, 1/125 second.

Choosing White Balance Options

To get accurate image color, you have to tell the camera what type of light you're shooting in by selecting one of seven white balance options or by setting a custom white balance that measures the specific light in the scene. Using the correct white balance settings will help you spend less time color-correcting images on the computer and more time shooting. The following images show the color bias of the preset white balance settings using the same subject.

TIP If you shoot RAW images, you can set and adjust the white balance in the RAW conversion program after the image is captured.

3.1 Automatic White Balance (AWB) setting. Exposure: ISO 200, f/3.5, 1/250 second.

3.2 Daylight white balance setting and the Standard Picture Style

3.3 Shade white balance setting

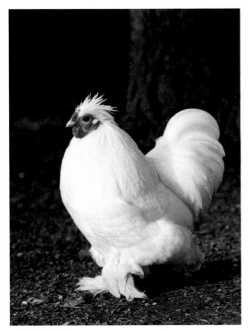

3.4 Cloudy white balance setting

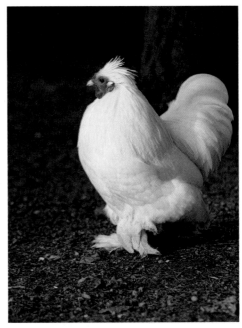

3.5 Tungsten white balance setting

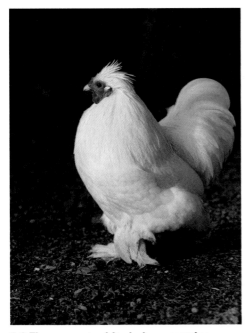

3.6 Fluorescent white balance setting

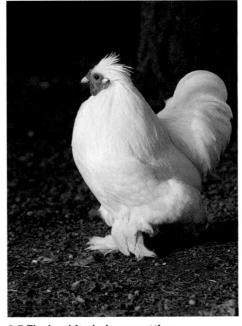

3.7 Flash white balance setting

Using white balance options

For most scenes where there is clearly defined light, the preset white balance options such as Daylight, Cloudy, and so on, provide accurate image color. In mixed lighting situations, you'll get the most accurate image color by setting a custom white balance. Setting a custom white balance takes a little more time than choosing a preset option, but it delivers very accurate and pleasing color. Whether you choose to use a preset or create a custom white balance setting may depend on how much time you have. If you don't have time to set a custom white balance, then use the Auto white balance that's designed to work well in any type of light.

Whatever your approach to white balance options, the time you spend using and understanding them and how they can enhance your images is time that you'll save color-correcting images on the computer.

To change to a preset white balance option such as Daylight, Tungsten, Shade, and so on, follow these steps:

1. **Set the Mode dial to P, Av, Tv, M, or A-DEP, and then press the WB button on the back of the camera.** The WB button is the up cross key. The White balance screen appears.

2. **Press the left or right cross key to select a white balance setting, and then press the Set button.** Because the white balance option you set remains in effect until you change it, remember to reset it when you begin shooting in different light.

In practice, the AWB white balance setting tends to have an overall cool, bluish, hue. While it is an acceptable choice in mixed light when there isn't time to set a custom white balance, be aware of the tendency for a cooler color rendering.

Set a custom white balance

Mixed-light scenes, such as tungsten and daylight, can make getting accurate or visually pleasing image color a challenge. In mixed-lighting scenes, setting a custom white balance balances colors for the specific light or combination of light types in the scene. A custom white balance is relatively easy to set, and it's an excellent way to ensure accurate color.

You can learn more about setting custom white balance at www.cambridgeincolour.com/tutorials/white-balance.htm.

Getting Accurate Color with RAW Images

If you are shooting RAW capture, a great way to ensure accurate color is to photograph a white or gray card that is in the same light as the subject, and then use the card as a color-balancing point when you convert RAW images on the computer.

For example, if you're taking a series of portraits in unchanging light, ask the subject to hold the gray or white card under or beside his or her face for the first shot. Then remove the card and continue shooting. When you begin converting the RAW images on the computer, open the picture that you took with the card. Click the card with the white balance tool to correct the color, and then click Done to save the corrected white balance settings. If you're using a RAW conversion program such as Adobe Camera Raw or Canon's Digital Photo Professional, you can copy the white balance settings from the image you just color balanced. Just select all the images shot under the same light, and then paste the white balance settings to them. In a few seconds, you can color balance 10, 20, 50, or more images.

There are a number of white and gray card products you can use such as the WhiBal cards from RawWorkflow.com (www.rawworkflow.com/products/whibal) or ExpoDisc from expoimaging (www.expodisc.com/index.php) to get a neutral reference point. And there is a gray card included in the back of this book. There are also small reflectors that do double duty by having one side in 18 percent gray and the other side in white or silver. You can also use a plain white unlined index card.

Another advantage to creating a custom white balance setting is that it works whether you're shooting JPEG or RAW capture in P, Tv, Av, M, or A-DEP mode. Just remember that if light changes, you need to set a new custom white balance to get accurate color.

To set a custom white balance, follow these steps:

1. **Set the camera to P, Av, Tv, M, or A-DEP shooting mode, and ensure that the Picture Style is not set to Monochrome.** To check the Picture Style, press the Picture Style button (the down cross key) on the back of the camera. The Picture Style screen is displayed. To change from Monochrome, which is denoted on the Picture Style screen with an "M," press the left or right cross key to select another style, and then press the Set button. Also have the white balance set to any setting except Custom.

2. **With the subject in the light you'll be shooting in, position a piece of unlined white paper so that it fills the center of the viewfinder, and take a picture.** If the camera cannot focus, switch the lens to MF (manual focus) and focus on the paper. Not all lenses have a MF switch on the side of the lens. Also ensure that the exposure is neither underexposed nor over-exposed such as by having Exposure Compensation (detailed in Chapter 2) set.

3. **Press the Menu button, and then turn the Main dial to select the Shooting 2 menu.**

4. **Press the up or down cross key to highlight Custom WB, and then press the Set button.** The camera displays the last image captured (the white piece of paper) with a Custom White Balance icon in the upper left of the display. If the image of the white paper is not displayed, press the left cross key until it is.

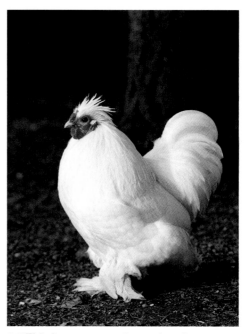

3.8 This image was taken using the Custom white balance setting.

5. **Press the Set button again.** The T2i/550D displays a confirmation screen asking if you want to use the white balance data from this image for the Custom white balance setting.

6. **Press the right cross key to highlight OK, and then press the Set button.** A second confirmation screen appears.

7. **Press the Set button to select OK, and then press the Shutter button to dismiss the menu.** The camera imports the white balance data from the selected image.

8. **Press the WB (White Balance) button on the back of the camera, and then press the right cross key to select Custom White Balance.** The White balance screen appears. The Custom white balance setting is identified with text and is denoted by an icon with two triangles on their sides with a black dot between them.

9. **Press the Set button.** You can begin shooting now and get custom color in the images as long as the light doesn't change. The Custom white balance setting remains in effect until you change it by setting another white balance.

When you finish shooting in the light for which you set a custom white balance and move to a different area or subject, remember to reset the white balance option.

Use White balance auto bracketing

Given the wide range of indoor tungsten, fluorescent, and other types of lights that are available, the preset white balance options may or may not be spot-on accurate for the type of light in the scene. And even if they are, you may prefer a bit more of a green or blue bias to the overall image color. With the Rebel T2i/550D, you can use the White balance auto bracketing setting to get a set of three images, each a slightly different color bias up to plus/minus three levels in one-step increments.

White balance auto bracketing is handy when you don't know which color bias will give the most pleasing color or when you don't have time to set a manual white balance correction. The white balance bracketed sequence gives you three images from which you can choose the most visually pleasing color.

 White balance auto bracketing reduces the maximum burst rate of the Rebel T2i/550D by one-third because each press of the Shutter button records three images.

To set the White balance auto bracketing setting, follow these steps:

1. **With the camera set to P, Tv, Av, M, or A-DEP shooting mode, press the Menu button, and then turn the Main dial until the Shooting 2 menu appears.**

2. **Press the down cross key to highlight WB SHIFT/BKT (White Balance Shift/Bracket), and then press the Set button.** The WB Correction/WB Bracketing screen appears.

3. **Turn the Main dial clockwise to set Blue/Amber bias, or counterclockwise to set a Magenta/Green bias.** As you turn the Main dial, three squares appear and the distance between them increases as you continue to turn the dial. The distance between the squares sets the amount of bias. On the right side of the screen, the camera indicates the bracketing direction and level under BKT. You can set up to plus/minus three levels of bias. If you change your mind and want to start again, press the Display button on the back of the camera.

4. **Press the Set button.** The Shooting 2 (red) menu appears with the amount of bracketing displayed next to the menu item.

5. **Lightly press the Shutter button to dismiss the menu.**

6. **If you're in One-shot drive mode, press the Shutter button three times to capture the three bracketed images, or if you're in Continuous drive mode, press and hold the Shutter button to capture the three bracketed images.** With a blue/amber bias, the standard white balance is captured first, and then the bluer and more amber bias shots are captured. If magenta/green bias is set, then the image-capture sequence is the standard, then more magenta, then more green bias. White balance auto bracketing continues in effect until you remove it or the camera is turned off.

 You can combine White balance auto bracketing with Auto Exposure bracketing. If you do this, a total of nine images are taken for each shot. Bracketing also slows the process of writing images to the media card.

Set White balance correction

Similar to White balance auto bracketing, you can also manually bias the color of images by using White balance correction. This feature is much like using a color-correction filter on a film camera. The color can be biased toward blue (B), amber (A), magenta (M), or green (G) in plus/minus nine levels measured as mireds, or densities. Each level of color correction that you set is equivalent to five mireds of a color-temperature conversion filter. When you set a color correction or bias, it is used for all images until you change the setting.

 In film photography, densities of color-correction filters range from 0.025 to 0.5. On the Rebel T2i/550D, shifting one level of blue/amber correction is equivalent to five mireds of a color-temperature conversion filter.

To set White balance correction, follow these steps:

1. **Press the Menu button, and then turn the Main dial to select the Shooting 2 menu.**

2. **Press the down cross key to highlight WB SHIFT/BKT, and then press the Set button.** The WB Correction/WB Bracketing screen appears.

3. **Press a cross key to set the color bias and amount that you want — toward blue, amber, magenta, or green.** On the right of the screen, the SHIFT panel

shows the bias and correction amount. For example, A2, G1 shows a two-level amber correction with a one-level green correction. If you change your mind and want to start again, press the Display button on the back of the camera.

4. **Press the Set button.** The Shooting 2 menu appears. The color shift you set remains in effect until you change it. To turn off White balance correction, repeat Steps 1 and 2, and in Step 3, press the Display button to return the setting to zero.

Choosing and Customizing a Picture Style

In addition to setting the appropriate white balance option, the choice of Picture Style also affects how color is rendered in images by setting the color tone and saturation used in images. A Picture Style provides the foundation for how images are rendered, and, whether you select a style or not, the T2i/550D applies a Picture Style to all of your images. Individual styles offer different looks. For example, the Landscape Picture Style has vivid color saturation, while the Portrait Picture Style renders portraits with warm, soft skin tones and subdued color saturation.

Choosing a preset Picture Style

The Rebel T2i/550D offers six Picture Styles, which are detailed in Table 3.1. The camera uses the Standard Picture Style as the default style for P, Tv, Av, M, and A-DEP shooting modes, and for all Basic Zone modes except Portrait and Landscape shooting modes. Each Picture Style has settings for sharpness, contrast, color saturation, and color tone that you can use as is or you can modify them to suit your preferences. In addition, you can create up to three User Defined Styles that are based on one of Canon's Picture Styles.

Figures 3.9 through 3.14 show how Picture Styles change image renderings. The differences may not be as apparent in this book due to commercial printing, but they give you a starting point for evaluating differences in Picture Styles. The images were shot using a custom white balance.

In addition to forming the basis of image rendering, Picture Styles are designed to give you good prints with little or no post-processing so that you can print JPEG images directly from the media card. If you shoot RAW capture, you can't print directly from the media card, and the Picture Style is noted for the file, but it's not applied unless you use Canon's Digital Photo Professional program. You can also apply a Picture Style during RAW-image conversion using Canon's Digital Photo Professional conversion program.

 Be sure to test Picture Styles first, and then choose the ones that provide the best prints for your JPEG images.

In addition, you can modify a Picture Style on the computer using Canon's Picture Style Editor as detailed later in this chapter.

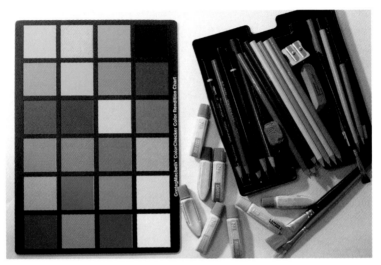

3.9 Standard Picture Style

3.10 Portrait Picture Style

3.11 Landscape Picture Style

3.12 Neutral Picture Style

3.13 Faithful Picture Style

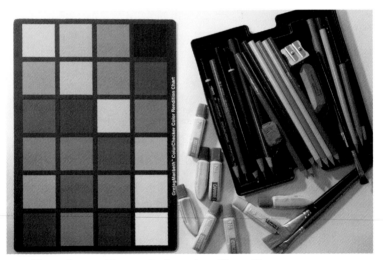

3.14 Monochrome Picture Style and no filter effect

You can also customize Picture Styles to help you get the kind of results out of the camera that you want. If you find that you want to adjust a Picture Style, here are the adjustments that you can modify when you're shooting in P, Tv, Av, M, and A-DEP shooting modes.

▶ **Sharpness: 0 to 7.** Level zero applies no sharpening and renders a very soft look, whereas level 7 is the highest sharpening setting. If you print images directly from the media card, a moderate amount of sharpening, such as level 3, produces sharp images. But if your workflow includes sharpening images after editing and sizing them in an editing program, then you may want to set a lower sharpening level for the Picture Style in the camera to avoid oversharpening.

▶ **Contrast.** This setting affects the image contrast as well as the vividness of the color. For images printed directly from the media card, a 0 (zero) to level 1 setting produces snappy contrast in prints. A negative adjustment produces a flatter look and a positive setting increases the contrast.

▶ **Saturation.** This setting affects the strength or intensity of the color with a negative setting producing low saturation and vice versa. A zero or +1 setting is adequate for snappy JPEG images destined for direct printing.

▶ **Color Tone.** This control primarily affects skin tone colors. Negative adjustments to color tone settings produce redder skin tones while positive settings produce yellower skin tones.

With the Monochrome Picture Style, only the sharpness and contrast parameters are adjustable, but you can add toning effects, as detailed in Table 3.1. Default settings in this table are listed in order of sharpness, contrast, color saturation, and color tone.

Table 3.1: EOS T2i/550D Picture Styles

Picture Style	Description	Sharpness	Color Saturation	Default Settings
Standard	Vivid, sharp, crisp images with uniform color that are suitable for direct printing from the media card	Moderate	High	3,0,0,0
Portrait	Provides a warmer rendition in skin tones, lower contrast and color saturation, and soft texture rendering	Low	Low	2,0,0,0
Landscape	Deepens blues and brightens greens to create vivid reproduction, high color saturation, and high sharpness to emphasize landscape details	High	High saturation for greens and blues	4,0,0,0

continued

Table 3.1: EOS T2i/550D Picture Styles *(continued)*

Picture Style	Description	Sharpness	Color Saturation	Default Settings
Neutral	True color reproduction with low contrast and color saturation reducing the chance of overexposure and oversaturation. Helps retain highlight details. Allows latitude for image editing.	None	Low	0,0,0,0
Faithful	Provides true-to-life color rendition for subjects shot in light with a color temperature of 5200K, low color saturation and sharpness.	None	Low	0,0,0,0
Monochrome	Black-and-white or toned images with slightly high sharpness	Slightly high	Yellow, orange, red, and green filter effects available	3,0, N, N

Many people have grown accustomed to seeing images with strong contrast, vivid color, and a higher sharpness level. If this is your preference, and if you routinely print images from the media card without first editing them on the computer, then you'll likely be pleased using the Standard Picture Style for everyday shooting, and the Landscape Picture Style for landscapes and cityscapes. The Standard style is the one set on the T2i/550D by default.

However, if you prefer a subtler rendering of color, saturation, and contrast that offers more fine details in the highlights and shadows, and if you enjoy editing images on the computer before printing them, then you'll likely appreciate the Neutral, Portrait, and Faithful styles. You can choose a Picture Style by following these steps:

1. **Press the Picture Style button on the back of the camera.** The Picture Style button is the down cross key. The Picture Style screen appears with the current Picture Style highlighted. The screen also shows the default setting for the style.

2. **Press the left or right cross key to highlight the Picture Style you want, and then press the Set button.**

Customizing a Picture Style

After using, evaluating, and printing with different Picture Styles, you may want to change the default parameters to get the rendition that you want. Alternately, you may want to create a custom style. You can create up to three Picture Styles that are based on an existing style.

While the default Picture Styles are certainly good choices, I highly recommend modifying one or more Picture Styles to suit your visual tastes, and shooting and printing needs. After much experimentation, I settled on a modified Neutral Picture Style that provides pleasing results for any images that I shoot in JPEG format. Here is how I've modified the Neutral Picture Style settings.

- ▶ **Sharpness.** +2
- ▶ **Contrast.** +1
- ▶ **Saturation.** +1
- ▶ **Color tone.** 0

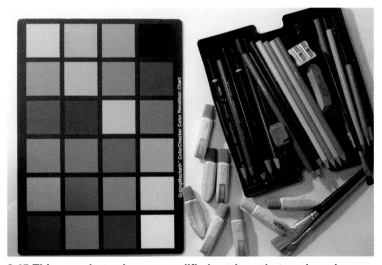

3.15 This was shot using my modified settings that are based on the Neutral Picture Style.

These settings provide excellent skin tones provided that the image isn't underexposed and the lighting isn't flat. You can try this variation and modify it to suit your work. I also often use the Portrait Picture Style that I modified by increasing the contrast setting to +1. This style is an excellent choice for photographing women and

children. For men, I've found that the rendering is a bit too subtle, and I prefer to use the Standard Picture Style for men with a decreased Sharpness setting. I decrease the Sharpness setting because I always edit images on the computer before printing, and, as the final step in editing, I apply sharpening after I've sized a copy of the edited image for either Web display or for printing.

 Adjusting the color tone of a Picture Style shifts the color subtly. For example, in the Portrait Picture style a +2 setting shifts skin tones to a more yellow rendering while a -2 shifts the color to a more reddish rendering.

To modify a Picture Style, follow these steps:

1. **With the camera set to P, Tv, Av, M, or A-DEP shooting mode, press the Menu button, and then turn the Main dial to select the Shooting 2 menu.**

2. **Press the up or down cross key to highlight Picture Style, and then press the Set button.** The Picture Style screen appears with a list of the preset Picture Styles.

3. **Press the down cross key to highlight the Picture Style you want to modify, and then press the Display button.** The Detail set. screen for the selected Picture Style appears.

4. **To change the Sharpness parameter, which is selected by default, press the Set button.** The Sharpness control is activated.

5. **Press the left or right cross key to change the parameter, and then press the Set button.** For all the parameter adjustments, negative settings decrease sharpness, contrast, and saturation, and positive settings provide higher sharpness, contrast, and saturation. Negative color tone settings provide reddish tones, and positive settings provide yellowish skin tones.

6. **Press the down cross key to move to the Contrast parameter, and then press the Set button.** The camera activates the control.

7. **Press the left or right cross key to adjust the parameter, and then press the Set button.**

8. **Repeat Steps 5 through 7 to change additional parameters.**

9. **Press the Menu button. The Picture Style screen appears where you can modify other Picture Styles.** The Picture Style changes are saved, changes are shown in blue, and the changes remain in effect until you change them. Press the Set button to return to the Shooting 2 menu, or lightly press the Shutter button to dismiss the menu.

Using Monochrome Filter and Toning Effects

While you can customize the Monochrome Picture Style, only the Sharpness and Contrast parameters can be changed. But, you have the additional option of applying a variety of Filter and/or Toning effects.

▶ **Monochrome Filter effects.** Filter effects mimic the same types of color filters that photographers use when shooting black-and-white film. The Yellow filter makes skies look natural with clear white clouds. The Orange filter darkens the sky and adds brilliance to sunsets. The Red filter further darkens a blue sky, and makes fall leaves look bright and crisp. The Green filter makes tree leaves look crisp and bright and renders skin tones realistically. You can increase the effect of the filter by increasing the Contrast setting.

▶ **Monochrome Toning effects.** You can choose to apply a creative toning effect when shooting with the Monochrome Picture Style. The Toning effect options are None, S: Sepia, B: Blue, P: Purple, and G: Green.

Registering a User-Defined Picture Style

You can also create a Picture Style to suit your personal preferences. You begin by choosing one of Canon's existing styles, and then you set the options for Sharpness, Contrast, Saturation, and Color Tone. Then you can save the style as a User Defined style on the camera.

Given that you can create up to three different User Defined styles, there is latitude to set up styles for different types of shooting situations. For example, you might want to create your own Picture Style for everyday photography that is less contrasty than the Standard Picture Style. Certainly you could alternately modify the existing Standard style, but you may want to leave it unmodified and use it for images you're going to print directly from the media card. Then you can set up a second User Defined style for portraits of women and children, and a third style for portraits of men. Because the styles are named and displayed as 1, 2, and 3, just remember which style you set up for each number.

To create and register a User Defined Picture Style, follow these steps:

1. **With the camera set to P, Tv, Av, M, or A-DEP shooting mode, press the Menu button, and then turn the Main dial to select the Shooting 2 menu.**

2. **Press the down cross key to select Picture Style, and then press the Set button.** The Picture Style screen appears.

3. **Press the down cross key to highlight User Def. 1, and then press the Display button.** The Detail set. User Def. 1 screen appears with the currently selected Picture Style listed.

4. **Press the Set button.** The Standard Picture Style control is activated so that you can choose a different base Picture Style if you want.

5. **Press the up or down cross key to select a base Picture Style, and then press the Set button.**

6. **Press the down cross key to highlight the parameter you want to change, and then press the Set button.** The camera activates the parameter's control.

7. **Press the left or right cross key to set the parameter and then press the Set button.**

8. **Repeat Steps 6 and 7 to change the remaining settings.** The remaining parameters are Contrast, Saturation, and Color tone.

9. **Press the Menu button to register the style.** The Picture Style changes are saved, the Picture Style name is displayed in blue, and the changes remain in effect until you change them. Press the Set button to return to the Shooting 2 menu, or lightly press the Shutter button to dismiss the menu.

You can repeat these steps to set up User Def. 2 and 3 styles.

Using the Picture Style Editor

One approach to getting Picture Styles that are to your liking is to set or modify one of the styles provided in the camera. But that approach is experimental: You set the style, capture the image, and then check the results on the camera and in prints. If the style needs adjustment, you go through the process again until you get the results you want.

There is a more precise way to modify Picture Styles using Canon's Picture Style Editor, a program that comes on the disc included in the camera box. With the Picture Style Editor, you can make precise custom changes to Picture Styles. The process is to open a RAW image that you've already captured in the Picture Style Editor program, apply a Picture Style, and then make changes to the style while watching the effect of the changes as you work. Then you save the changes as a Picture Style file (.PF2), and use the EOS Utility, a program that's also provided on the disc, to register the file in the camera and apply it to images.

The Picture Style Editor looks deceptively simple, but it offers powerful and exact control over the style. Because the goal of working with the Picture Style Editor is to

create a Picture Style file that you can register in the camera, the adjustments that you make to the RAW image are not applied to the image. Rather, the adjustments are saved as a file with a .PF2 extension. After saving the settings as a PF2 file, you can apply them to images in Digital Photo Professional.

> If you use the Picture Style Editor, it's best to use a Color Management System (CMS) that includes calibrating your monitor, using the correct monitor and printer profiles, and using a consistent color space among the camera, monitor, and printer. For monitor calibration, I recommend the Spyder 3 Pro or Elite from Datacolor, spyder.datacolor.com/product-mc-s3pro.php.

While the full details of using the Picture Style Editor are beyond the scope of this book, I encourage you to read the Picture Style Editor descriptions on the Canon Web site at http://web.canon.jp/imaging/picturestyle/editor/index.html.

Be sure you install the EOS Digital Solution Disk programs before you begin. To start the Picture Style Editor, follow these steps:

1. **On your computer, start the Picture Style Editor. On a PC, the Picture Style Editor application is located in the Canon Utilities folder. On the Mac, look in the Applications folder for the Canon Utilities folder.** The Picture Style Editor main window appears.

2. **Click and drag a RAW CR2 image onto the main window**. You can also choose File➔Open Image, and navigate to a folder that contains RAW images, double-click a RAW file, and then click Open. When the file opens, the Picture Style Editor displays the Tool palette.

3. **To choose a style other than the current style, click the arrow next to Base Picture Style on the Tool Palette, and then choose the style you want.** The Base Picture Style is at the top left of the Tool Palette.

> To show the original image and the image with the changes you make side by side, click one of the split-screen icons at the bottom left of the main window. To switch back to a single image display, click the icon at the far-left bottom of the window.

4. **Click Advanced button in the Tool palette to display the parameters for Sharpness, Contrast, Color saturation, and Color tone.** These are the same settings that you can change on the camera. But with the Picture Style Editor, you can watch the effect of the changes as you apply them to the RAW image.

5. **Make the changes you want, and then click OK.**

6. **Adjust the color, tonal range, and curve using the palette tools.** If you are familiar with image-editing programs, or with Digital Photo Professional, most of the tools will be familiar. Additionally, you can go to the Canon Web site at http://web.canon.jp/imaging/picturestyle/editor/functions.html for a detailed description of the functions.

When you modify the style to your liking, you can save it and register it to use in the T2i/550D. However, when you save the PF2 file, I recommend saving two versions of it. During the process of saving the file, you can select the Disable subsequent editing option, which prevents disclosing the adjustments that have been made in the Picture Style Editor as well as captions and copyright information. This is the option to turn on when you save a style for use in the T2i/550D and in the Digital Photo Professional program. But by selecting that option, the style file no longer can be used in the Picture Style Editor.

For that reason, you'll likely want to save a second copy of the PF2 file without selecting the Disable subsequent editing option in the Save Picture Style File dialog box. That way, if you later decide to modify the style, you can use the Picture Style Editor to make adjustments to this copy of the PF2 file.

Before you begin, ensure that you've installed the EOS Digital Solution Disk programs on your computer. To save a custom Picture Style, follow these steps:

1. **Click the Save Picture Style File icon at the top far right of the Picture Style Editor Tool palette or choose it from the menu.** The Save Picture Style File dialog box appears.

2. **Navigate to the folder where you want to save the file.**

3. **To save a file to use in the T2i/550D, select the Disable subsequent editing option at the bottom of the dialog box.** To save a file that you can edit again in the Picture Style Editor, do not select this option.

4. **Type a name for the file, and then click Save.** The file is saved with a .PF2 file extension in the folder you specified.

To install the custom Picture Style on the Rebel T2i/550D, follow these steps. Before you begin, be sure that you have the USB cable that came with the camera available.

1. **With the camera turned off, connect the camera to the computer using the USB cable supplied in the T2i/550D box.**

2. **On your computer, start the Canon EOS Utility program.** The EOS Utility program is located in the Canon Utilities folder on your computer. The EOS Utility screen appears.

3. **Turn on the T2i/550D.**

4. **Click Camera settings/Remote shooting under the Control Camera tab in the EOS Utility.** The capture panel appears.

5. **Click the red camera icon in the toolbar, and then click Picture Style.** The Picture Style window appears.

6. **Click User Defined 1, 2, or 3 from the list.** The Shooting menu appears. If a Picture Style file was previously registered to this option, the new style overwrites the previous style. When you select User Defined, additional options appear.

7. **Click Register User Defined style.** The Register Picture Style File screen appears.

8. **Click the browse icon.** A window opens for you to navigate to the folder where you saved the Picture Style.

9. **Navigate to the folder where you saved the Picture Style file that you modified in the Picture Style Editor, and click Open.** The Picture Style settings dialog box appears with the User Defined Picture Style displaying the modified style you opened. If necessary, you can make further adjustments to the file before applying it.

10. **Click OK.** The modified style is registered in the T2i/550D. It's a good idea to verify that the style was copied by pressing the Picture Style button on the back of the T2i/550D, and then selecting the User Defined Style you registered to see if the settings are as you adjusted them.

 In addition to creating your own styles, you can download additional Picture Styles from Canon's Web site at http://web.canon.jp/imaging/picturestyle/index.html.

About Color Spaces

A *color space* defines the range of colors that can be reproduced and the way that a device such as a digital camera, a monitor, or a printer reproduces color. Of the two color space options offered on the Rebel T2i/550D, the Adobe RGB (Red, Green, Blue) color space is richer because it supports a broader gamut, or range, of colors than the sRGB (standard RGB) color space option. And in digital photography, the more data

captured, or, in this case, the more colors the camera captures, the richer and more robust the file. It follows that the richer the file, the richer the file you have to work with whether you're capturing RAW or JPEG images. And with the T2i/550D's 14-bit analog/digital conversion, you get a rich 16,384 colors per channel when you shoot in RAW capture.

Comparing color spaces

The following histograms show the difference between a large and small color space in terms of image data. Spikes on the left and right of the histogram indicate colors that will be clipped, or discarded, from the image.

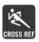 For details on evaluating histograms, see Chapter 2.

Much more image data is retained by using the wider Adobe RGB color space. Richer files can withstand editing, which is by nature destructive, much better than files with less color data and resolution. So if you routinely edit images on the computer, rather than printing directly from the media card, then Adobe RGB is a good choice to provide richer files. But if you don't edit images on the computer, and if you want to print and display images straight from the camera on the Web or in e-mail, then sRGB is the color space to choose.

For printing images, Adobe RGB is the color space of choice for printing on inkjet printers and for printing by some commercial printers, although other commercial printing services use sRGB. If you print at a commercial lab, check with them to see which color space they use.

For images destined for online use in e-mail or Web display, sRGB provides the best image color display. While this may sound like a conflict in choosing color spaces, for most photographers it translates into using Adobe RGB for capture in the camera, and for editing and printing. Then when an image is needed for the Web or e-mail, you can make a copy of the image and convert it to sRGB in an image-editing program such as Photoshop.

3.16 This RAW image was converted in Adobe Camera Raw and edited in Photoshop CS4. The inset histograms show the image in the sRGB color space on the left and in Adobe RGB color space on the right. Notice that the shadows block up much more in the sRGB color space than in Adobe RGB. Exposure: ISO 100, f/2.8, 1/6400 second with -1 1/3-stop Exposure Compensation.

The High Bit-Depth Advantage

A digital picture is made up of many pixels that are each made up of a group of bits. A bit is the smallest unit of information that a computer can handle. In digital images, each bit stores information that, when aggregated with other pixels and color information, provides an accurate representation of the picture.

Digital images are based on the RGB color space. That means that an 8-bit JPEG image has 8 bits of color information for Red, 8 bits for Green, and 8 bits for Blue. This gives a total of 24 bits of data per pixel (8 bits × 3 color channels). Because each bit can be one of two values, either 0 or 1, the total number of possible values is 2 to the 8th power, or 256 values per color channel.

On the other hand, a 14-bit file, which is offered on the T2i/550D, provides 16,384 colors per channel.

High bit-depth images offer not only more colors but they also offer more subtle tonal gradations and a higher dynamic range than low bit-depth images. If you're shooting JPEG images, this high bit-depth means that when the camera automatically processes and converts the images to 8-bit JPEGs, it uses the much richer 14-bit color file to do so. You get better tonal range and gradations as a result. And if you're shooting RAW files, then you get the full advantage of the 14-bit color, and you can save the images to 16-bit in an editing program such as Adobe Photoshop.

Choosing a color space

On the T2i/550D, you can select one of two color spaces for shooting in the P, Tv, Av, M, and A-DEP shooting modes. The options are Adobe RGB or sRGB. The color space you choose applies to both JPEG and RAW files shot in Creative Zone modes. In all Basic Zone modes, the camera automatically selects sRGB.

If you choose Adobe RGB, image file names are appended with _MG_.

NOTE The Rebel T2i/550D does not append an ICC (International Color Consortium) profile with the image so you will need to embed it when you're editing the file in an editing program. An ICC profile identifies the color space so that it is read by other devices, such as monitors and printers that support ICC profiles.

To set the color space on the T2i/550D for Creative Zone modes, follow these steps:

1. **Set the Mode dial to a Creative Zone mode: P, Tv, Av, M, or A-DEP.**

2. **Press the Menu button, and then turn the Main dial to select the Shooting 2 menu.**

3. **Press the up or down cross key to highlight Color space, and then press the Set button.** The camera displays two color space options.

4. **Press the up or down cross key to highlight the color space you want, either sRGB or Adobe RGB, and then press the Set button.** The color space remains in effect until you change it or switch to a Basic Zone mode.

Customizing the EOS Rebel T2i/550D

You can make the Rebel T2i/550D even more enjoyable to use by customizing it for your personal shooting preferences and setting the camera up to suit your most common shooting situations. The T2i/550D offers excellent options for customizing the operation of controls and buttons and the shooting functionality, both for everyday shooting and for shooting specific scenes and subjects.

The T2i/550D offers three helpful features for customizing the use and operation of the camera: a group of 12 Custom Functions that enable you to control everything from whether digital noise reduction is applied for long-exposure and high-ISO images to the way the camera controls operate; a My Menu camera tab where you can include six of your most often used menu

Customization options such as turning on Highlight Tone Priority help retain highlight details in this picture of a miniature Schnauzer puppy. Exposure: ISO 200, f/14, 1/125 second.

items in priority order for fast access; and, modifying the LCD screen color.

Setting Custom Functions

Custom Functions can save you time because they enable you to customize camera controls and operations to better suit your shooting style. The T2i/550D offers 12 Custom Functions ranging from customizing exposure changes to changing the functions of various buttons. There are a couple of specifics that you should keep in mind regarding Custom Functions:

▶ They can be set only in Creative Zone modes such as P, Tv, Av, M, and A-DEP.

▶ Once you change a Custom Function, the change remains in effect until you change it.

 Canon denotes Custom Functions using the abbreviation C.Fn [group Roman numeral]-[function number]; for example, C.Fn II-3.

Some Custom Functions are useful for specific shooting specialties or scenes while others are more broadly useful for everyday shooting. For example, the Mirror Lockup Custom Function is useful in specific scenarios such as when you're shooting macro and long exposures and when you're using a super-telephoto lens. On the other hand, the Custom Function that enables the Set button to be used during shooting is an example of a function that is broadly useful for everyday shooting.

 Be sure to remember how you have set the Custom Functions because some options change the behavior of the camera controls.

Custom Function groupings

Canon organized the 12 Custom Functions into four main groups denoted with Roman numerals, all of which you can access from the Setup 3 camera menu.

Table 4.1 delineates the groupings and the Custom Functions within each group. In addition, the function and options that are either enabled or disabled in Live View and Movie mode shooting are noted.

Custom Function specifics

In this section, I explain each of the Custom Functions and the options that you can set. As you read about each Custom Function, consider how you could use it to make your use of the camera more useful for your common shooting scenarios. You don't

have to set each option, and it is
likely you may find only a few that
are useful to you in the beginning.
But as you continue shooting, you
may recognize other functions that
you want to use. Over time, you'll
grow to appreciate the power that
Custom Functions offer.

Keep in mind that the functions are
easy to find, so that you can go back
and reset them if you don't like the

4.1 The Custom Functions (C.Fn) menu item

changes that you've made. In addition, you can reset all Custom Functions to the original
settings if necessary. The steps to reset all Custom Functions are included at the end
of this section.

Table 4.1: Custom Functions

C.Fn Number	Function Name
Group I: Exposure	
1	Exposure level increments. (The option you choose works for Live View and Movie shooting).
2	ISO Expansion.
3	Flash synchronization speed in Av mode.
Group II: Image	
4	Long exposure noise reduction.
5	High ISO speed noise reduction.
6	Highlight tone priority.
Group III: Autofocus/Drive	
7	AF-assist beam firing.
8	Mirror Lockup. (This option does not work when you use Live View shooting).
Group IV: Operation/Others	
9	Shutter /AE lock button.
10	Assign Set button. (The options do not work when you use Live View shooting).
11	LCD display when power on.
12	Add image verification data.

C.Fn I: Exposure

In this group, the three Custom Functions enable you to determine the level of fine control you have over exposure and over flash exposure synchronization speeds when you're shooting in Aperture Priority (Av) mode.

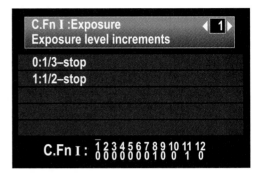

4.2 The Exposure level increments Custom Functions (C.Fn) screen

C.Fn-1: Exposure-level increments

The options available for this function enable you to set the exposure increment to use for shutter speed, aperture, exposure compensation, and Auto Exposure Bracketing (AEB). The exposure increment you choose is displayed in the viewfinder and on the LCD as double marks at the bottom of the exposure-level indicator. Your choice depends on the level of control you want. If you're setting Exposure Compensation to get truly white snow in a snow scene, then I recommend using the 1/2-stop increment to get to a +1- or 2-stop compensation in fewer steps. But if you're perfecting the exposure on a portrait, you may find that the small 1/3-stop increment is more exact. Here are the C.Fn-1 options with a description of each one:

▶ **0: 1/3-stop.** This is the Rebel T2i/550D's default option, and it offers the finest level of exposure control. Using this option, the camera displays shutter speeds in finer increments such as 1/60, 1/80, 1/100, 1/125 second, and so on. And it offers apertures as f/4, f/4.5, f/5, f/5.6, f/6.3, f/7.1, and so on.

▶ **1: 1/2-stop.** This is a coarser exposure control setting. Using this option, the T2i/550D displays shutter speeds in increments such as 1/60, 1/90, 1/125, 1/180 second, and so on. And it offers apertures as f/4, f/4.5, f/5.6, f/6.7, f/8, f/9.5, and so on. You may want to set this option when you want to quickly make larger changes in exposure settings with a minimum of adjustments.

C.Fn-2: ISO Expansion

You can choose to increase the ISO range from the default 100 to 6400 to include ISO 12800 by choosing Option 1: On. Enabling the expansion has no effect on the Auto ISO range that is 100 to 6400 by default in P, Tv, Av, M, and A-DEP shooting modes unless you set a lower maximum ISO setting on the Shooting 3 menu. The expanded setting is available only when you shoot in P, Tv, Av, M, and A-DEP modes. The ISO range for the automatic shooting modes such as Close-up, Landscape, and so on is ISO 100 to 3200. If you enable ISO expansion, then additional ISO setting is denoted as

"H" in the viewfinder and on the LCD. Be sure to test the high ISO setting for digital noise before you use it. However, in scenes where you would otherwise not be able to get the picture, the expanded ISO setting can be useful. Here are the options.

▶ **0: Off.** With this option set, the ISO range is 100 to 6400 in P, Tv, Av, M, and A-DEP shooting modes. This is the default setting on the Rebel T2i/550D. For all but the lowest of light, this ISO range offers plenty of versatility for low-light shooting.

▶ **1: On.** With this option set, you can choose "H" that is equivalent to ISO 12800. I recommend enabling and using this setting only in the most extreme of low-light scenes.

C.Fn-3: Flash sync. speed in Av (Aperture Priority AE) mode

This function enables you to set the Flash Sync speed range, have the Rebel set it automatically, or set it to a fixed 1/200 second when you're using Av shooting mode. Here are the options and a description of each one:

▶ **0: Auto.** When you're shooting in Av mode, choosing this option means that the T2i/550D will choose a shutter speed of 1/200 second to 30 seconds depending on the level of existing light. Slower Flash Sync speeds allow the scene to be illuminated by both the flash and the existing light in the scene. However, you must watch the shutter speed because at slow shutter speeds, any subject or camera movement appears as a blur. As long as the shutter speed is reasonably fast, this option is nice because the combination of ambient light and flash creates a natural-looking image.

▶ **1: 1/200-1/60 sec. auto.** This option limits the Flash Sync speed from going slower than 1/60 second when you're using Av shooting mode. The advantage is that it helps prevents slow shutter speeds that can cause blur from handholding the camera or from subject movement. The downside is that the background will be dark because less existing light and more flash light factors into the exposure. With this setting, you cannot use high-speed Flash Sync with an accessory Speedlite.

▶ **2: 1/200 sec. (fixed).** With this option, the Flash Sync speed is always set to 1/200 second and the flash typically provides the main illumination with less existing light being included in the exposure. This depends, of course, on the amount of existing light. While this option prevents blur from subject or camera movement that you may get using Option 1, the image may have flash shadows and a dark background that are characteristic of flash images with this option. With this setting, you cannot use high-speed Flash Sync with an accessory Speedlite.

C.Fn II: Image

The Image Custom Function group concentrates primarily on avoiding and reducing digital noise that can cause a grainy appearance with flecks of color particularly in the shadows, and in avoiding blown highlights, or highlights that are completely white with no detail.

C.Fn-4: Long-exposure noise reduction

With this function, you can turn noise reduction on, off, or set it to automatic for exposures of 1 second and longer. If you turn on noise reduction, the reduction process takes the same amount of time as the original exposure. In other words, if the original image exposure is 1 second, then noise reduction takes an additional 1 second. This means that you cannot take another picture until the noise reduction process finishes, and, of course, this greatly reduces the maximum shooting rate in Continuous drive mode. I keep the T2i/550D set to Option 1 to automatically perform noise reduction if it is detected in long exposures. Here are the options and a description of each one:

▶ **0: Off.** This is the default setting where no noise reduction is performed on long exposures. This maximizes fine detail in the image, but it also increases the chances of noise in images of 1 second and longer. With this option, there is no reduction in the maximum burst rate when you're using Continuous drive mode.

▶ **1: Auto.** The camera automatically applies noise reduction on 1 second and longer exposures if it finds noise present. If the Rebel T2i/550D detects noise that is typically found in long exposures, then it takes a second picture at the same exposure time as the original image, and it uses the second image, called a "dark frame," to subtract noise from the first image. Although technically two images are taken, only one image — the original exposure with noise subtracted — is stored on the media card.

▶ **2: On.** The Rebel automatically performs noise reduction on all exposures of 1 second and longer. This option slows shooting down considerably because the Rebel T2i/550D always makes the dark frame to subtract noise from the original image, and the dark frame is exposed at the same amount of time as the first image. If you're shooting in Live View mode, then "Busy" is displayed during the noise reduction process. Weigh the option you choose based on the shooting situation. If you need to shoot without delay, then Option 0 or 1 is preferable. But if you want to save time at the computer applying noise reduction during image editing, then Option 2 is the ticket.

C.Fn-5: High ISO speed noise reduction

This option applies additional noise reduction when you shoot at high ISO speed settings. (The camera applies some noise reduction to all images.) Because Canon has a good noise-reduction algorithm, this setting maintains a good level of fine detail in

images, and reducing shadow noise is advantageous. You may want to set this function for specific shooting situations, or you may want to set a level and leave it to be applied to all your images. Here are the options, and the level names are self-explanatory:

▶ **0: Standard**

▶ **1: Low**

▶ **2: Strong**

▶ **3: Disable**

 If you have C.Fn-5 set to Option 2, the burst rate in Continuous drive mode is **NOTE** decreased.

C.Fn-6: Highlight tone priority

One of the most interesting and useful functions is Highlight tone priority, which helps ensure good image detail in bright areas of the image such as those on a bride's gown. With the function turned on, the high range of the camera's dynamic range (the range between deep shadows and highlights in a scene as measured in f-stops) is extended from 18 percent gray (middle gray) to the brightest highlights. Also, the gradation from middle gray tones to highlights is smoother with this option turned on. The downside of enabling this option is increased digital noise in shadow areas. But if you shoot weddings or any other scene where it's critical to retain highlight detail, then the trade-off is worthwhile. If noise in the shadow areas is objectionable, you can apply noise reduction in an image-editing program.

If you turn on Highlight tone priority, the lowest ISO setting is 200 rather than 100. The ISO display in the viewfinder, on the LCD, and in the Shooting information display uses a D+ to indicate that this Custom Function is in effect. Here are the options and a description of each one:

▶ **0: Disable.** Highlight tone priority is not used and the full range of ISO settings is available.

▶ **1: Enable.** The T2i/550D emphasizes preserving the highlight tonal values in the image and improving the gradation of tones from middle gray to the brightest highlight. Shadows go dark quicker and tend to show more digital noise. Also the ISO range is 200 to 6400. When you press the ISO button to change the ISO, the ISO speed screen notes Highlight tone priority at the bottom to remind you that this function is set. Choosing this option also automatically turns off Auto Lighting Optimizer regardless of the setting that you've chosen for it on the Shooting 2 menu.

C.Fn III: Autofocus/Drive

This group of functions concentrates on autofocus speed and on enabling Mirror Lockup to prevent blur from the action of the reflex mirror in macro and long exposures.

C.Fn-7: AF-assist beam firing

This function enables you to control whether the Rebel T2i/550D's built-in flash or an accessory EX Speedlite's autofocus-assist light is used to help the camera's autofocus system establish focus. The AF-assist beam speeds up focusing and ensures sharp focus in low-light or low-contrast scenes. Here are the options and a description of each one:

- ▶ **0: Enable.** This option allows the AF-assist beam from either the built-in flash or a Canon Speedlite mounted on the camera to help the camera focus. Enable is the default setting for the Rebel T2i/550D.

- ▶ **1: Disable.** If you choose this option, neither the built-in flash nor the Speedlite AF-assist beam lights to help establish focus. While this option is useful in shooting situations where the AF-assist light may be annoying or intrusive, it can be difficult for the T2i/550D to establish accurate focus in low-light scenes.

- ▶ **2: Enable external flash only.** If you choose this option, the AF-assist beam emits only when a Canon Speedlite is mounted on the camera's hot shoe. The Speedlite's AF-assist beam is more powerful than the beam of the built-in flash, and that makes this option good for low-light and low-contrast subjects that are farther away from the camera. However, be aware that if you have set the Custom Function on the Speedlite so that the AF-assist beam does not fire, then the Speedlite's Custom Function option overrides the camera's Custom Function option.

- ▶ **3: IR AF-assist beam only.** If your accessory Speedlite has an infrared AF-assist beam, this option will enable using the IR AF-assist beam, and it prevents flash units that use a series of small flashes from firing the AF-assist beam.

C.Fn-8: Mirror Lockup

Option 1 for this function prevents blur that can be caused in close-up and super-telephoto shots by the camera's reflex mirror flipping up at the beginning of an exposure. While the effect of motion from the mirror is negligible during normal shooting, it can make a difference in the extreme magnification levels for macro shooting and when using super-telephoto lenses. If you turn on Mirror Lockup, the first time that you press the Shutter button, it flips up the reflex mirror. You then have to press the Shutter button again to make the exposure. Also be sure to use a tripod in conjunction

with Mirror Lockup. This option obviously doesn't apply during Live View shooting since the reflex mirror is already locked up to provide the live view of the scene. Here are the options and a description of each one:

▶ **0: Disable.** This is the default setting where the reflex mirror does not lock up before making an exposure.

▶ **1: Enable.** Choosing this option locks up the reflex mirror when you first press the Shutter button. With the second press of the Shutter button, the exposure is made and the reflex mirror drops back down.

 If you often use Mirror Lockup, you can add this Custom Function to My Menu for easy access. Customizing My Menu is detailed later in this chapter. Also, if you use Mirror Lockup with bright subjects such as snow, bright sand, the sun, and so on, be sure to take the picture right away to prevent the camera curtains from being scorched by the bright light.

C.Fn IV: Operation/Others

This group of Custom Functions enables you to change the functionality of camera buttons for ease of use to suit your shooting preferences, to control the LCD display, and to add data that verifies that the images are original and unchanged.

C.Fn-9: Shutter/AE Lock button

This function changes the function of the Shutter button and the AE Lock button (the button located at the top-right back of the camera with an asterisk above it) for focusing and exposure metering. To understand this function, it's important to know that the Rebel T2i/550D biases or weights the light metering in Evaluative metering mode toward the active AF point, which it assumes is the subject.

However, there are times when you want to meter somewhere other than where you want to focus. For example, if you're shooting a portrait, you may want to meter the light (on which the exposure will be calculated) and have it biased toward an area of the subject's skin. This area isn't where you want to set the focus; rather, you want to focus on the subject's eyes. To bias the metering on one area and focus on another area, you can use AE Lock.

The options of this function enable you to switch or change the functionality of the Shutter button and the AE Lock button, or to disable AE Lock entirely when you use continuous focusing via AI Servo AF mode. Note that only Option 1 can be used in Live View shooting, and none of the options works in Movie mode shooting.

Here are the options and a description of each one:

▶ **0: AF/AE lock.** This is the default setting where you set the focus using the Shutter button, and you can set and lock the exposure by pressing the AE Lock button.

▶ **1: AE lock/AF.** Choosing this option switches the function of the Shutter button and the AE Lock button. Pressing the AE Lock button focuses while pressing the Shutter button halfway sets and locks the exposure. Then you press the Shutter button completely to make the picture. You cannot use the Remote Switch RS-60E3 to focus by half-pressing the Shutter button.

▶ **2: AF/AF lock, no AE lock.** If you're shooting in AI Servo AF mode where the camera automatically tracks focus on a moving subject, this function enables you to press the AE Lock button to stop focus tracking momentarily such as when an object moves in front of the subject. If you enable this option, you cannot use AE Lock.

▶ **3: AE/AF, no AE lock.** With this option, you can start and stop AI Servo AF focus tracking by pressing the AE Lock button. For example, if you are photographing an athlete who starts and stops moving intermittently, you can press the AE Lock button to start and stop continuous autofocus tracking (AI Servo AF) depending on the motion of the subject. In AI Servo AF mode, the exposure and focusing are set when you press the Shutter button. You cannot use the Remote Switch RS-60E3 to focus by half-pressing the Shutter button.

C.Fn-10: Assign SET button

This Custom Function enables you to take advantage of using the Set button while you're shooting rather than only when you're using camera menus. The Set button continues to function normally when you're accessing camera menus. Here are the options and a description of each one:

▶ **0: Normal (disabled).** With this option selected, pressing the Set button during shooting has no effect.

▶ **1: Image quality.** With this option, you can press the Set button as you shoot to display the Image-recording quality screen on the LCD so that you can make changes.

▶ **2: Flash exposure compensation.** With this option, you can press the Set button to display and change Flash Exposure Compensation setting screen to set or change the amount of flash exposure compensation.

▶ **3: LCD monitor On/Off.** With this option, pressing the Set button toggles the LCD monitor display on or off, replicating the functionality of the Display button.

▶ **4: Menu display.** With this option, pressing the Set button displays the last camera menu that you accessed with the last menu item highlighted.

▶ **5: ISO speed.** With this option, pressing the Set button displays the ISO speed screen where you can adjust the ISO sensitivity setting.

C.Fn-11: LCD display when power ON

This function enables you to save a bit of battery power by choosing whether the shooting information is displayed on the LCD when you turn on the Rebel T2i/550D. Here are the options and a description of each one:

▶ **0: Display on.** This is the default setting where the T2i/550D displays shooting information on the LCD when you turn on the camera. To turn off the display, you must press the Display button on the back of the camera.

▶ **1: Previous display status.** With this option, the T2i/550 remembers the last state of the LCD display when you turn the camera off, and then it returns to that state when you turn on the camera again. So if you turned off the LCD display by pressing the Display button, and then turn off the camera, the LCD display is not turned on when you turn on the camera and vice versa. If you want to use this option to save battery power or simply to have the camera behave in one or the other way, you have to remember to press the Display button to either turn on or off the LCD before powering down the camera each time.

C.Fn-12: Add image verification data

When this option is turned on, data is appended to verify that the image is original and hasn't been changed. This is useful when images are part of legal or court proceedings. The optional Original Data Security Kit OSK-E3 is required. Here are the options and a description of each one:

▶ **0: Disable.** Image verification data is not appended to the image.

▶ **1: Enable.** With this option and when used with the Original Data Security Kit OSK-E3, data is automatically appended to the image to verify that it is original. When you display shooting information for the image, a distinctive locked icon appears.

Setting Custom Functions

Depending on your shooting preferences and needs, you may immediately recognize functions and options that would make your shooting faster or more efficient. You may also find that combinations of functions are useful for specific shooting situations. Whether used separately or together, Custom Functions can significantly enhance your use of the T2i/550D.

To set a Custom Function, follow these steps:

1. **Set the Mode dial to P, Tv, Av, M, or A-DEP.**

2. **Press the Menu button, and then turn the Main dial until the Setup 3 menu is displayed.**

3. **If necessary, press the up or down cross key to highlight Custom Functions (C.Fn), and then press the Set button.** The most recently accessed Custom Function screen appears.

4. **Press the right or left cross key to move through the Custom Function numbers displayed in the box at the top right of the screen, and when you get to the number you want, press the Set button.** The Custom Function option control is activated and the option that is currently in effect is highlighted.

5. **Press the up or down cross key to highlight the option you want, and then press the Set button.** You can refer to the previous descriptions in this section of the chapter to select the function option that you want. Repeat Steps 4 and 5 to select other Custom Functions and options. Lightly press the Shutter button to return to shooting.

If you want to reset one of the Custom Functions, repeat these steps to change it. If you want to restore all Custom Function options to the camera's default settings, follow Steps 1 and 2 above. Then, press the down cross key to highlight Clear Settings, and press the Set button. On the Clear Settings screen, select Clear all Custom Func. (C.Fn), and then press the Set button. Press the right cross key to select OK, and then press the Set button.

4.3 The Clear all Custom Func. (C.Fn) screen

Customizing My Menu

Given the number of menus and menu options on the T2i/550D, and given that in an average day of shooting you may use only a few menus and options consistently, customizing the My Menu option makes it easy to select and register six of your most frequently used menu items and Custom Functions for easy access.

You can add and delete items to My Menu easily and quickly, and you can change the order of items by sorting the items you register. You can also set the T2i/550D to display My Menu first when you press the Menu button.

Before you begin registering items to My Menu, look through the camera menus and Custom Functions carefully and choose your six most frequently changed items.

To register camera Menu items and Custom Functions to My Menu, follow these steps:

1. **Set the Mode dial to P, Av, Tv, M, or A-DEP.**

2. **Press the Menu button, and then turn the Main dial until My Menu is displayed.**

3. **Press the up or down cross key to highlight My Menu settings, if necessary, and then press the Set button.** The My Menu settings screen appears.

4. **Press the up or down cross key to highlight Register to My Menu, and then press the Set button.** The Select item to register screen appears. This screen contains a scrolling list of all the camera's menu items, options, and Custom Functions.

5. **Press the down cross key until you get to a menu item or Custom Function that you want to register, and then press the Set button.** As you press the down cross key to scroll, a scroll bar on the right of the screen shows your relative progress through the list. When you select an item and press the Set button, a confirmation screen appears.

6. **Press the right cross key to highlight OK, and then press the Set button.** The Select item to register screen reappears.

7. **Repeat Steps 5 and 6 until you've selected and registered as many items as you want up to six.**

8. **When you finish registering menu items, press the Menu button.** The My Menu settings screen appears. If you want to sort your newly added items, from here go to Step 3 in the next set of steps.

To arrange your My Menu items in the order you want, follow these steps:

1. **In P, Av, Tv, M, or A-DEP mode, press the Menu button, and then press the right cross key until My Menu is displayed.**

2. **Press the down cross key to highlight My Menu settings, and then press the Set button.** The My Menu settings screen appears.

3. **Press the down cross key to highlight Sort, and then press the Set button.** The Sort My Menu screen appears.

4. **Press the down or up cross key to select the item that you want to move, and then press the Set button.** The sort control for the selected item is activated and is displayed with up and down arrow icons.

5. **Press the up cross key to move the item up in the list, or press the down cross key to move it down in the list, and then press the Set button.**

4.4 These are the items on my camera's My Menu screen ready to sort.

6. **Repeat Steps 4 and 5 to move other menu items in the order that you want.** Lightly press the Shutter button to return to shooting.

NOTE The My Menu settings item always appears at the bottom of the My Menu list. Selecting it gives you access to the My Menu settings screen where you can Register, Sort, Delete, Delete all items, and disable or enable the display of My Menu as the first menu displayed.

You can delete either one or all items from My Menu. And you can choose to have My Menu displayed first every time you press the Menu button.

To delete one or more items from My Menu, follow these steps:

1. **In P, Av, Tv, M, or A-DEP mode, press the Menu button, and then press the right cross key until My Menu is displayed.**

2. **Press the down cross key to highlight My Menu settings, and then press the Set button.** The My Menu settings screen appears.

3. **Press the down cross key to highlight Delete item/items, or highlight Delete all items to delete all registered items, and then press the Set button.** The Delete item from My Menu or the Delete all My Menu items screen appears depending on the option you chose.

4. **If you chose to delete individual menu items, press the down cross key to highlight the menu item you want to delete, and then press the Set button.** The Delete My Menu confirmation screen appears. If you chose to Delete all items, the Delete all My Menu items screen appears.

5. **Press the right cross key to select OK, and then press the Set button.** Lightly press the Shutter button to return to shooting.

If you want the My Menu tab to be the first menu displayed when you press the Menu button, follow these steps:

1. **On the My Menu menu, press the down cross key to highlight Display from My Menu, and then press the Set button.** The My Menu settings screen appears.

2. **Press the down cross key to highlight Display from My Menu, and then press the Set button.** Two options appear.

3. **Press the down cross key to select Enable, and then press the Set button.** Lightly press the Shutter button to return to shooting.

Additional Customization Options

In addition to setting Custom Functions and setting up My Menu, you can also display a handy Quick Control screen from which you can quickly change key camera and exposure settings in P, Tv, Av, M, and A-DEP shooting modes, and you can change the color of the LCD monitor.

Displaying the Quick Control screen

The Quick Control screen is a very convenient way to not only see what settings the Rebel T2i/550D is currently set to, but also to quickly change settings on the fly with a minimum of changing among camera controls and menus.

Here is how to display and use the Quick Control screen:

1. **In any camera mode, press the Display button.** The shooting settings screen appears on the LCD showing the current exposure and camera settings.

2. **Press the Q button.** The Quick Control screen is activated. In Basic Zone modes such as Portrait, Landscape, and so on, the only option you can change is the image recording quality. In CA mode, you can change the shooting and exposure options displayed on the screen. And in P, Tv, Av, M, and A-DEP shooting modes, you can change the options displayed on the screen including ISO, shutter speed, or aperture, depending on the shooting mode, Exposure Compensation, Picture Style, white balance, Metering mode, and so on.

3. **Press a cross key to select the option or setting that you want to change, and then turn the Main dial to change the setting.** As you turn the Main dial, the camera cycles through the available options. To change another setting, repeat this step.

If you press a cross key and you get the screen for the function of that cross key, it means that you are not on the Quick Control screen. For example, if you press the WB cross key, and the White balance screen appears, it means that you are on the shooting settings screen instead of the Quick Control screen. You can tell the difference by looking in the lower left corner of the screen. If the LCD shows a Q in the lower left corner, it means that you are on the shooting setting screen. Just press the Q button to change to the Quick Control screen, and then you can press a cross key to make changes as described in Step 3. If the bottom of the screen displays descriptive text, then you're on the Quick Control screen.

> **NOTE** The Quick Control screen automatically changes to the shooting settings screen in about eight seconds if you are not making changes on the Quick Control screen. It also automatically reverts to the shooting settings screen when you half press the Shutter button.

Changing the shooting settings screen color

Another customization option on the Rebel T2i/550D is choosing the screen color you want for the LCD shooting information display. You can choose from four options:

▶ Black text on a light gray background, which is the default setting

▶ White text on a black background

▶ White text on a brown background

▶ Green text on a black background

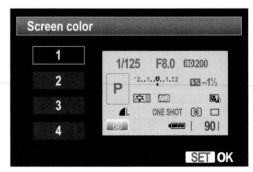

4.5 The Screen color screen

To set the screen color, follow these steps.

1. **In any camera mode, press the Menu button, and then turn the Main dial to select the Setup 1 menu.**

2. **Press the down cross key to highlight Screen Color, and then press the Set button.** The Screen color screen appears.

3. **Press the up or down cross key to select the color scheme that you want, and then press the Set button.** The option you choose remains in effect until you change it.

The T2i/550D offers you a high level of customization. While the full complement of choices may initially seem overwhelming, I recommend taking each one in turn and building on it to set more custom settings until you get the camera set up for your shooting style.

Shooting in Live View and Tethered

Live View shooting enables you to view, compose, and focus using a real-time view of the scene on the camera's 3-inch LCD monitor. Alternately, you can shoot with the T2i/550D connected (*tethered*) to the computer, and then control image settings ranging from focus and exposure to white balance and Picture Style on the computer by using the EOS Utility program from Canon. Live View and tethered shooting give you added flexibility in shooting scenarios that normal shooting doesn't provide.

Live View shooting is an excellent choice for getting tack-sharp focus on a still subject such as these daisies. Exposure: ISO 100, f/2.2, 1/2500 second.

About Live View Shooting

While Live View shooting is a staple feature on point-and-shoot digital cameras, it is a relatively new feature for digital SLR cameras such as the T2i/550D. In fact, the concept of a digital SLR being able to hold the shutter open to give you a real-time view of the scene and yet pause long enough to focus is impressive. Normally, the camera can't see the live scene because the shutter and reflex mirror block the view to the image sensor. The T2i/550D overcomes this blind spot with a mechanical shutter that stays completely open during Live View shooting.

Live View offers some advantages that you don't get with non-Live View shooting. For example, Live View offers Face Detection that automatically identifies faces in the scene and focuses on one of the faces. And you can use the supplied or an accessory cable to connect the T2i/550D to a TV and see Live View on the TV screen.

Although Live View shooting has a high coolness factor, it comes at a price with a few side effects:

▶ **Temperature affects the number of shots you can get using Live View.** With a fully charged LP-E8 battery, you can expect 200 shots without flash use and approximately 170 shots with 50 percent flash use in 73-degree temperatures. In freezing temperatures, expect 170 shots without flash use and 150 shots with 50 percent flash use per charge. With a fully charged battery, you get approximately one-and-a-half hours of continuous Live View shooting before the battery is exhausted.

▶ **High ambient temperatures, high ISO speeds, and long exposures can cause digital noise or irregular color in images taken using Live View.** Before you start a long exposure, stop shooting in Live View and wait several minutes before shooting. With continual use of Live View, the sensor heats up quickly. Both high internal and external temperatures can degrade image quality and cause Live View to automatically shut down until the internal temperature is reduced.

An icon that resembles a thermometer is displayed on the LCD when internal and/or external temperatures are high enough to degrade image quality. If the icon appears, it's best to stop shooting until the temperature cools down. Otherwise, the camera will automatically stop shooting if the internal temperature gets too high. Additionally, high ISO settings combined with high temperatures can result in digital noise and inaccurate image colors.

▶ **The Live View may not accurately reflect the captured image in several different conditions.** Image brightness may not be accurately reflected in low and bright-light conditions. If you move from low to a bright light and if the LCD brightness level is high, the Live View may display chrominance (color) noise, but the noise will not appear in the captured image. Suddenly moving the camera in a different direction can also throw off accurate rendering of the image brightness. If you capture an image in magnified view, the exposure may not be correct. And if you focus and then magnify the view, the focus may not be sharp.

Live View features and functions

While some key aspects of Live View shooting differ significantly from standard shooting, other aspects carry over to Live View shooting. For example, you can use the Quick Control screen during Live View shooting to change settings including the white balance, Picture Style, Auto Lighting Optimizer, Image Quality, drive mode, and focusing option. Likewise, you can press the Display button one or more times to change the display to include more or less shooting information along with a Brightness histogram. The following sections give you a high-level view of setting up for and using Live View shooting.

Live View focus

With the T2i/550D's large and bright LCD monitor, you can use Live View shooting to get tack-sharp focus. Here is an overview of the Live View focusing options so that you can decide in advance which is best for the scene or subject that you are shooting:

▶ **Live mode.** With this focusing option, the camera's image sensor is used to establish focus. This focusing mode keeps the reflex mirror locked up so that the Live View on the LCD is not interrupted

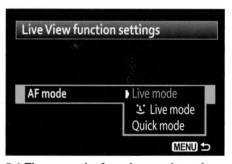

5.1 These are the focusing mode options that are available by selecting the Live View function settings/AF mode on the Setup 2 menu.

during focusing. However, focusing takes longer with Live mode. To focus in this mode, press a cross key to move the focusing rectangle over the subject, and then press the Shutter button halfway to focus. The AF point turns green when focus is achieved.

▶ **Face Detection Live mode.** This is the same as Live mode except that the camera automatically looks for and focuses on a human face in the scene. If the camera does not choose the face of the subject you want, you can move the focusing frame to the correct face. If the camera cannot detect a face, then the AF point reverts to the center AF point, and you can manually move the AF point to a face.

If the person is a long way from the camera, you may need to manually focus to get the subject in reasonable focus range, and then focus by half-pressing the Shutter button. Face detection does not work with extreme close-ups of a face, if the subject is too far away, too bright or dark, partially obscured, or is tilted horizontally or diagonally. In Face Detection Live mode, you can't magnify the image on the LCD using the AF-point selection/Magnify button. In both Live and Face Detection Live modes, focus at the edges of the frame is not possible and the face focusing frame is grayed out. Instead, the Rebel switches to the center AF point for focusing.

▶ **Quick mode.** This focusing mode uses the camera's autofocus sensor to focus. In this mode, when the camera focuses, it suspends the Live View on the LCD long enough for the reflex mirror to drop down so the camera can establish focus. With Quick mode focusing, you can select any of the nine AF points by pressing the Q button, and then pressing the left or right cross key to turn on AF point selection. Then turn the Main dial to select an AF point. Then half-press the Shutter button to focus and make the picture.

▶ **Manual Focus.** This focusing option is the most accurate, and you get the best manual focusing results when you magnify the image to focus. Another advantage is that Live View is also not interrupted during focusing. To focus manually, you need to have a lens that offers a manual focus (MF) switch on the side of the lens. Then set the lens switch to MF (Manual Focus), and then move the focusing frame wherever you want. Turn the focusing ring on the lens to focus.

 If you use Live View with Continuous shooting, the exposure is set for the first shot and is used for all images in the burst. If the light changes during a burst of shots, the exposure may not be correct.

Metering

For Live View, the camera uses Evaluative metering. Unlike standard shooting, the most recent meter reading is maintained for a minimum of 4 seconds even if the lighting changes. You can set how long the camera maintains the current exposure by setting the Live View Metering timer from 4 seconds to 30 minutes. If the light or your shooting position changes frequently, set a shorter meter time. Longer meter times

speed up Live View shooting operation, and longer times are effective in scenes where the lighting remains constant.

 Auto Lighting Optimizer automatically corrects underexposed and low-contrast images. If you want to see the effect of exposure modifications, then turn off Auto Lighting Optimizer on the Shooting 2 menu.

Using a flash

When shooting in Live View with the built-in flash, the shooting sequence (after fully pressing the Shutter button) is for the reflex mirror to drop to allow the camera to gather the preflash data. The mirror then moves up out of the optical path for the actual exposure. As a result, you hear a series of clicks, but only one image is taken. Here are some things you should know about using Live View shooting with a flash unit:

▶ With an EX-series Speedlite, FE Lock, modeling flash, and test firing cannot be used except for wireless flash shooting.

▶ Flash Exposure Lock cannot be used with the built-in or an accessory Speedlite.

Setting up for Live View Shooting

The settings on the Setup 2 menu not only activate Live View shooting, but they also enable you to set your preferences for shooting in this mode, including enabling Live View shooting, displaying a grid in the LCD, and setting the Exposure metering timer.

To set up the T2i/550D for Live View shooting and to set your preferences, follow these steps:

1. **With the Mode dial set to P, Tv, Av, M, or B, press the Menu button, and then turn the Main dial to select the Setup 2 tab.**

2. **Press the down or up cross key to highlight Live View function settings, and then press the Set button.** The Live View function settings screen appears.

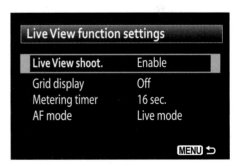

5.2 These are the options that you can set for Live View shooting on the Setup 2 menu.

3. **Press the up or down cross key to select Live View shoot., and then press the Set button.** The Enable and Disable options appear.

4. **Press the up or down cross key to select Enable, and then press the Set button.**

5. **On the Live View function settings screen menu, press the down cross key to highlight any of the following options, and then press the Set button to display the settings you can select.**

 - **Grid display.** Select a 3 × 3 or 4 × 6 grid to help you align horizontal and vertical lines in the scene. Or select Off if you do not want to use a grid, and then press the Set button.

 - **Metering timer.** Choose 4, 16, or 30 seconds, or 1, 10, or 30 minutes to determine how long the camera retains the exposure, and then press the Set button. If the light changes often, choose a shorter time.

 - **AF mode.** Select Live mode, Face Detection Live mode, or Quick mode, and then press the Set button.

Working with Live View

Now that you've chosen the focusing mode and selected the shooting options, you're ready to begin shooting. Here are a few tips to get you started:

▶ For still life and macro shooting, manual focusing with the image enlarged to 5 or 10X helps ensure tack-sharp focus. To enlarge the view, press the AF-point selection/Magnify button on the top right back of the camera. Note that manual focusing is possible only with lenses that have a manual focusing switch on the side of the lens barrel.

▶ For a really large view, tether the camera to your laptop using the supplied USB cable, or you can hook up the camera to the TV and use the TV screen as a monitor.

 See Chapter 2 for details on connecting the T2i/550D to a TV.

▶ Just a few minutes of watching the real-time view will convince you that a tripod is necessary for Live View shooting. With any focal length approaching telephoto, Live View provides a real-time gauge of just how steady or unsteady your hands are.

Shooting in Live View

The operation of the camera during Live View shooting differs from traditional still shooting, but the following steps guide you through the controls and operation of the camera.

To shoot in Live View using autofocus, follow these steps:

1. **With the camera set to any shooting mode and with Live View enabled on the Setup 2 menu, press the Live View/ Movie shooting button on the back of the camera.** A current view of the scene appears on the LCD.

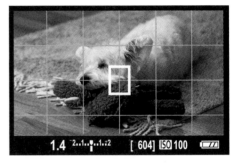

5.3 The Live View screen with the 6 × 4 grid is displayed

2. **Press the Q button to display the Quick Control screen. From here you can press a cross key to change settings such as the white balance, Picture Style, and so on.** You can press the Q button a second time to display the grid if you turned on the grid option.

3. **Press the Display button one or more times to show more or less information, and to display the histogram.**

4. **Compose the image by moving the camera or the subject.** As you move the camera, the exposure changes and is displayed in the bottom bar under the Live View display. If the histogram is displayed, it shows the changes as you move the camera as well.

5. **If you are using Quick mode to focus, press the Q button to display the Quick Control screen, press the right cross key to activate AF-point selection, and then turn the Main dial to select the AF point that you want.** In Live Focusing mode, press a cross key to move the focus point.

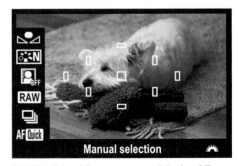

5.4 The Live View screen with the AF points displayed for Quick focusing mode

6. **Press the AF-point Selection/Magnify button on the top far-right corner of the camera to magnify the view.** The first press of the button enlarges the view to 5X, and a second press enlarges the view to 10X. The magnifications are shown on the LCD as X5 and X10. You cannot magnify the image if you're using Face Detection Live mode focusing.

7. **Press the Shutter button completely to make the picture.** The shutter fires to make the picture, the image preview is displayed, and then Live View resumes.

Shooting Tethered or with a Wireless Connection

One of the most useful ways to use Live View shooting is for shooting in a studio, particularly when you shoot still-life subjects such as products, food, stock shots, and portraits. You can set up with the T2i/550D connected to a computer using the USB cable supplied with the camera. The extra-long cord allows a good range of movement, particularly if the computer is on a wheeled or swivel table.

Before you begin, install the EOS Digital Solution Disk on the computer to which you are connecting the camera. To shoot in Live View with the T2i/550D tethered to the computer, follow these steps:

1. **Turn off the camera and attach the USB cord to the Digital terminal located under the terminal cover on the side of the camera.** Be sure that the icon on the cable connector faces the front side of the camera.

2. **Connect the other end of the USB cable to a USB terminal on the computer.**

3. **Turn on the power switch on the camera.** If this is the first time you've connected the camera to the computer, then the computer installs the device driver software and identifies the camera.

4. **Click Camera settings/Remote shooting in the EOS Utility window.** The EOS T2i/550D control panel appears. You can use the panel to control exposure settings, set the white balance, set the Picture Style, and set White Balance Shift.

5. **Click Preferences to set the options you want, such as choosing the destination folder in which to save captured images and whether to save the images both on the computer and on the media card.**

6. **Click Remote Live View Shoot... toward the bottom of the Remote Shooting control panel.** The Remote Live View window appears and the camera reflex mirror flips up to preview the scene on the computer screen. In this window, you can set the white point by clicking a white area or neutral gray area in the scene, use the controls to set the focus, preview the depth of field by clicking the On button, and switch between the Brightness and RGB histograms as well as view the image magnified to tweak focus.

7. **Press the Shutter button in the EOS Utility Control Panel to take the picture.** The Digital Photo Professional main window opens with the image selected.

8. **When you finish, turn off the camera and disconnect the USB cable from the camera.**

5.5 The EOS Utility Remote Shooting control panel

5.6 I set the white balance by clicking the White Balance eyedropper and clicking on the white background.

5.7 You can set the exposure settings such as I did here by changing the aperture to f/5.6.

5.8 You can set Exposure Compensation during tethered shooting, and in this scene, it increased the brightness for a truer white rendering.

5.9 This is the final image taken in Live View shooting with Remote shooting using the EOS Utility with the camera tethered to a laptop. Exposure: ISO 100, f/5.6, 1/8 second with a +2/3-stop of Exposure Compensation.

Using Mode

Movie mode on the EOS T2i/550D offers a new avenue to creative expression. Now the visual stories that you capture with the T2i/550D can be enriched with high-definition movies.

It is to your advantage that the T2i/550D's movie quality is among the best available. And it is packaged for you in a lightweight camera that accepts more than 60 lenses to enhance your videos in ways that traditional video cameras cannot.

This chapter is by no means exhaustive, but it is written to be a starting point for you as you explore the world of digital video with the T2i/550D.

Whether you're shooting video or pulling a still image from a video, the T2i/550D offers high-quality results. Exposure: ISO 100, f/11, 1/125 second.

About Video

For still photographers, videography is like learning a new visual language. The language is different, but video shares with traditional still photography the aspect of creative communication. So with the Rebel T2i/550D, you can spend time envisioning ways in which you can use still images with video to create multimedia stories.

If you are new to videography, then it is good to have a basic understanding of digital video and how it relates to the T2i/550D.

Video standards

In the world of video, there are several industry standards, including the following resolutions: 720p, 1080i, and 1080p.

The numbers 720 and 1080 represent vertical resolution. The 720 standard has a resolution of 921,600 pixels, or 720 (vertical pixels) × 1280 (horizontal pixels). The 1080 standard has a resolution of 2,073,600 pixels, or 1080 × 1920. It seems obvious that the 1080 standard provides the highest resolution, and so you would think that it would be preferable. But that is not the entire story.

The rest of the story is contained in the *i* and *p* designations. The *i* stands for *interlaced*. Interlaced is a method of displaying video where each frame is displayed on the screen in two passes — first, a pass that displays odd-numbered lines, and then a second pass that displays even-numbered lines. Each pass is referred to as a *field*, and two fields comprise a single video frame. This double-pass approach was engineered to keep the transmission bandwidth for televisions manageable. And the interlaced transmission works only because our minds automatically merge the two fields, so that the motion seems smooth with no flickering. Interlacing, however, is the old way of transmitting moving pictures.

The newer way of transmitting video is referred to as *progressive scan*, hence, the *p* designation. Progressive scan quickly displays a line at a time until the entire frame is displayed. And the scan happens so quickly that you see it as if it were being displayed all at once. The advantage of progressive scanning is most apparent in scenes where either the camera or the subject is moving fast. With interlaced transmission, fast camera action or moving subjects tend to blur between fields. That is not the case with 720p, which provides a smoother appearance. So while 1080i offers higher resolution, 720p provides a better video experience, particularly when there are fast-action scenes.

Another piece of the digital video story is the frame rate. In the world of film, a frame rate of 24 frames per second (fps) provided the classic cinematic look of old movies. In the world of digital video, the standard frame rate is 30 fps. Anything less than 24 fps, however, provides a jerky look to the video. The TV and movie industries use standard frame rates, including 60i that produces 29.97 fps and is used for NTSC; 50i that produces 25 fps and is standard for PAL, which is used in some parts of the world; and 30p that produces 30 fps, which produces smooth rendition for fast-moving subjects.

NTSC is the standard for North America, Japan, Korea, Mexico and other countries. PAL is the standard for Europe, Russia, China, Australia, and other countries.

Videographers who want a cinematic look prefer cameras that convert or *pull down* 30 fps to 24 fps.

With this very brief background on video, it is time to look at the digital video options on the T2i/550D.

Video on the T2i/550D

By now, you probably have questions, like how the T2i/550D compares to industry standards, how long you can record on your media card, and how big the files are. The following list is a rundown of the digital video recording options that you can choose on the T2i/550D.

▶ **Full HD (Full High-Definition) at 1920 × 1080p at 30 (actual 29.97), 25 (when set to PAL), or 24 (actual 23.976) fps.** You get about 12 minutes of recording time with a 4GB card and about 49 minutes with a 16GB card. The file size is 330MB per minute. Full HD enables you to use HDMI output for HD viewing of stills and video.

▶ **HD (High-Definition) at 1280 × 720p at 60 (actual 59.94) and 50 (when set to PAL) fps.** You get about 12 minutes of recording time with a 4GB card, and 49 minutes with a 16GB card. The file size is 330MB per minute.

▶ **SD (Standard recording) at 640 × 480 at 60 (actual 59.94) or actual 50 fps when set to PAL.** You get 24 minutes of recording time with a 4GB card, and 1 hour and 39 minutes with a 16GB card. The file size is 165MB per minute.

▶ **Crop 640 × 480.** This option gives a telephoto effect of 7 times by cropping the movie. On the T2i/550D, this is called Movie Crop mode. This mode records the 640 × 480 pixels at the center of the image sensor. Thus the video is at a 1:1 ratio. Crop is helpful if you can't get the reach you need with your lens, but it also is more likely to display any digital noise. You'll doubtless get higher quality video at the other settings, but when you need to bring the subject closer, this is a mode to consider.

There is a 4GB or 30-minute length limit to individual movie clips, and the clips are MPEG-4 avch/H.264-comperessed movie files with a .MOV file extension. You can also trim the beginning and end of a clip in the camera. Videos can be viewed in Apple's QuickTime Player.

So you have two high-quality video options, albeit at different frame rates. The 30 fps option is the traditional recording speed for online use whereas the actual 29.97 speed is the TV standard in North America. As a result, the 30 fps option is suitable for materials destined for DVD or display on a standard definition or HDTV. Although 24 fps may be more filmlike, it can produce jerky motion for subjects that are moving, and it requires slower shutter speeds of around 1/50 second. In addition, the actual 29.97 frame rate makes it easier to sync separately recorded audio using a video-editing program.

Here are other aspects to consider when shooting video:

▶ **Audio.** You can use the T2i/550D's built-in monaural microphone, which is adequate if you do not want to invest in a separate audio recorder and microphone. The audio is 16-bit and is output in mono. If you use the built-in microphone, be aware that all of the mechanical camera functions are recorded, including the sound of the Image Stabilization function on the lens, and the focusing motor. You cannot control the recording volume because it is adjusted automatically. Optionally, you can plug in a stereo microphone using the input jack on the side of the camera.

▶ **Exposure and camera settings.** Video exposure offers full manual exposure control with the slowest shutter speed being linked to the frame rate. For example, the slowest frame rate at 60 or 50 fps is 1/60 second. And at Full HD and HD resolutions, the shutter speed range is 1/60 to 1/4000 second. At Standard-definition recording quality the shutter speed range is 1/30 to 1/4000 second. The ISO can be set automatically or manually with a range from 100 to 6400. To use manual exposure, set the Mode dial to M.

You can use fully automatic exposure with the T2i/550D setting the aperture, shutter speed, and ISO automatically. You can, as well, use AE Lock. To enable auto exposure for movies, set the Mode dial to Movie. You can change the focus mode, Picture Style, white balance, recording quality, and Auto Lighting Optimizer level before you begin shooting in Movie mode.

▶ **Battery life.** At normal temperatures, you can expect to shoot for 1 hour and 40 minutes on a fully charged battery, with the time diminishing in colder temperatures.

▶ **Video capacities and cards.** The upper limit is 4GB of video per movie. When the movie reaches the 4GB point, the recording automatically stops. You can start recording again by pressing the Live View/Movie shooting button, provided that you have space on the card, and the camera creates a new file. As the card reaches capacity, the T2i/550D warns you by displaying the movie size and time remaining in red. Also, Canon recommends a large-capacity SD card that is rated as Class 6 or higher. Slower cards may not provide the best video recording and playback.

▶ **Focusing.** You have the same options for focusing as you have in Live View shooting. In Quick mode, the reflex mirror has to flip down to establish focus, and this blackout is not the best video experience. However Quick mode focusing can be suitable for an interview or other still subject where you can set the focus before you begin recording.

 For more details on Live View focusing options, see Chapter 5.

▶ **HDMI output.** The T2i/550D offers HDMI-CEC (Consumer Electronics Control) video output connectivity. This means that when you play back movies on your HD TV, you can use the TV remote control to play back movies or view still images to control image playback, display an index, display the shooting information, rotate images, and run a slide show.

▶ **Still-image shots during recording.** You can capture, or grab, a still image at any time during video recording by pressing the Shutter button completely. When you half-press the Shutter button, the T2i/550D displays the current aperture and shutter speed on the LCD, and these settings are used for the still image. Capturing a still image results in a 1-second pause in the video, and then movie recording resumes. The still image is recorded to the media card as a file separate from the video. The still image is captured at the image-quality setting that was previously set for still-image shooting, and the camera automatically

sets the aperture and shutter speed unless you are shooting in M mode. The white balance, Picture Style, and quality settings that are set for shooting in P, Tv, Av, M, and B shooting modes are used for still images. The flash is not used, and you cannot use a Self-timer mode for capturing the still image. In addition, the mask around the frame during movie recording is also recorded on the still image.

▶ **Frame grabs.** You can opt to pull a still image from the video footage rather than shooting a still image during movie recording. If you shoot at 1920 × 1080, frame grabs are limited to approximately 2 million pixels. Stills grabbed from a 1280 × 720 movie are 1 megapixel, and stills from a 640 × 480 movie are 300,000 pixels. Also because the shutter speeds during automatic exposure tend to be slow to enhance video movement, frame grabs can appear blurry.

Recording and Playing Back Videos

Some of the setup options for Movie shooting are the same as or similar to those offered in Live View shooting. In particular, the focusing modes are the same in both cases. Also when you set the Mode dial to Movie, the camera menus change showing a variety of options that you can set for recording movies.

The following sections help you set up the T2i/550D for video recording.

Setting up for movie recording

To set up for movie shooting, you can choose the movie recording size, the focusing mode, and whether to record audio using the built-in speaker. As with Live View shooting, you can also display a grid to line up vertical and horizontal lines, set the amount of time the camera retains the last metering for exposure, and choose whether to use a remote control.

 Be sure to review Chapter 5 for details on the focusing modes, grid display, and **NOTE** Metering timer because the same options are used in Movie mode shooting.

To set up options for shooting movies, follow these steps:

1. **With the Mode dial set to Movie shooting mode.** The reflex mirror flips up and a current view of the scene appears on the LCD.

2. **Press the Menu button, and then turn the Main dial to select the Movie 1 menu.**

3. **On the Movie 1 menu, press the down cross key to highlight any of the following options, and then press the Set button to display the settings that you can select.**

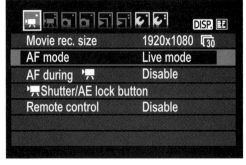

6.1 **The Movie 1 shooting mode menu**

 - **Movie recording size.** Select the resolution of movie you want to shoot, and then press the Set button. Remember that just as with image quality, the size you choose affects the overall quality of your movie, so for the best quality, choose one of the 1920 × 1080 or 1280 × 720 options.

 - **AF mode.** Select Live mode, Face Detection Live mode, or Quick mode, and then press the Set button.

 - **AF during [Movie recording].** Adjusting focus during movie recording causes a visual transition that isn't optimal, so you can either choose to focus before recording begins, or during. Here your options are Enable and Disable. Choose the option you want, and then press the Set button.

 - **Shutter/AE Lock button.** This option enables you to swap the functions of the Shutter button and the AE Lock button on the top right back of the camera. Switching functions is helpful if you find it easier to use one button over the other. Make your selection, and then press the Set button. The options are: AF/AE lock, which is no change from the standard camera operation of these controls; AE lock/AF initiates AE Lock when pressing the Shutter button and initiates focusing while pressing the AE Lock button; AF/AF lock, no AE lock initiates focusing by half-pressing the Shutter button and takes a still image by pressing the Shutter button completely when holding the AE Lock button (you can't use AE Lock with this option selected); and, AE/AF with no AE lock, which initiates focusing when pressing the AE Lock button and meters the scene or subject when half-pressing the Shutter button.

 - **Remote control.** Choose Enable or Disable depending on whether you want to use the accessory RC-6 remote control, and then press the Set button.

4. **Turn the Main dial to select the Movie 2 menu, press the down cross key to highlight any of the following options, and then press the Set button to display the options.**

- **Movie exposure.** The options are Auto or Manual, depending on whether you want the T2i/550 to set the exposure automatically, or if you want to control the ISO, shutter speed, and aperture yourself. Press the Set button to make your selection.

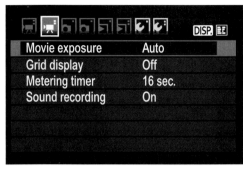

6.2 The Movie 2 shooting mode menu

- **Grid display.** Select a 3 × 3 or 4 × 6 grid to help you align horizontal and vertical lines in the scene. Or select Off if you do not want to use a grid, and then press the Set button.

- **Metering timer:** Choose 4, 16, 30 seconds, or 1, 10, or 30 minutes. Your choice depends on how often the light in the scene will change. If the light is constant, then a longer time is the best choice and vice versa. Press the Set button to make your selection.

- **Sound recording:** Choose On or Off, and then press the Set button.

- **Highlight tone priority:** Choose Disable or Enable, and then press the Set button. This option is available only when you are shooting in Manual movie exposure mode. Highlight tone priority can help avoid blown highlights — highlights that go completely white with no image detail or texture in them. If you choose Enable, the lowest ISO setting is 200 instead of 100, and Auto Lighting Optimizer is automatically disabled.

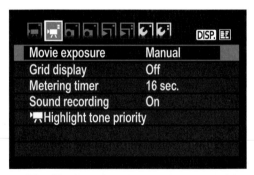

6.3 The Movie 2 shooting mode menu with manual exposure adds the option to turn on Highlight tone priority.

NOTE In Movie mode, the stabilizer on an Image-Stabilized lens functions continuously even if you're not half-pressing the Shutter button. The stabilization consumes battery power and may shorten the length of time you can shoot.

Recording movies

To get a feel for shooting, you may want to record your first movies using automatic exposure, and then move into manual exposure shooting. Preparation is also important. Here are a few things to do before you begin shooting a movie.

▶ **Focus on the subject first.** While you can reset focus during shooting, it creates a visual disconnect that isn't optimal. This is especially important if you use Quick focusing mode where the reflex mirror flips down to establish focus.

▶ **Plan the depth of field.** One advantage of Movie mode on any digital SLR, particularly if you are recording with manual exposure, is that you can create a shallow depth of field that isn't possible with a video camera. Thus, you can blur the foreground and background for creative effect. Plan ahead for the look you want.

▶ **Make camera adjustments before recording.** If you're using the built-in microphone, think through camera adjustments that you can make before you begin shooting to keep the camera sounds they produce to a minimum during recording. Switch to Movie mode on the Mode dial, and then set the Picture Style, white balance, recording quality, and so on before you begin shooting. However, if you shoot using automatic movie exposure, the camera sets the exposure as well as the Picture Style, white balance, and so on. You can change these settings during shooting, however.

▶ **Attach and test the accessory microphone.** Stereo sound recording with an accessory microphone is possible by connecting the microphone with a 3.5mm-diameter mini plug that can be connected to the camera's external microphone IN terminal.

▶ **Stabilize the camera.** Use a tripod or specialized holding device for video shooting to ensure smooth movement. And if you stabilize the camera, turn off Image Stabilization (IS) on the lens if the lens has IS.

Before you begin recording, set up the camera by following these steps:

1. **Set the Mode dial to Movie.** The reflex mirror flips up and a current view of the scene appears on the LCD.

2. **If you are using an automatic exposure, press the Q button to display the settings you can adjust.** The settings you can

6.4 The Movie display with automatic exposure

change are the white balance, Picture Style, Auto Lighting Optimizer setting, still and movie quality, and the focusing mode. Press a cross key to move to the setting you want to change, and then turn the Main dial to make changes.

3. **If you are using a manual exposure, half-press the Shutter button, and then follow these steps to set the exposure and make changes to other settings:**

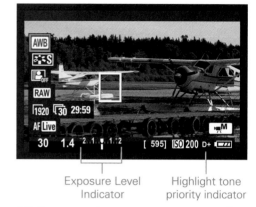

Exposure Level Indicator Highlight tone priority indicator

6.5 For manual exposure, you can set the exposure by metering from a gray card as described in previous chapters, or, if you want to use the camera's recommended exposure, adjust the aperture and shutter speed until the tick mark is in the center of the scale. In this image, Highlight tone priority is also enabled as indicated by the D+ notation.

- **Set the shutter speed.** Turn the Main dial to set the shutter speed. At 50 or 60 fps, you can choose 1/4000 to 1/60 second. At 24, 25, and 30 fps, you can choose 1/4000 to 1/30 second. For smooth motion of moving subject, shutter speeds 1/30 to 1/125 second are recommended.

- **Set the aperture.** Hold the AV button as you turn the Main dial to set the aperture. Shooting with the same aperture is best to avoid variations in exposure during the movie.

- **Set the ISO.** Press the ISO button and set the ISO between 100 and 6400. If you have Highlight tone priority enabled, the ISO range is 200 to 6400.

- **Display the other settings you can adjust.** Press the Q button to display the white balance, Picture Style, Auto Lighting Optimizer setting, still and movie quality, and the focusing mode. Press a cross key to move to the setting you want to change, and then turn the Main dial to make changes.

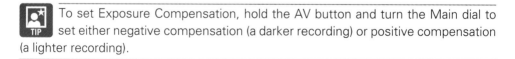

To set Exposure Compensation, hold the AV button and turn the Main dial to set either negative compensation (a darker recording) or positive compensation (a lighter recording).

4. **Focus on the subject.** Here is how to use the focusing options that are the same as in Live View shooting.

- **Live mode.** Press a cross key to move the white magnifying rectangle so that it is over the part of the subject that you want in focus, and then half-press the Shutter button. When focus is achieved, the AF-point rectangle turns green. If focus is not achieved, the AF-point rectangle turns orange. In Live mode, focus takes slightly longer than you are accustomed to.

- **Face Detection Live mode.** The camera looks for a face or faces in the scene, and displays corner marks over the face it finds. You can press the left or right cross key to move the focusing frame to another face. To focus, half-press the Shutter button. When focus is obtained, the corner marks appear in green. If the camera cannot find a face in the scene, it displays a solid rectangle and the camera uses the center AF point for focusing.

- **Quick mode.** Press the Q button to display the nine AF points. Press the left or right cross key to activate the AF points, and then select the AF point by turning the Main dial.

- **Manual focusing.** You need to have a lens that offers manual focusing to use this option. Set the switch on the side of the lens to MF (Manual Focus). Then turn the focusing ring on the lens to focus on the subject. If you have to change focus during shooting, manual focusing avoids the noise of the AF motor being recorded, but the focusing adjustment can be intrusive to the video.

 You can't focus continuously on a moving subject in Movie shooting mode.

Now the camera is set up for video shooting. Note that video recording can raise the camera's internal temperature. If an icon that resembles a thermometer appears, wrap up shooting and let the camera cool. Taking still photos when the icon is displayed can cause overall image degradation.

To begin recording, follow these steps.

1. **Press the Live View/Movie shooting button to begin recording the movie.** The Movie mode (red) dot appears at the top right of the screen.

2. **Press the Display button one or more times to cycle through the various shooting displays to display more or less shooting and camera setting information.**

3. **To stop recording, press the Live View /Movie shooting button.**

Playing back videos

For a quick preview of your movies, you can play them back on the camera's LCD. Of course, with the high-definition quality, you will enjoy the movies much more by playing them back on a television or computer.

To play back a movie on the camera LCD, follow these steps:

1. **Press the Playback button, and then press the left or right cross key until you get to a movie file.** Movies are denoted with a movie icon and the word *Set* in the upper-left corner of the LCD display.

2. **Press the Set button.** A progress bar appears at the top of the screen, and a control bar appears at the bottom of the display.

3. **Press the Set button to begin playing back the movie, or press the right cross key to select a playback function, and then press the Set button.** You can choose from the following:

 - **Exit.** Select this control to return to single-image playback.

 - **Play.** Press the Set button to start or pause the movie playback.

 - **Slow motion.** Press the left or right cross key to change the slow-motion speed.

 - **First frame.** Select this control to move to the first frame of the movie.

 - **Previous frame.** Press the Set button once to move to the previous frame, or press and hold the Set button to rewind the movie.

 - **Next frame.** Press the Set button once to move to the next frame, or press and hold the Set button to fast forward through the movie.

 - **Last frame.** Select this control to move to the last frame or the end of the movie.

 - **Edit.** Select this control to display the editing screen where you can edit out 1-second increments of the first and last scenes of a movie.

 - **Volume.** This is denoted as ascending gray or green bars; just turn the Main dial to adjust the audio volume.

4. **Turn the left cross key to select Exit, and then press the Set button.** The playback screen appears.

Using Flash

The Rebel T2i/550D's onboard flash unit or an accessory Canon EX-series Speedlite extends your creative opportunities with the Rebel in many different scenes. And with the nice compliment of flash settings and options on the Rebel, you can get natural-looking results whether you're shooting indoors or outdoors, particularly when you're using P, Tv, Av, and M shooting modes.

This chapter explores flash technology, details the use of the T2i/550D's onboard flash, and covers the menu options for both the built-in flash and for accessory EX-series Speedlites. The focus of this chapter is on fundamental flash techniques and ideas for using flash for both practical situations and creative effect.

To light this glass of wine, I used Christmas lights behind fabric for the background, and then I used a Speedlite to light the front of the glass. Exposure: ISO 200, f/8, 1/6 second.

Exploring Flash Technology

Both the onboard flash and Canon's EX-series Speedlites employ E-TTL II technology. E-TTL stands for Evaluative Through-the-Lens flash exposure control. E-TTL II is a flash technology that receives information from the camera, including the focal length of the lens, distance from the subject, and exposure settings including aperture, and then the camera's built-in Evaluative metering system balances subject exposure with the existing light in the scene.

In more technical terms, with E-TTL II, the camera's meter reads through the lens, but not off the focal plane. After the Shutter button is fully pressed but before the reflex mirror goes up, the flash fires a preflash beam. Information from this preflash is combined with data from the Evaluative metering system to analyze and compare existing light exposure values with the amount of light needed to make a good exposure. Then the camera calculates and stores the flash output needed to illuminate the subject while maintaining a natural-looking balance with the ambient light in the background.

7.1 For this image, I used the built-in flash, which provided a nice front light to supplement the window light above the scene. Exposure: ISO 200, f/2.8, 1/200 second.

In addition, the flash automatically figures in the angle of view of the lens for the T2i/550D given its cropped image sensor size. Thus, regardless of the lens being used, the built-in flash and EX-series Speedlites automatically adjust the flash zoom mechanism for the best flash angle and to illuminate only key areas of the scene, which conserves power. Altogether, this technology makes the flash very handy for a variety of subjects.

Whether you use the built-in flash or an accessory EX Speedlite, you can use flash in Tv, Av, and M shooting modes knowing that the exposure settings are taken into account during exposure given the maximum sync speed for the flash. When you use

the flash in P shooting mode, you cannot shift, or change, the exposure. Instead, the camera automatically sets the aperture, and it sets the shutter speed between 1/200 and 1/60 second. The same is true for using the flash in A-DEP mode.

When shooting with accessory Speedlites, Canon's flash technology allows wireless, multiple-flash photography where you can simulate studio lighting in both placement of lights and light ratios (the relative intensity of each flash unit).

Using the onboard flash

The T2i/550D's onboard flash unit is a handy complement to existing-light shooting. You can use it to add just a pop of flash for subjects that are backlit and in low-light scenes to ensure that there is no blur from handholding the camera at slow shutter speeds. Once you understand both the flexibility as well as the limitations of the flash, you'll have another tool that helps ensure tack-sharp, well-lit images in scenes where you might not have been able to shoot without using the flash. And, most important, there is enough control that you can also avoid the sterile, overly bright, deer-in-the-headlights images that are commonly associated with flash use.

Why Flash Sync Speed Matters

Flash Sync speed matters because if it isn't set correctly, only part of the image sensor has enough time to receive light while the shutter is open. The result is an unevenly exposed image. The T2i/550D doesn't allow you to set a shutter speed faster than 1/200 second, but in some modes you can set a slower Flash Sync speed. Using Custom Function C.Fn-I-3, you can set whether the T2i/550D sets the Flash Sync speed automatically (Option 0), from 1/200 to 1/60 second (Option 1), or always uses 1/200 second (Option 2) when you shoot in Av mode. If you choose to always use 1/200 second, then the flash becomes the main light source rendering a bright subject with a dark background, but you can handhold the camera and get a sharp image when using non-Image Stabilized lenses up to 200mm. If you use Auto, then the existing light contributes more to the exposure providing a natural-looking subject and background exposure. If you choose Option 1 of 1/200 to 1/60 second, then the background will be dark but you can avoid blur from handholding the camera at the slower shutter speed that Auto may use.

It's important to understand a few aspects of the built-in flash that help you know when to use it and what to expect from it.

▶ The built-in flash unit offers coverage for lenses as wide as 17mm (equivalent to 27mm in full 35mm frame shooting).

▶ After firing the flash, it takes approximately 3 seconds for the flash to recycle or repower itself depending on the number of firings. When the flash is fully recycled, the Flash-ready light that resembles a lightning bolt illuminates in the viewfinder.

▶ When using the built-in flash, be sure the subject is no closer than 3.3 feet (1 meter) and no farther than 16.4 feet (5 meters) from the camera.

▶ Don't use a lens hood when you're using the flash, as it will obstruct part of the light from the flash.

▶ In both Tv and Av shooting modes, if you use automatic flash (with shutter speed ranging from 1/200 to 30 seconds), the flash output is set based on the aperture (f-stop).

7.2 For this image, I used the built-in flash to provide front light while the top and bottom light came from a small, portable fluorescent studio. Exposure: ISO 200, f/8, 1/30 second.

▶ In the automatic Basic Zone shooting modes of Portrait and Close-up, the Rebel T2i/550D automatically fires the flash when it detects lower light or backlit subjects. In Night Portrait shooting mode, the flash fires in every shot. In Landscape, Sports, and, of course, in Flash Off modes, the flash doesn't fire. In Landscape mode, the range of the flash isn't sufficient to illuminate distant scenes. In Sports mode, the shutter speed often exceeds the Flash Sync speed or the subject distance exceeds the range of the flash.

The built-in flash also offers good versatility and features overrides, including Flash Exposure Compensation (FEC) and Flash Exposure Lock (FE Lock) covered later in this chapter. In addition, many flash options can be set on the camera's Flash Control menu when you shoot in P, Tv, Av, M, and A-DEP modes.

The Flash Control menu options on the Shooting 1 menu include the ability to turn off firing of the built-in flash, set shutter sync with first or second curtain, set Flash Exposure Compensation, and choose between using Evaluative or Average metering. The T2i/550D also allows you to set Custom Functions for an accessory EX-series Speedlite — a handy feature that enables you to use the camera's larger size LCD to set up external flash functions. Control of Red-eye Reduction is also provided on the Shooting 1 menu.

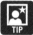 As the subject distance increases, the light from the flash falls off. If you double the distance, the light is one quarter as much as before. This is called the Inverse Square Law.

Using Guide Numbers

A guide number indicates the amount of light that the flash emits so that you can determine the best aperture to use at a particular distance and at a given ISO, usually ISO 100. The guide number for the built-in flash is 43 (feet)/13 (meters) at ISO 100. Knowing that guide number, you can then divide the guide number by the flash-to-subject distance to determine what aperture to set. The relationship between the aperture and the flash-to-subject distance is Guide Number ÷ Aperture = Distance for optimal exposure and Guide Number ÷ Distance = Aperture for optimal exposure.

For example, with a guide number of 43, and shooting 8 feet from the subject, the optimal aperture is determined thusly: 43 ÷ 8 feet is 5.375, or rounded up to f/5.6. If that aperture isn't what you want, then you can change the camera-to-subject distance, or you can increase the ISO sensitivity setting. By increasing the ISO, the camera needs less light to make the exposure, and it simultaneously increases the range of the flash. When you increase the ISO from 100 to 200, the guide number increases by a factor of 1.4X, while increasing from 100 to 400 doubles the guide number.

Table 7.1 shows the behavior of the flash in each of the Rebel T2i/550D's Creative Zone shooting modes. Table 7.2 shows the approximate effective range of the flash with the Canon EF 18-55mm lenses.

 If you're using a non-Canon flash unit, the sync speed is 1/200 second or slower. Non-Canon flash units do not fire in Live View shooting mode. Also Canon advises against using a hot-shoe mount high-voltage flash unit.

Table 7.1: Using the Built-in Flash in Creative Zone Modes

Mode	Shutter Speed	Automatic Exposure (AE) Setting
Tv (Shutter-priority AE)	1/200 sec. to 30 sec.	You can set the shutter speed up to 1/200 second, and the camera automatically sets the appropriate aperture.
Av (Aperture Priority AE)	1/200 sec. to 30 sec.	You set the aperture, and the camera automatically sets the shutter speed up to 1/200 second. In this mode, the camera may set long shutter speeds that can result in blur if the subject moves or if you handhold the camera. To avoid this, you can set C.Fn I-3 to Option 1: 1/200-1/60 second, or to Option 2: 1/200 second (fixed).
M (Manual)	1/200 to 30 sec.	You set both the aperture and the shutter speed. Flash exposure is set automatically.
A-DEP (Automatic depth-of-field), and P (Program)	1/60 sec. to 1/200 sec.	Both the aperture and the shutter speed are set automatically by the camera. In A-DEP shooting mode, using the flash sacrifices getting the maximum depth of field.

Table 7.2: Built-in Flash Range with the EF-S 18-55mm Lens

ISO	18mm	55mm
100	1 to 3.7m (3.3 to 12.1 ft.)	1 to 2.3m (3.3 to 7.5 ft.)
200	1 to 5.3m (3.3 to 17.4 ft.)	1 to 3.3m (3.3 to 10.8 ft.)
400	1 to 7.4m (3.3 to 24.3 ft.)	1 to 4.6m (3.3 to 15.1 ft.)
800	1 to 10.5m (3.3 to 34.4 ft.)	1 to 6.6m (3.3 to 21.7 ft.)
1600	1 to 14.9m (3.3 to 47.9 ft.)	1 to 9.3m (3.3 to 30.5 ft.)

Using the flash's autofocus-assist beam without firing the flash

In some low-light scenes, you may not want to use the flash, but at the same time, the camera has difficulty focusing in the low light. In these situations, you can set up the Rebel so that it uses the flash's autofocus-assist (AF-assist) beam, but it does not fire the flash itself. In other words, when you pop up the flash, and half-press the Shutter button, the autofocus-assist beam fires to help the camera establish focus, but the flash does not fire when you make the picture.

This is a handy feature to use especially when you're shooting a still subject in low light or at night and you have the camera on a tripod. The autofocus-assist beam will

speed up focusing significantly, and it will help ensure sharp focus. You can also use this technique in low-light indoor museums or churches where flash is not allowed. Just be sure to stabilize the camera if the shutter speed is slow.

To use the flash's AF-assist beam for focusing but not use the flash, follow these steps:

1. **Press the Menu button, and then turn the Main dial until the Setup 3 menu is displayed.**

2. **Press the up or down cross key to highlight Custom Functions (C.Fn), and the press the Set button.**

3. **Press the left or right cross key until the number 7 appears in the control box at the top right of the screen, and then press the Set button.** The currently selected option is activated.

4. **If you want to use the built-in flash's AF-assist beam, then press the up cross key to select Option 0: Enable, and then press the Set button.** If you are using an accessory Speedlite, then choose Option 2: Enable external flash only, and then press the Set button.

5. **Lightly press the Shutter button to dismiss the menu.**

6. **Press the Menu button, and then turn the Main dial until the Shooting 1 menu is displayed.**

7. **Press the down or up cross key to highlight Flash control, and then press the Set button.** The Flash control screen appears.

8. **Press a cross key to highlight Flash firing, and then press the Set button.** Two options appear.

9. **Press the up or down cross key to highlight Disable, and then press the Set button.** By choosing Disable, neither the built-in flash nor an accessory Speedlite will fire. However, the camera will use the flash's AF-assist beam to establish focus in low-light scenes where the camera has difficulty focusing.

10. **Pop up the built-in flash by pressing the Flash button on the front of the camera, or mount an accessory EX-series Speedlite on the Rebel, press the Shutter button halfway to focus, and then press the Shutter button completely to make the picture.** When you press the Shutter button halfway, the flash's AF-assist beam fires to help the camera establish focus, but the flash will not fire.

Red-eye reduction

A disadvantage of flash exposure in portraits of people and pets is unattractive red or green in the subject's eyes. There is no sure way to prevent red-eye except by not using the flash, but a few steps help reduce it. First, be sure to turn on Red-Eye Reduction mode on the T2i/550D. This option is set to Off by default. Before making the picture, have the subject look at the Red-Eye Reduction lamp on the front of the camera when it fires at the beginning of a flash exposure. Also have the room well lit.

To turn on Red-Eye Reduction mode, follow these steps:

1. **Press the Menu button, and then turn the Main dial to select the Shooting 1 menu.**

2. **Press the down cross key to highlight Red-eye reduc., and then press the Set button.** Two options are displayed.

3. **Press the down cross key to highlight Enable, and then press the Set button.** The setting you choose applies in all shooting modes.

4. **If you're shooting in P, Tv, Av, M, or A-DEP, press the Flash button on the camera to pop up the built-in flash.** In Basic Zone modes such as Full Auto, Portrait, and so on, the built-in flash pops up and fires automatically depending on the amount of light in the scene.

Courtesy of Canon

7.3 Canon's newest Speedlite 270EX, a compact, lightweight unit that allows bounce flash from four position steps from 0 to 90 degrees.

5. **Focus on the subject by pressing the Shutter button halfway, and then watch the timer display at the bottom center of the viewfinder.** When the timer display in the viewfinder disappears, press the Shutter button completely to make the picture.

Modifying Flash Exposure

There are doubtless times when the output of the flash will not be what you envisioned. Most often, the output is stronger than desired, creating an unnaturally bright

illumination on the subject. The Rebel T2i/550D offers two options for modifying the flash output: Flash Exposure Compensation (FEC) and Flash Exposure Lock (FE Lock) for both the built-in flash and one or more accessory Speedlites.

Flash exposure modification controls are available only when you're shooting in P, Tv, Av, M, and A-DEP shooting modes. In the automatic modes such as Portrait, Landscape, and Full Auto, the T2i/550D fires the flash and controls the flash output automatically.

Flash Exposure Lock

One way to modify flash output is by using Flash Exposure Lock (FE Lock), or FEL as it sometimes appears on the Rebel. Much like Auto Exposure Lock (AE Lock), FE Lock allows you to meter and set the flash output on any part of the scene while you focus on another part of the scene.

With FE Lock, you lock the flash exposure on a midtone area in the scene or any area where exposure is critical. The camera calculates a suitable flash output, and locks or remembers the exposure, and then you can recompose, focus on a different area from where the flash metering was taken, and make the picture.

FE Lock is also effective when there are reflective surfaces such as a mirror, chrome, or glass in the scene. Without using FE Lock, the camera takes the reflective surface into account and reduces the flash, causing underexposure. Instead, set FE Lock for a middle gray area in the scene that does not include the reflective surface, and then make the exposure.

For details on using middle gray areas to meter with, see Chapter 11.

Before you begin, ensure that flash firing is enabled on the Shooting 1 menu under Flash control. Then, to set FE Lock, follow these steps:

1. **Set the camera to P, Tv, Av, or M, and then press the Flash button to raise the built-in flash or mount the accessory Speedlite.** The flash icon appears in the viewfinder.

2. **Point the center of the lens, the Spot-metering circle in the viewfinder, over the area where you want to lock the flash exposure.** The area can be midtone (middle gray) area in the scene or you can meter from the gray card that's provided in the back of this book. Or, if you are taking a portrait, you can point the lens to a skin tone area.

3. **Press the Shutter button halfway, and then press the AE/FE Lock button on the top back-right side of the camera.** This button has an asterisk above it. The camera fires a preflash. FEL is displayed momentarily in the viewfinder, and the flash icon in the viewfinder displays an asterisk beside it to indicate that flash exposure is locked.

 If the flash icon in the viewfinder blinks, you are too far from the subject for the flash range. Move closer to the subject and repeat Step 3.

4. **Move the camera to compose the image, press the Shutter button halfway to focus on the subject, wait for the flash-timer display to disappear, and then completely press the Shutter button to make the image.** You can take additional pictures at this flash output as long as the asterisk is displayed in the viewfinder.

FE Lock is a practical technique to use when shooting individual images. But if you're shooting a series of images in the same light, then Flash Exposure Compensation, detailed next, is more efficient and practical.

Flash Exposure Compensation

Flash Exposure Compensation is much like Auto Exposure Compensation in that you can increase or decrease flash exposure up to +/-2 stops in 1/3-stop increments. If you set a positive compensation amount, the T2i/500D increases the flash output making the image brighter and vice versa. The compensation is applied to all flash exposures until you reset the compensation back to 0.

If you use flash compensation to create a more natural-looking portrait in daylight, try setting negative compensation between -1 and -2 stops. Also be aware that in bright light, the camera assumes that you're using fill flash to reduce dark shadows and automatically provides flash reduction. Experiment with the Rebel T2i/550D in a variety of lighting to know what to expect.

It's important to note that if you use FEC, you may not see much if any difference with negative compensation because the T2i/550D has Auto Lighting Optimizer turned on by default for all JPEG images, but not for RAW images. This feature automatically corrects images that are underexposed or have low contrast. So if you set FEC to a negative setting to reduce flash output, the camera may detect the image as being underexposed (too dark) and automatically brighten the picture.

If you're using FEC, it's best to turn off Auto Lighting Optimizer Off on the Shooting 2 menu.

If you use an accessory Speedlite, you can set FEC either on the camera or on the Speedlite. However, the compensation that you set on the Speedlite overrides any compensation that you set on the T2i/550D's Shooting 1 camera menu. If you set compensation on both the Speedlite and the camera, the Speedlite setting overrides what you set on the camera. In short, you can set the compensation either on the Speedlite or on the camera, but not set them to the same setting on the camera and the flash.

FEC can be combined with Exposure Compensation. If you're shooting a scene where one part of the scene is brightly lit and another part of the scene is much darker — for example, an interior room with a view to the out-

7.4 This image was made using late-afternoon light from a window to camera right, and one Speedlite mounted on a stand and shooting into a silver umbrella. The 580 EX II Speedlite was just to the right of the camera. Exposure: ISO 200, f/4, 1/8 second.

doors — then you can set Exposure Compensation to -1 and set the FEC to -1 to make the transition between the two differently lit areas more natural.

To set FEC for the built-in flash, follow these steps:

1. **Set the Mode dial to P, Tv, Av, M, or A-DEP.**

2. **Press the Menu button, and turn the Main dial to select the Shooting 1 menu.**

3. **Press the down cross key to highlight Flash control, and then press the Set button.** The Flash control screen appears.

4. **Press the down cross key to highlight Built-in flash func. setting, and then press the Set button.** The Built-in flash func. setting screen appears.

5. **Press the down cross key to highlight Flash exp. comp, and then press the Set button.** The Flash Exposure Compensation control is activated.

6. **Press the left cross key to set negative compensation (lower the flash output for a darker image) or press the right cross key to set positive flash output (increase the flash output for a brighter image), and then press the Set button.** As you make changes, a tick mark under the exposure level meter moves to indicate the amount of FEC in 1/3-stop increments. The FEC is displayed in the viewfinder when you press the Shutter button halfway. The FEC you set on the camera remains in effect until you change it.

To remove FEC, repeat these steps, but in Step 2, press the left or right cross key to move the tick mark on the exposure level meter back to the center point.

Using flash control options

With the T2i/550D, many of the onboard and accessory flash settings are available on the camera menus. The Shooting 1 menu offers onboard flash settings including the first or second curtain shutter sync, Flash Exposure Compensation, and E-TTL II or Average exposure metering.

When an accessory Speedlite is mounted, you can use the Flash control menu to set FEC and to set Evaluative or Average flash metering. In addition, you can change or clear the Custom Function settings for compatible Speedlites such as the 580 EX II. If the Speedlite functions cannot be set with the camera, these options display a message notifying you that the flash is incompatible with this option. In that case, set the options you want on the Speedlite itself.

To change settings for the onboard or compatible accessory EX-series Speedlites, follow these steps:

1. **Set the camera to a P, Tv, Av, M, or A-DEP.** If you're using an accessory Speedlite, mount it on the hot shoe and turn on the power.

2. **Press the Menu button, and then press the right cross key until the Shooting 1 menu is displayed.**

3. **Press the down cross key to highlight Flash control, and then press the Set button.** The Flash Control screen appears with options for the built-in and external flash.

4. **Press a cross key to highlight the option you want, and then press the Set button.** Choose a control option from the Flash Control menu and press the Set button. Table 7.3 lists the menu settings, options, and sub-options that you can choose to control the flash.

Table 7.3: Flash Control Menu Options

Setting	Option(s)	Suboptions/Notes
Built-in flash func. setting	Flash mode	E-TTL II (Cannot be changed)
	Shutter sync	**1st curtain:** Flash fires at the beginning of the exposure. Can be used with a slow-sync speed to create light trails in front of the subject. **2nd curtain:** Flash fires just before the exposure ends. Can be used with a slow-sync speed to create light trails behind the subject.
	Flash exp. Comp	Press the Set button to activate the exposure level meter, and then turn the Quick Control dial to set +/-2 stops in 1/3-stop increments.
	E-TTL II	**Evaluative:** This default setting sets the exposure based on an evaluation of the entire scene. **Average:** Flash exposure is metered and averaged for the entire scene. Results in brighter output on the subject and less balancing of ambient background light.
External flash func. setting	Flash mode	The available options depend on the EX-series Speedlite. Depending on the Speedlite, you can choose E-TTL II, Manual flash, MULTI flash, TTL, AutoExtFlash, or Man.ExtFlash.
	Shutter sync	**1st curtain:** Flash fires at the beginning of the exposure. Can be used with a slow-sync speed to create light trails in front of the subject. **2nd curtain:** Flash fires just before the exposure ends. Can be used with a slow-sync speed to create light trails behind the subject.
	FEB	Flash Exposure Bracketing can be set to +/- 3 stops in 1/3-stop increments.
	E-TTL meter.	You can choose Evaluative or Average metering. Average metering averages the entire scene whereas Evaluative metering takes into account the subject position as indicated by the active AF point(s). Average metering results in a brighter flash output on the subject and less balancing of the surrounding light.
	Zoom	Press the Set button to active the Zoom option, and then press the up or down cross key to set the lens focal length (zoom setting on the lens) from 24mm to 105mm.
	Wireless func.	Choose Enable if you are shooting with wireless flash or flashes.
	Master flash	Choose Enable if you're using multiple Speedlites to have one Speedlite as the master, or controlling, flash unit with the other flash units as slaves.

continued

Table 7.3: Flash Control Menu Options (continued)

Setting	Option(s)	Suboptions/Notes
External flash func. setting	Channel	Press the Set button to activate this control and set the channel you want. This is useful if you're shooting around other photographers using wireless flash so that you can ensure you're on a different channel from theirs.
	Firing group	A+B+C, A:B, or A:B C
	Flash exp. comp	Press the Set button to activate the control, and then press the left or right cross key to set Flash Exposure Compensation as described previously in this chapter.
	External flash C.Fn setting	Press the Set button to display the C.Fn screen for the external Speedlite.
	Clear external flash C.Fn setting	Available only with a compatible Speedlite attached. Resets Speedlite Custom Functions to the default settings.

Using Accessory Speedlites

With one or more accessory flash units, a new level of lighting options opens up, ranging from simple techniques such as bounce flash and fill flash to controlled lighting ratios with up to three groups of accessory flash units. With E-TTL II metering, you have the option of using one or more flash units as either the main or an auxiliary light source to balance ambient light with flash to provide even and natural illumination and balance among light sources.

One or more Speedlites provide an excellent portable studio for portraits and still-life shooting. And you can add light stands and light modifiers such as umbrellas and softboxes, and use a variety of reflectors to produce images that either replicate studio lighting results or enhance existing light.

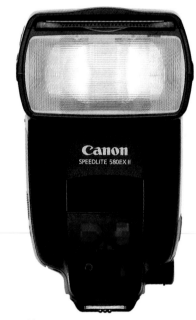

Courtesy of Canon

7.5 The Canon Speedlite 580 EX II. The flash includes a waterproof jacket around the hot shoe that matches up to the 580EX II seal to keep water from getting into the electrical connection in wet weather.

Using multiple Speedlites

The Rebel T2i/550D is compatible with all EX-series Speedlites. With EX-series Speedlites, you get Flash Exposure Bracketing and flash modeling (to preview the flash pattern before the image is made).

When I travel to shoot portraits on location, I take three Speedlites with stands and silver umbrellas. This setup is a lightweight mobile studio that can either provide the primary lighting for subjects or supplement existing light. I also use a variety of reflectors.

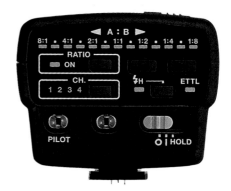

7.6 This is the back of the Canon Speedlite Transmitter ST-E2. It enables you to set up groups of flash units, control the channel in case other photographers are shooting wirelessly nearby, and to set up the lighting ratio.

In addition to the Speedlites, I use Canon's Speedlite Transmitter ST-E2. This transmitter wirelessly communicates with multiple Speedlites set up as groups or individually so that they fire at the same flash output. Alternately, you can set up slave units and vary the flash ratio from 1:8 – 1:1 – 1:8.

If you have a studio lighting system, you can use the T2i/550D for studio shooting. Just buy a relatively inexpensive hot shoe-to-PC adapter to connect the studio lighting sync cord, or a wireless hot-shoe trigger can be used as well. Then set the Rebel to 1/200 second or slower, the sync speed for flash use. I recommend the Wein Safesync hot-shoe adapter to regulate the sync voltage of studio strobes to a safe level of 6 volts to protect the camera.

Exploring flash techniques

While it's beyond the scope of this book to detail all the lighting options that you can use with one or multiple Speedlites, I'll cover some common flash techniques that provide better flash images than using straight-on flash.

Bounce flash

One frequently used flash technique is bounce flash used with an accessory Speedlite, which softens hard flash shadows by diffusing the light from the flash. To bounce the light, turn the flash head so that it points diagonally toward the ceiling or a nearby wall

so that the light hits the ceiling or wall and then bounces back to the subject. This technique spreads and softens the flash illumination.

If the ceiling is high, then it may under-expose the image. As an alternative, I often hold a silver or white reflector above the flash to act as a ceiling. This technique offers the advantage of pro-viding a clean light with no colorcast.

Adding catchlights to the eyes

Another frequently used technique is to create a catchlight in the subject's eyes by using the panel that is tucked into the flash head of some Speedlites. Just pull out the translucent flash panel on the Speedlite. At the same time, a white panel comes out, and that is the panel you use to create catchlights. The translucent panel is called the wide panel and it's used with wide-angle lenses to spread the light. Push the translucent panel back in while leaving the white panel out. Point the flash head up, and then take the image. The panel throws light into

7.7 For this portrait, I used a 580 EX II Speedlite on a stand shooting into a silver umbrella to the right of the camera, and a 480 EX II set on a stand behind the subject. There was late afternoon light filtering into the scene from a window to the right of the camera as well. Exposure: ISO 200, f/2.8, 1/15 sec. using a negative 1/2-stop of Exposure Compensation.

the eyes, creating catchlights that add a sense of vitality to the eyes. For best results be within 5 feet of the subject.

 If your Speedlite doesn't have a panel, you can tape an index card to the top of the flash to create catchlights.

Of course, the built-in flash also adds catchlights to the person's eyes, but the catch-light is an unattractive pinpoint of white that often falls inside the pupil rather than on the iris of the eye. For this reason, I avoid using the built-in flash for portraits.

Balancing lighting extremes

With a little creativity in thinking about the flash and exposure modifications that are available on the T2i/550D and Speedlites, you can balance the extremes in lighting differences between two areas. For example, if you're shooting an interior space that has a view to the outdoors and you want good detail and exposure in both areas, then combine Auto Exposure Compensation on the camera with Flash Exposure Compensation to balance the two areas.

For detailed information on using Canon Speedlites, be sure to check out the *Canon Speedlite System Digital Field Guide* by Brian McLernon (Wiley).

Using the T2i/550D with Studio and Other Lighting Options

While the T2i/550D lacks a PC sync terminal that allows connection to a studio lighting system, you can buy an inexpensive attachment that fits on the hot shoe and allows connection to a traditional studio lighting system. I've had good success using the Wein Safe Sync adapter. In addition, you can use continuous lights that require no adapters.

If you are using the Rebel to photograph small products that you sell, then a light dome, tent, or the Samigon Internet Photo Studio work well. I use the Internet photo studio that consists of two light-boxes attached to each other by brackets to photograph objects up to the size of a wine glass. The light is balanced to 5000K for excellent color out of the camera on the Flash or Auto WB settings. I used this Internet studio for this image, and I used an accessory Speedlite to provide some front light for the watch.

Exploring Canon Lenses and Accessories

The EOS T2i/550D delivers fine images with all of the Canon lenses, and it delivers the best images with high-quality lenses. With the smaller size image sensor, the camera uses the central area of the lens, often called the "sweet spot" of the lens. If you're starting out with a kit lens and considering adding a second and third lens, this chapter helps you think about building a lens system that serves you well now and in the future. Building a system is important because ultimately, your investment in lenses will far exceed your investment in the camera body. Careful planning and research help you make wise decisions.

And as you build your lens system, keep in mind what most photographers know — a camera is only as good as the lens. And this is no less true for the T2i/550D.

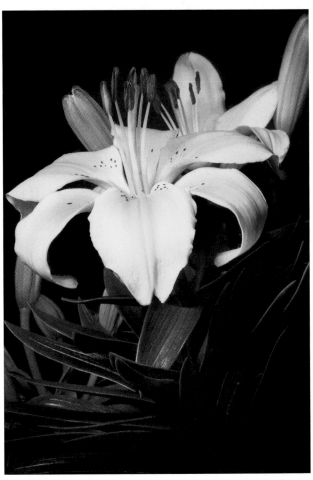

This image of a lily was made using the venerable Canon EF 100m f/2.8L Macro USM lens. Exposure: ISO 100, f/32, 1/125 second.

Building a Lens System that Lasts

The T2i/550D is compatible with more than 60 Canon EF and EF-S lenses and accessories. That's a wide range of lenses, and your options are even more extensive when you factor in compatible lenses from third-party companies.

One of the first considerations photographers face is building a lens system. A few basic tips can help you create a solid strategy for adding new lenses to your system. For photographers buying their first and second lenses, a rule of thumb is to buy two lenses that cover the focal range from wide-angle to telephoto. With those two lenses as the foundation of your system, you can shoot 80 to 95 percent of the scenes and subjects that you'll encounter.

8.1 The EF 70-200mm f/2.8L IS USM, the EF 50mm f/1.4 USM, and the 16-35mm f/2.8L USM lenses cover most everyday shooting situations, and they are a good starting point for building a lens system.

Because you'll use these lenses so often, they should be high-quality lenses that produce images with snappy contrast and excellent sharpness, and they should be fast enough to allow shooting in low-light scenes. A *fast lens* is generally considered to be a lens with a maximum, or widest, aperture of f/2.8 or faster. With a fast lens, you can

often shoot in lower light without a tripod and get sharp images. And if the lens has Image Stabilization, detailed later in this chapter, you gain even more flexibility.

When I switched to Canon cameras about eight years ago, I bought the Canon EF 24-70mm f/2.8L USM lens and the EF 70-200mm f/2.8L IS USM lens — two high-quality lenses that covered the focal range of 24mm to 200mm. Today these two lenses are still the ones I use most often for everyday shooting. And because I shoot with a variety of Canon EOS cameras, I know that I can mount these lenses on the T2i/550D or the 5D Mark II and get beautiful images.

If you bought the T2i/550D as a kit with the EF-S 18-55mm f/3.5-5.6 IS USM, then you may already have learned that while this lens seems to provide a good focal range, in practice, it falls short of providing a telephoto range. So if you use my strategy of covering the focal range, then you'll want to consider buying a telephoto lens as a second lens.

Understanding the Focal-Length Multiplier

One of the most important lens considerations for the T2i/550D is its smaller APS-C-size image sensor. *APS-C* is simply a designation that indicates that the image sensor is 1.6 times smaller than a traditional full 35mm frame. As a result, the lenses you use on the T2i/550D have a smaller angle of view than a full-frame camera. A lens's angle of view is how much of the scene, side-to-side and top-to-bottom that the lens encompasses in the image.

In short, the angle of view for Canon EF lenses that you use on the T2i/550D is reduced by a factor of 1.6X at any given focal length. That means that a 100mm lens is equivalent to a 160mm when used on the T2i/550D. Likewise, a 50mm normal lens is the equivalent to using a 80mm lens — a short telephoto lens.

This focal-length multiplication factor works to your advantage with a telephoto lens because it effectively increases the lens's focal length (although technically the focal length doesn't change). And because telephoto lenses tend to be more expensive than other lenses, you can buy a shorter and less expensive telephoto lens and get 1.6X more magnification at no extra cost.

The focal-length multiplication factor works to your disadvantage with a wide-angle lens; the sensor sees less of the scene because the focal length is magnified by 1.6. However, because wide-angle lenses tend to be less expensive than telephoto lenses, you can buy an ultrawide 14mm lens to get the equivalent of an angle of view of 22mm.

As you think about the focal-length multiplier effect on telephoto lenses, it seems reasonable to assume that the multiplier also produces the same depth of field that a

longer lens — the equivalent focal length — gives. That isn't the case, however. Although an 85mm lens on a full 35mm-frame camera is equivalent to a 136mm lens on the T2i/550D, the depth of field on the T2i/550D matches the 85mm lens, not a 136mm lens. This depth of field principle holds true for enlargements.

And that brings us to another important lens distinction for the T2i/550D – lens compatibility. The T2i/550D is compatible with all EF-mount lenses and with all EF-S-mount lenses. EF lenses are compatible across all Canon EOS cameras regardless of image sensor size, and regardless of camera type, whether digital or film. The EF-S lens mount, however, is only compatible with cropped sensor cameras such as the Rebel T2i/550D. EF-S lenses are specially designed to have a smaller image circle, or the area covered by the image on the sensor plane. EF-S lenses can be used only on cameras with a cropped frame such as the T2i/550D, T1i, 50D, and 7D among others because of a rear element that protrudes back into the camera body.

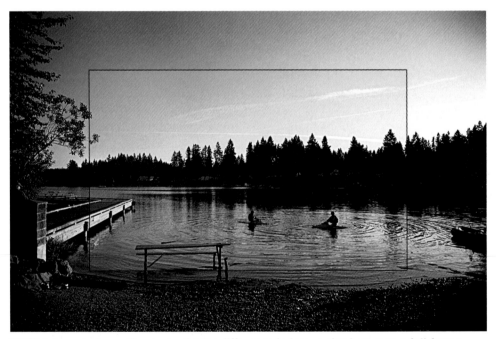

8.2 This image shows the approximate difference in image size between a full-frame 35mm camera and the T2i/550D. The smaller image size represents the T2i/550D's image size.

The difference in lens mounts should also factor into your plan for building a lens system. As you consider lenses, think about whether you want lenses that are compatible with both a full-frame camera and a cropped sensor, or not. Remember that as

your photography career continues, you'll most likely buy a second, backup camera body or move from the T2i/550D to another EOS camera body. And if your next EOS camera body has a full-frame sensor, then you'll want the lenses that you've already acquired to be compatible with it.

Zoom versus Prime Lenses

Lenses are categorized by whether they zoom to different focal lengths or have a fixed focal length — known as prime lenses. Then within those two categories, lenses are grouped by focal length (how much of the scene the lens "sees") in three main categories: wide angle, normal, and telephoto. And within those categories are macro lenses that serve double-duty as either normal or telephoto lenses with macro capability. The primary difference between zoom and prime lenses is that zoom lenses offer a range of focal lengths in a single lens while prime lenses offer a fixed, or single, focal length. There are additional distinctions that come into play as you evaluate whether a zoom or prime lens is best for your shooting needs.

About zoom lenses

Because zoom lenses offer variable focal lengths by just zooming the lens to bring the subject closer or farther away, they are very versatile in a variety of scenes. As a result, zoom lenses allow you to carry fewer lenses. For example, carrying a Canon EF-S 17-55mm f/2.8 IS USM lens and a Canon EF 55-200mm f/4.5-5.6 II USM lens, or a similar combination of lenses, provides the focal range needed for most everyday shooting.

Zoom lenses, which are available in wide-angle and telephoto ranges, are able to maintain focus during zooming. To keep the lens size compact and to compensate for aberrations with fewer lens elements, most zoom lenses use a multi-group zoom with three or more movable lens groups.

8.3 Wide-angle zoom lenses such as the Canon EF 16-35mm f/2.8L USM lens help bridge the focal-length multiplier gap by providing a wide view of the scene.

Most mid-priced and more expensive zoom lenses offer high-quality optics that produce sharp images with excellent contrast. And many Canon lenses offer full-time manual focusing available by switching the button on the side of the lens to MF (Manual Focusing).

Some zoom lenses are slower than single focal-length lenses, and getting a fast zoom lens means paying a higher price. In addition, some zoom lenses have a variable aperture, which means that the maximum aperture changes at different zoom settings (discussed in the following sections). While zoom lenses allow you to carry around fewer lenses, they tend to be heavier than their single focal-length counterparts.

Other zoom lenses have variable apertures. An f/4.5 to f/5.6 variable-aperture lens means that at the widest focal length, the maximum aperture is f/4.5 and at the longer end of the focal range, the maximum aperture is f/5.6. In practical terms, this limits the versatility of the lens at the longest focal length for shooting in all but bright light or at a high ISO setting. And unless you use a tripod or your subject is stone still, your ability to get a crisp picture in lower light at f/5.6 will be questionable.

More expensive zoom lenses offer a fixed and fast maximum aperture, meaning that with maximum apertures of f/2.8, they allow faster shutter speeds that enhance your ability to get sharp images when handholding the camera.

About prime lenses

While you hear much less about prime or single focal-length lenses, they are worth careful evaluation. With a prime lens, the focal length is fixed, meaning that you cannot zoom the lens. Rather you must move closer to or farther from your subject or change lenses to change image composition. Canon's venerable EF 50mm f/1.4 USM and EF 100mm f/2.8L IS Macro USM lenses are only two of a full lineup of Canon prime lenses.

Unlike zoom lenses, prime lenses tend to be fast with maximum apertures of f/2.8 or wider. Wide apertures allow fast shutter speeds that enable you to handhold the camera in lower light and

8.4 Single focal-length lenses such as the EF 50mm f/1.4 USM lens are smaller and lighter and provide excellent sharpness, contrast, and resolution when used on the T2i/550D.

still get a sharp image. Compared to zoom lenses, single focal-length lenses are lighter and smaller. In addition, single focal-length lenses tend to be sharper than some zoom lenses.

Most prime lenses are lightweight, but you need more of them to cover the range of focal lengths needed for everyday photography. Prime lenses also limit the options for on-the-fly composition changes that are possible with zoom lenses.

Working with Different Types of Lenses

Within the categories of zoom and prime lenses, lenses are grouped by their focal length. While some lenses cross group lines, the groupings are still useful for talking about lenses in general. Before going into specific lenses, it is helpful to understand a few concepts.

First, the lens's *angle of view* is expressed as the angle of the range that's being photographed, and it's generally shown as the angle of the diagonal direction. The image sensor is rectangular, but the image captured by the lens is circular, and it's called the *image circle*. The image that's captured is taken from the center of the image circle.

For a 15mm fisheye lens, the angle of view is 180 degrees on a full-frame 35mm camera. For a 50mm lens, it's 46 degrees; and for a 200mm lens, the angle of view is 12 degrees. Simply stated, the shorter the focal length, the wider the scene coverage, and the longer the focal length, the narrower the coverage.

The depth of field is affected by several factors including the lens's focal length, aperture (f-stop), camera-to-subject distance, and subject-to-background distance.

Finally, the lens you choose affects the perspective of images. *Perspective* is the visual effect that determines how close or far away the background appears to be from the main subject. The shorter (wider) the lens, the more distant background elements appear to be, and the longer (more telephoto) the lens, the more compressed the elements appear.

Using wide-angle lenses

Wide-angle lenses are aptly named because they offer a wide view of a scene. Generally, lenses shorter than 50mm are commonly considered wide angle on full-frame 35mm image sensors. Not including the 15mm fisheye lens, wide-angle and ultra-wide lenses range from 17mm to 40mm on a full-frame camera. The wide-angle lens category provides angles of view ranging from 114 to 63 degrees.

However, on the T2i/550D, the 1.6X focal-length multiplier works to your disadvantage. For example, with the EF 28-135mm f/3.5-5.6 IS lens, the lens translates to only 44mm on the wide end and 216mm on the telephoto end of the lens. The telephoto range is excellent, but you don't get a wide angle of view on the T2i/550D with this lens. Thus, if you often shoot landscapes, cityscapes, architecture, and interiors, a first priority will be to get a lens that offers a true wide-angle view. Good choices include the EF 16-35mm f/2.8L II USM (approximately 26 to 56mm with the 1.6X multiplier), the EF-S 10-22mm f/3.5-4.5 USM lens (approximately 16 to 35mm with the multiplier), or the EF 17-40mm f/4L USM lens (approximately 27 to 64mm with the multiplier).

Wide-angle lenses are ideal for capturing scenes ranging from sweeping landscapes and underwater subjects to large groups of people, and for taking pictures in places where space is cramped.

8.5 To get the wide-angle view on the T2i/550D, you need a wide or a wide-angle lens such as the EF 16-35mm f/2.8L USM lens that I used here to photograph this boat. The focal length was set to 29mm. Exposure: ISO 100, f/11, 1/100 second using -1/3 stop Exposure Compensation.

When you shoot with a wide-angle lens, keep these lens characteristics in mind:

▶ **Extensive depth of field.** Particularly at small apertures from f/11 to f/32, the entire scene, front to back, will be in acceptably sharp focus. This characteristic gives you slightly more latitude for less-than-perfectly focused pictures.

▶ **Fast apertures.** Wide-angle lenses tend to be faster (meaning they have wider apertures) than telephoto lenses. As a result, these lenses are good choices for everyday shooting when the lighting conditions are not optimal.

▶ **Distortion.** Wide-angle lenses can distort lines and objects in a scene, espe-cially if you tilt the camera up or down when shooting. For example, if you tilt the camera up to photograph a group of skyscrapers, the lines of the buildings tend to converge and the buildings appear to fall backward (also called *keystoning*). You can use this wide-angle lens characteristic to creatively enhance a composi-tion, or you can move back from the subject and keep the camera parallel to the main subject to help avoid the distortion.

▶ **Perspective.** Wide-angle lenses make objects close to the camera appear dis-proportionately large. You can use this characteristic to move the closest object farther forward in the image, or you can move back from the closest object to reduce the effect. Wide-angle lenses are popular for portraits, but if you use a wide-angle lens for close-up portraiture, keep in mind that the lens exaggerates the size of facial features closest to the lens, which is unflattering.

Using telephoto lenses

Telephoto lenses offer a narrow angle of view, enabling close-ups of distant scenes. On full 35mm-frame cameras, lenses with focal lengths longer than 50mm are consid-ered telephoto lenses. For example, 80mm and 200mm lenses are telephoto lenses. On the T2i/550D the focal-length multiplier works to your advantage with telephoto lenses. Factoring in the 1.6X multiplier, a 50mm lens is equivalent to 80mm, or a short telephoto lens. And because telephoto lenses are more expensive overall than wide-angle lenses, you get more focal length for your money when you buy telephoto lenses for the T2i/550D.

Telephoto lenses offer an inherently shallow depth of field that is heightened by shoot-ing at wide apertures. Lenses such as 85mm and 100mm are ideal for portraits, while longer lenses (200mm to 800mm) allow you to photograph distant birds, wildlife, and athletes. When photographing wildlife, these lenses also allow you to keep a safe distance.

When you shoot with a telephoto lens, keep these lens characteristics in mind:

▶ **Shallow depth of field.** Telephoto lenses magnify subjects and provide a lim-ited range of sharp focus. At wide apertures, you can reduce the background to a soft blur. Because of the extremely shallow depth of field, it's important to get tack-sharp focus. Many Canon lenses include full-time manual focusing that you can use to fine-tune the camera's autofocus. Canon also offers an extensive lineup of Image Stabilized telephoto lenses.

▶ **Narrow coverage of a scene.** Because the angle of view is narrow with a tele-photo lens, much less of the scene is included in the image. You can use this characteristic to exclude distracting scene elements from the image.

▶ **Slow speed.** Midpriced tele-photo lenses tend to be slow; the widest aperture is often f/4.5 or f/5.6, which limits the ability to get sharp images without a tri-pod in all but the brightest light unless they also feature Image Stabilization. And because of the magnification factor, even the slightest movement is exagger-ated.

▶ **Perspective.** Telephoto lenses tend to compress perspective, making objects in the scene appear close together.

Using normal lenses

Normal lenses offer an angle of view and perspective very much as your eyes see the scene. On full 35mm-frame cameras, 50mm to 55mm

8.6 For this image, I used the EF 100-400mm f/4.5-5/6L IS USM lens. I used a 310mm focal length, and Image Stabilization enabled me to handhold the camera and lens at a 1/125-second shutter speed. Exposure: ISO 200, f/5.6, 1/125 second.

lenses are considered normal lenses. However, on the T2i/550D, a normal lens is 28mm to 35mm when you take into account the focal-length multiplier. And, likewise, the 50mm lens is equivalent to an 80mm lens on the T2i/550D.

8.7 On the T2i/550D a focal length of 28 to 35mm provides a normal angle of view, and this image shows the effect using a focal length of 35mm. Exposure: ISO 200, f/11, 1/50 second.

When you shoot with a normal lens, keep these lens characteristics in mind:

► **Natural angle of view.** On the T2i/550D, a 28 or 35mm lens closely replicates the sense of distance and perspective of the human eye. This means the final image will look much as you remember seeing it when you made the picture.

► **Little distortion.** Given the natural angle of view, the 28-35mm lens retains a normal sense of distance, especially when you balance the subject distance, perspective, and aperture.

Using macro lenses

Macro lenses are designed to provide a closer lens-to-subject focusing distance than non-macro lenses. Depending on the lens, the magnification ranges from half life-size (0.5X) to 5X magnification. Thus, objects as small as a penny or a postage stamp can fill the frame, while nature macro shots can reveal breathtaking details that are commonly overlooked. Using extension tubes can further reduce the closest focusing distance.

Normal and telephoto lenses offer macro capability. Because these lenses can be used both at their normal focal length as well as for macro photography, they do double duty. Macro lenses offer one-half or life-size magnification or up to 5X magnification with the MP-E 65mm f/2.8 1-5 Macro Photo lens.

8.8 Canon offers several macro lenses including the EF 180mm f/3.5L Macro USM (left) that offers 1X (life-size) magnification and a minimum focusing distance of 0.48m/1.6 ft. Also shown here is the older Canon EF 100mm f/2.8 Macro USM lens. Canon updated the 100mm Macro, and I highly recommend the new version of this macro lens.

If you're buying a macro lens, you can choose lenses by focal length or by magnification. If you want to photograph moving subjects such as insects, choose a telephoto lens with macro capability. Moving subjects require special techniques and much practice.

Using tilt-and-shift lenses

Tilt-and-shift lenses, referred to as *TS-E lenses*, allow you to alter the angle of the plane of focus between the lens and sensor plane to provide a broad depth of field even at wide apertures and to correct or alter perspective at almost any angle. This allows you to correct perspective distortion and control focusing range.

Tilt movements allow you to bring an entire scene into focus even at maximum apertures. By tilting the lens barrel, you can adjust the lens so that the plane of focus is uniform on the focal plane, thus changing the normally per-

8.9 The EF 100mm f/2.85L Macro USM lens not only delivers stunning macro images, but it is also a fine "walk-around" lens for the type of shooting that I do. Here I used it to capture this ram shot. Exposure: ISO 200, f/4, 1/160 second using a -1/3-stop of Exposure Compensation.

pendicular relationship between the lens's optical axis and the camera's focal plane. Alternatively, reversing the tilt has the opposite effect of greatly reducing the range of focusing.

Shift movements avoid the trapezoidal effect that results from using wide-angle lenses pointed up to take a picture of a building, for example. Keeping the camera so that the focal plane is parallel to the surface of a wall and then shifting the TS-E lens to raise the lens results in an image with the perpendicular lines of the structure being rendered perpendicular and with the structure being rendered with a rectangular appearance.

TS-E lenses revolve within a range of plus/minus 90 degrees making horizontal shift possible, which is useful in shooting a series of panoramic images. You can also use

shifting to prevent having reflections of the camera or yourself in images that include reflective surfaces, such as windows, car surfaces, and other similar surfaces.

All of Canon's TS-E lenses are manual focus only. These lenses, depending on the focal length, are excellent for architectural, interior, merchandise, nature, and food photography.

Using Image Stabilized lenses

For anyone who has thrown away a stack of images blurred from handholding the camera at slow shutter speeds, the idea of Image Stabilization is a welcome one. Image Stabilization (IS) counteracts some or all of the motion blur from handholding the camera and lens. If you've shopped for lenses lately, then you know that IS comes at a premium price. IS lenses are pricey because they give you from 1 to 4 f-stops of additional stability over non-Image Stabilized lenses — and that means that you may be able to leave the tripod at home.

With an IS lens, miniature sensors and a high-speed microcomputer built into the lens analyze vibrations and apply correction via a stabilizing lens group that shifts the image parallel to the focal plane to cancel camera shake. The lens detects camera motion via two gyro sensors — one for yaw and one for pitch. The sensors detect the angle and speed of shake. Then the lens shifts the IS lens group to suit the degree of shake to steady the light rays reaching the focal plane.

Stabilization is particularly important with long lenses, where the effect of shake increases as the focal length increases. As a result, the correction needed to cancel camera shake increases proportionately.

To see how the increased stability pays off, consider that the rule of thumb for hand-holding the camera and a non-IS lens is 1/[focal length]. For example, the slowest shutter speed at which you can handhold a 200mm lens and avoid motion blur is 1/200 second. If the handholding limit is pushed, then shake from handholding the camera bends light rays coming from the subject into the lens relative to the optical axis, and the result is a blurry image.

Thus, if you're shooting in low light at a music concert or a school play, the chances of getting sharp images at 200mm are low because the light is too low to allow a 1/200 second shutter speed even at the maximum aperture of the lens. You can, of course, increase the ISO sensitivity setting and risk introducing digital noise into the images. But if you're using an IS lens, the extra stops of stability help minimize ISO increases to get better image quality, and you still have a good chance of getting sharp images by handholding the camera and lens.

8.10 This 70-200mm f/2.8L IS USM lens offers Image Stabilization in two modes: one for stationary subjects and the second for panning with subjects horizontally.

But what about when you want to pan or move the camera with the motion of a subject? Predictably, IS detects panning as camera shake and the stabilization then interferes with framing the subject. To correct this, Canon offers two modes on IS lenses. Mode 1 is designed for stationary subjects. Mode 2 shuts off Image Stabilization in the direction of movement when the lens detects large movements for a preset amount of time. So when panning horizontally, horizontal IS stops but vertical IS continues to correct any vertical shake during the panning movement.

Setting Lens Peripheral Correction

Depending on the lens that you use on the T2i/550D, you may notice a bit of *light fall-off* and darkening in the four corners of the frame. Light falloff describes the effect of less light reaching the corners of the frame as compared to the center of the frame. The darkening effect at the frame corners is known as *vignetting*. Vignetting is most likely to be evident in images when you shoot with wide-angle lenses, when you shoot at a lens's maximum aperture or when an obstruction such as the lens barrel rim or a filter reduces light reaching the frame corners.

On the T2i/550D, you can correct vignetting for JPEG shooting. If you shoot RAW images, you can correct vignetting in Canon's Digital Photo Professional program during RAW image conversion. When you turn on Peripheral Illumination Correction, the camera detects the lens that you have mounted, and it applies the appropriate correction level. The T2i/550D has correction information for 25 lenses, but you can add information for other lenses by using the EOS Utility software supplied on the EOS Solutions Disk.

You can test your lenses for vignetting by photographing an evenly lit white subject such as a white paper background or wall at the lens's maximum aperture and at a moderate aperture such as f/8 and examine the images for dark corners. Then you can enable Peripheral Illumination Correction on the camera and repeat the images to see how much difference it makes.

8.11 This image was made with the EF 24-70mm f/2.8L USM lens, and the image shows darkening at all four corners, or vignetting. Exposure: ISO 100, f/2.8, 1/60 second.

NOTE In the strictest sense, vignetting is considered to be unwanted effects in images. However, vignetting is also a creative effect that photographers sometimes intentionally add to an image during editing to bring the viewer's eye inward toward the subject.

If you use Peripheral Illumination Correction for JPEG images, the amount of correction applied is just shy of the maximum amount. If you shoot RAW images, you can, however, apply the maximum correction in Digital Photo Professional. Also, the amount of correction for JPEG images decreases as the ISO sensitivity setting increases. If the lens has little vignetting, the difference in using Peripheral Illumination Correction may be difficult to detect. If the lens does not communicate distance information to the camera, then less correction is applied. Canon recommends that you turn off correction if you use a non-Canon lens even if the camera can recognize the lens.

Here is how to turn on Peripheral Illumination Correction:

1. **Press the Menu button, and then turn the Main dial to high-light the Shooting 1 menu.**

2. **Press the down or up cross key to highlight Peripheral illumin. correct., and then press the Set button.** The Peripheral illumin. Correct. screen appears with the attached lens listed, and whether or not correction data is available. If correction data is unavailable, then you can register correction data using the Canon EOS Utility program.

3. **If Enable is not already selected, press the up cross key to select Enable, and then press the Set button.**

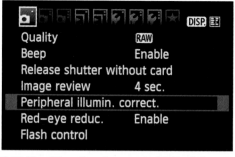

8.12 The Shooting 1 menu with Peripheral illumination correction selected

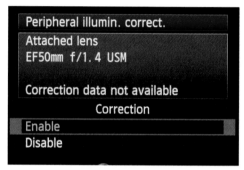

8.13 The Peripheral illumination correction screen

Doing More with Lens Accessories

There are a variety of ways to increase the focal range and decrease the focusing dis-tance to provide flexibility for the lenses you already own. These accessories are not only economical, but they extend the range and creative options of existing and new lenses. Accessories can be as simple as a lens hood to avoid flare, a tripod mount to quickly change between vertical and horizontal positions without changing the optical axis or the geometrical center of the lens, or a drop-in or adapter-type gelatin filter holder. Other options include using extension tubes, extenders, and close-up lenses.

Lens extenders

For relatively little cost, you can increase the focal length of any lens by using an extender. An *extender* is a small ring mounted between the camera body and a regu-lar lens. Canon offers two extenders, a 1.4X and 2X, that are compatible only with

L-series Canon lenses. Extenders can also be combined for even greater magnification. If you are using Peripheral Illumination Correction, the correction is applied even when using an extender.

For example, using the Canon EF 2x II extender with a 600mm lens doubles the lens's focal length to 1200mm before applying 1.6X. Using the Canon EF 1.4x II extender increases a 600mm lens to 840mm.

However, extenders reduce the light reaching the sensor. The EF 1.4x II extender decreases the light by 1 f-stop, and the EF 2x II extender decreases the light by 2 f-stops. In addition to being lightweight, the obvious advantage of extenders is that they can reduce the number of telephoto lenses you carry.

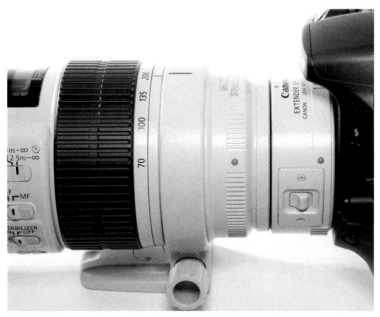

8.14 The image shows the Canon EF 1.4x II extender mounted between the camera body and the lens.

The EF 1.4x II extender can be used with fixed focal-length lenses 135mm and longer (except the 135mm f/2.8 Softfocus lens) and the 70-200mm f/2.8L, 70-200mm f/2.8L IS, 70-200mm f/4.0L, 70-200mm f/4.0L IS USM, and 100-400mm f/4.5-5.6L IS zoom lenses. With the EF 2x II, autofocus is possible if the lens has an f/2.8 or faster maximum aperture and compatible IS lenses continue to provide stabilization for two shutter speeds less than 1/focal length in seconds.

Extension tubes

Extension tubes are close-up accessories that provide magnification increases from approximately 0.3 to 0.7, and they can be used on many EF lenses, though there are exceptions. Extension tubes are placed between the camera body and lens and connect to the camera via eight electronic contact points. Extension tubes can be combined for greater magnification.

Canon offers two extension tubes, the E 12 II and the EF 25 II. Magnification differs by lens, but with the E 12 II and standard zoom lenses, it is approximately 0.3 to 0.5. With the EF25 II, magnification is 0.7. When combining tubes, you may need to focus manually. Extension tubes are compatible with specific lenses. Be sure to check the Canon Web site for lenses that are compatible with extension tubes.

Evaluating Bokeh Characteristics

The quality of the out-of-focus area in a wide-aperture image is called *bokeh*, originally from the Japanese word *boke*, pronounced bo-keh, which means fuzzy. In photography, bokeh reflects the shape and number of diaphragm blades in the lens, and that determines, in part, the way that out-of-focus points of light are rendered in the image. Bokeh is also a result of spherical aberration that affects how the light is collected.

Although subject to controversy, photographers often judge bokeh as being either good or bad. Good bokeh renders the out-of-focus areas as smooth, uniform, and generally circular shapes with nicely blurred edges. Bad bokeh, on the other hand, renders out-of-focus areas with polygonal shapes, hard edges, and with illumination that creates a brighter area at the outside of the disc shape. Also, if the disc has sharper edges, then either points of light or lines in the background become more distinct when, in fact, they are better rendered blurred. Bokeh is also affected by the number of blades used in the lens's diaphragm. Generally lens diaphragms are comprised of five, eight, or nine blades. A five-blade design renders the point of light as a pentagon while an eight-blade diaphragm renders it as an octagon. You can check the specifications for the lens you're considering to find out how many blades are used, but generally, the more blades, the more visually appealing the bokeh.

Ken Rockwell provides an article on bokeh with examples at www.kenrockwell.com/tech/bokeh.htm.

The Elements of Exposure and Composition

If you haven't used a digital SLR before, then the options for controlling exposure on the T2i/550D may seem foreign to you, and knowing when to use them to get specific results may seem mystifying and overwhelming. But once you know how the elements of exposure work together, the camera will make much more sense. In this chapter, you learn how aperture (f-stop), shutter speed, and ISO affect your images, as well as how they work together. And if you are returning to photography after time away, the information in this chapter serves as a refresher on the elements of exposure. In addition to introducing photographic exposure elements, this chapter includes an overview of composition guidelines and tips.

Both strong color and lines dominate this composition of a floatplane waiting for repairs. Exposure: ISO 200, f/11, 1/200 second using -1/3-stop of Exposure Compensation.

The Four Elements of Exposure

Making a picture begins with your creative eye and personal expression. The unique way that you see a subject or scene is the first step in making engaging and unique pictures. Then you use the camera to help you express how you see the scene or subject. While creativity is first and foremost in making images, there is also an essential technical aspect that enables you to use the camera effectively to express your vision.

While the technical aspects may not seem as exciting as the creative aspects of picture making, the more you understand what goes into making a photographic exposure, the more creative control you'll have. And creative control moves you out of the realm of getting a few "happy-but-accidental" images and into the realm of building a portfolio of "beautiful-and-intentional" images. A solid understanding of exposure also prepares you when you need to find creative workarounds for challenging lighting, scenes, subjects, or limitations of the camera itself.

Photographic exposure is a precise combination of four elements:

▶ **Light.** The starting point of exposure is the amount of light that is in the scene. Before making any image, the Rebel T2i/550D first measures, or meters, the amount of light in the scene, and only then can it calculate its suggested exposure settings. Your range of creative control with the Rebel T2i/550D is often determined by the amount of light you have to work with or the amount of light that you can add using a flash or other lights.

▶ **Sensitivity.** Sensitivity refers to the amount of light that the camera's image sensor needs to make an exposure or to the sensor's sensitivity to light. Sensitivity is controlled by the ISO setting. At high ISO settings, the camera needs less light to make an image than it does at low ISO settings.

▶ **Intensity.** Intensity refers to the strength or amount of light that reaches the image sensor. Intensity is controlled by the aperture, or f-stop. The aperture controls the lens diaphragm, an adjustable opening within the lens that opens or closes to allow more or less light into the camera.

▶ **Time.** Time refers to the length of time that light is allowed to reach the sensor. Time is controlled by setting the shutter speed, which determines how long the camera's shutter stays open to let light reach the sensor.

This language may sound unfamiliar, so it may be easier to think of exposure as filling the image sensor with light just as you would fill a glass with water. The goal is to fill the glass with the perfect amount of water, just as you want to fill the image sensor with just the right amount of light to get a good exposure.

In photography, you start with the amount of light that's in the scene and use that amount to determine the correct exposure. In the water glass analogy, that equates to the level to which you want to fill the glass with water. Then you have several choices. You can use a strong or weak stream of water, analogous to a large or a small aperture or f-stop. Then you can choose how long the water flows into the glass, analogous to setting the shutter speed. Finally, you can choose the size of the glass to fill. The size of the glass represents the ISO, or the sensitivity of the sensor. A small glass fills faster than a large glass just as a high ISO requires less light than a low ISO.

So starting with the goal of reaching the perfect level of water (the perfect amount of light reaching the sensor), you can choose to use fast or slow water flow (aperture), and you can let the water run a long or a short time (shutter speed) depending on the size of the glass (the ISO). And there are many combinations of these variables that will all result in getting just the right amount of water into the size glass that you're filling.

The following sections look at each exposure element in more detail. As you read, know that every exposure element is related to the other elements. If one exposure element changes, one or all of the other elements must also change proportionally.

Light

The first element in any image is the light that you have to make the picture. And that's the first thing the camera looks at — it first measures (meters) the light in the scene using the onboard light meter. Every time that you half-press the Shutter button, the camera measures the light.

 The Rebel uses a reflective light meter that measures the amount of light that is reflected from the subject back to the camera.

The light meter reading is biased toward the active autofocus (AF) point. The active AF point tells the camera where the subject is so that the camera can evaluate the subject light relative to the rest of the light in the scene. The camera factors in the current ISO setting, and then calculates how much light (determined by the aperture) is needed and for how long (determined by the shutter speed setting) to make a good exposure. Then the camera gives you its "recommended" exposure.

Once the exposure settings are calculated, the T2i/550D then applies the aperture, shutter speed, and the ISO automatically in the Basic Zone modes such as Portrait, Landscape, Sports, and so on. But in the semiautomatic shooting modes such as Tv and Av, you can influence the exposure by setting the shutter speed in Tv shooting mode, or the aperture in Av shooting mode. When you do that, then the camera takes

your aperture or shutter speed into account and calculates the aperture in Tv mode, or the shutter speed in Av mode based on the ISO that you've set.

Sensitivity: The role of ISO

In broad terms, the ISO setting determines how sensitive the image sensor is to light. ISO settings work this way: The higher the ISO number, the less light that's needed to make a picture; and the lower the ISO number, the more light that's needed to make a picture. In the analogy of filling a glass with water, the size of the glass corresponds to the ISO. If the glass is small (more sensitive to light), less water is needed, and vice versa.

In practical terms, high ISO settings such as ISO 800 to 1600 give you faster shutter speeds. That's important to know because if you're handholding the camera, slow shutter speeds in low light in the scenes result in blurry pictures caused by the slight shake of your hands. Fast shutter speeds in low light increase the chance that you can handhold the camera and get a sharp image. On the other hand, in bright to moderately bright scenes, low ISO settings from 100 to 400 provide fast shutter speeds because there is enough light in the scene that the camera can give you a fast enough shutter speed to handhold the camera and get a sharp image.

Each higher ISO setting is twice as sensitive to light as the previous setting. For example, ISO 800 is twice as sensitive to light as ISO 400. As a result, the sensor needs half as much light to make an exposure at ISO 800 as it does at ISO 400 and vice versa.

In P, Tv, Av, M, and A-DEP shooting modes, the ISO sequence encompasses Auto (ISO 100 to 6400, which is set automatically by the camera although you can set an upper limit) and ISO 100, 200, 400, 800, 1600, 3200, and 6400. The ISO can also be expanded to include ISO 12800 using Custom Function (C.Fn) I-2. In the automated Basic Zone modes, the T2i/550D automatically sets the ISO between 100 and 3200, depending on the light.

But ISO does more than affect the amount of light that's needed to make a good exposure. ISO also impacts the overall image quality in several areas, including sharpness, color saturation, contrast, and digital noise or lack thereof.

The area of digital noise merits further discussion. When you increase the ISO setting on a digital camera, it amplifies the output of the sensor so that less light is needed, but it also amplifies digital noise. This amplification is much like hiss or static in an audio

system that becomes more audible as the volume increases. In images, digital noise is comprised of luminance and chroma noise. Luminance noise is similar to film grain. Chroma noise appears as mottled color variations and as colorful pixels that are particularly evident in the shadow areas of the image.

Regardless of the type, digital noise degrades overall image quality by overpowering fine detail, reducing sharpness and color saturation, and giving the image a mottled look. The conditions that trigger digital noise include high ISO settings, long exposures, underexposure, and high ambient temperatures, such as from leaving the camera in a hot car or in the hot sun. In general then, the hotter the sensor gets, the more digital noise appears in images.

The tolerance for digital noise is subjective and varies by photographer. As an exercise, shoot the same scene or

9.1 This image was taken using ISO 800, and the digital noise isn't apparent until the image is viewed at 100 percent in an image-editing program. Exposure: ISO 800, f/2.8, 1/400 second.

subject at ISO 100 and at ISO 6400. Then view both images at 100 percent on your computer monitor. Scroll to the same shadow area in both images and compare the two images. You can see much more visible noise in the high-ISO image. This helps you know what to expect in terms of digital noise at each ISO setting. Then you can determine how high an ISO you want to use especially in low-light scenes.

In situations where you must use a high ISO setting, you can use Custom Function (C.Fn) II-5: High ISO speed noise reduction to minimize digital noise. With this Custom Function, you can choose one of three levels from low to strong. The higher levels of noise reduction can reduce the fine detail in images, so you may want to test each level at high ISO settings to see which works best for your photography. You can also use C.Fn II-4: Long exposure noise reduction) to reduce digital noise in exposures of 1 second or longer. This option slows down shooting, but it is very effective in reducing the level of noise in the image.

9.2 This detail of figure 9.1 shows the grainy appearance from digital noise in the shadow areas as well as a mottled appearance from using color noise reduction during RAW image processing.

CROSS REF

See Chapter 4 for details on setting Custom Functions.

Reducing Digital Noise

If you are unfamiliar with digital noise, zoom the image to 100 percent on the computer, and then look for flecks of color in the shadow and midtone areas that don't match the other pixels. Also look for an overall rough or bumpy appearance that is similar to film grain.

If you detect objectionable levels of digital noise, you can use noise-reduction programs such as Noise Ninja (www.picturecode.com), Neat Image (www.neati-mage.com), or NIK Dfine (www.niksoftware.com) to reduce it. Typically, noise reduction softens fine detail in the image, but these programs minimize the softening. If you shoot RAW images, programs including Canon's Digital Photo Professional and Adobe Camera Raw offer noise reduction options that you can apply during RAW conversion.

Intensity: The role of aperture

The lens aperture (the size of the lens diaphragm opening) determines the intensity of light — either a lot or a little — that reaches the image sensor. Going back to the water glass analogy, aperture represents the strength or size of the water flow. A strong flow, or a large aperture (f-stop) fills the glass (the image sensor) faster than a weak stream of water.

Aperture is indicated as f-stop numbers, such as f/2.8, f/4.0, f/5.6, f/8, and so on. Small aperture numbers such as f/5.6, f/4, f/2.8 correspond to a strong water flow. Large aperture numbers such as f/8, f/11, f/16 and so on correspond to a weak water flow.

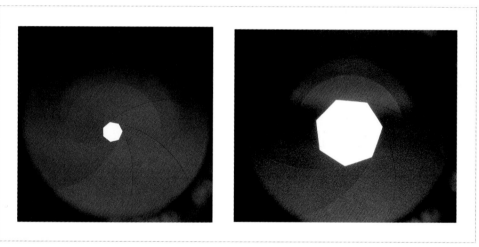

9.3 The left image shows the lens diaphragm at f/22, the smallest or "minimum" aperture for this lens. The right image shows the lens opened up to f/5.6. On a lens that has a maximum aperture of f/2.8, the diaphragm opens completely letting in the maximum amount of light.

When you increase or decrease the aperture by a full f-stop, it doubles or halves the exposure, respectively. For example, f/5.6 provides twice as much light as f/8 provides, while f/5.6 provides half as much light as f/4.0.

NOTE The apertures that you can choose depend on the lens that you're using. And with a variable aperture lens such as the Canon EF-S 18-55mm f/4.5-5.6 lens, the maximum aperture of f/4.5 can be used when the lens is zoomed to 18mm and f/5.6 can be used when the lens is zoomed to 55mm.

Wide aperture

Smaller f-stop numbers, such as f/5.6, f/4, f/3.5, and f/2.8, set the lens diaphragm to a large opening that lets more light reach the sensor. A large lens opening is referred to as a wide aperture. Based on the ISO and in moderate light, a wide aperture (a large diaphragm opening) such as f/5.6 delivers sufficient light to the sensor so that the amount of time that the shutter has to stay open to make the exposure decreases. Thus you get a faster shutter speed than you would by using a narrow aperture of f/8 or f/11. In very general terms, this means that wide apertures of f/5.6 to f/1.2 enable you to shoot in lower-light scenes with a reasonably fast shutter speed (depending on the existing light and the ISO setting). And that combination helps you get sharp handheld images in lower light.

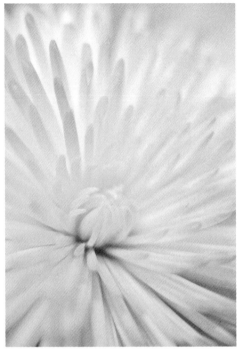

9.4 In this image, a wide f/2.8 combined with a close shooting distance blurred the background, and renders only the center of the flower in sharp focus. Exposure: ISO 100, f/2.8, 1/40 second using a +1 1/3-stop of Exposure Compensation.

Narrow aperture

Larger f-stop numbers, such as f/8, f/11, f/16, and narrower, set the lens diaphragm to a small opening that allows less light to reach the sensor. A small lens opening is referred to as a narrow aperture. Based on the ISO and in moderate light, a small diaphragm opening such as f/11 delivers less light to the sensor — or fills the glass slower — so the amount of time that the shutter has to stay open increases resulting in a slower shutter speed. Because narrow apertures of f/8 to f/32 require longer shutter speeds, you need lots of light to shoot with narrow apertures, or you need to use a tripod and have a scene or subject that remains stock still.

Choosing an aperture

In everyday shooting, photographers most often select an aperture based on how they want background and foreground to look — either showing acceptably sharp detail or with blurred detail. This is called controlling the depth of field, discussed next. But you may also need to choose a specific aperture for practical or creative reasons.

For example, if the light is low and you want to avoid blur from camera shake, then choosing a wide aperture (smaller f-number) provides faster shutter speeds. Or if you want to use selective focus, where only a small part of the image is in sharp focus, choose a wide aperture. But if you're shooting a group of people or a landscape, then choose a narrow aperture to render sharper detail throughout the entire frame.

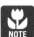 Aperture also plays a starring role in the depth of field of images. Depth of field is detailed later in this chapter.

9.5 In this image, I used a narrow aperture of f/22 to get as much sharp detail as possible throughout the strawberries. Exposure: ISO 1200, f/22, 1/125 second.

You can control the aperture by switching to Av or M shooting mode. In Av shooting mode, you set the aperture, and the camera automatically sets the correct shutter speed based on the selected ISO. In M shooting mode, you set both the aperture and the shutter speed based on the reading from the camera's light meter. The Exposure Level Indicator is displayed in the viewfinder as a scale and it indicates over-, under-, and correct exposure based on the aperture, shutter speed, and ISO.

You can use P mode to make one-time changes to the aperture and shutter speed from the camera's recommended exposure. Unlike Av mode where the aperture you choose remains in effect until you change it, in P mode, changing the aperture is temporary. After you take the picture, the camera reverts to its suggested aperture and shutter speed.

 You can learn more about shooting modes in Chapter 2.

What is depth of field?

Depth of field is the zone of acceptably sharp focus in front of and behind a subject. In simple terms, depth of field determines if the foreground and background are rendered as a soft blur or with distinct detail. Depth of field generally extends one-third in front of the plane of sharp focus and two-thirds behind it. Aperture is the main factor that controls depth of field, although camera-to-subject distance and focal length affect it as well.

Depth of field is both a practical matter — based on the light that's available in the scene to make the picture — and a creative choice to control the rendering of background and foreground elements in the image. For example, if you are shooting at a music concert and you've set the ISO where you want it, you might creatively prefer to shoot using f/8 so that the mid-stage props are in acceptably sharp focus. But on the practical level, you might glance at the shutter speed at f/8 and quickly decide that you need to use a wide aperture to get as fast a shutter speed as possible. A goodly number of scenes involve practical and creative trade-offs, and the more you know about exposure, the better prepared you are to make judicious decisions.

Shallow depth of field

Images where the background is a soft blur and the subject is in sharp focus have a shallow depth of field. As a creative tool, shallow depth of field is typically preferred for portraits, some still-life images, and food photography. As a practical tool, choosing a wide aperture that creates a shallow depth of field is necessary when shooting in low light. To create a shallow depth of field, choose a wide aperture ranging from f/5.6 to f/1.2 depending on the lens. The subject will be sharp, while the background and foreground will be soft and not distracting. Lenses also factor into depth of field, with a telephoto lens offering a shallower depth of field than a normal or wide-angle lens.

Extensive depth of field

Extensive depth of field maintains acceptably sharp focus in front of and behind the plane of sharpest focus. Extensive depth of field is preferred for images of landscapes, large groups of people, architecture, and interiors. When you want an image with extensive depth of field, choose a narrow aperture, such as f/8 or f/11, f/16, f/22 or smaller.

Once again, you may have to make creative and practical trade-offs when your goal is to create an extensive depth of field. Narrow apertures require a lot of light because

the lens diaphragm opening is very small. This is analogous to using a weak water stream to fill the water glass. And in photography, narrow apertures require longer shutter speeds than wide apertures at the same ISO.

Other factors affecting depth of field

While aperture is a key factor in determining the depth of field — the range of acceptably sharp focus in a picture — other factors also affect depth of field:

▶ **Camera-to-subject distance.** At any aperture, the farther you are from a subject, the greater the depth of field is and vice versa. Additionally, the farther the subject is from the background the shallower the depth of field.

▶ **Focal length.** Focal length, or angle of view, is how much of a scene the lens "sees." From the same shooting position, a wide-angle lens produces more extensive depth of field than a telephoto lens.

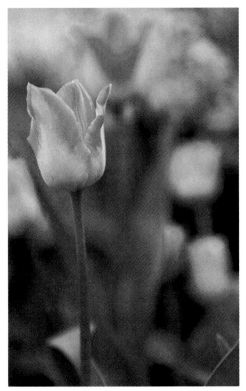

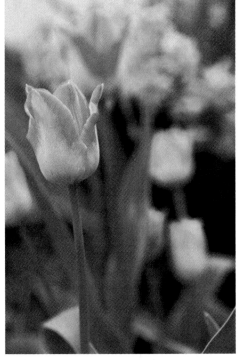

9.7 Changing the aperture to f/4.5, a modest change, shows noticeably more detail in the background than is seen in figure 9.6. Exposure: ISO 100, f/4.5, 1/125 second.

9.6 In this image, a wide aperture of f/2.8 provided a shallow depth of field blurring the background flowers and fence. Exposure: ISO 100, f/2.8, 1/320 second.

For more information on lenses, see Chapter 8.

Time: The role of shutter speed

Shutter speed controls how long the shutter stays open to let light from the lens strike the image sensor. The longer the shutter, or curtain, stays open, the more light reaches the sensor (at the aperture and ISO that you've set). In the water glass example, the amount of time that you let the water flow into the glass is analogous to shutter speed.

When you increase or decrease the shutter speed by one full setting, it doubles or halves the exposure. For example, twice as much light reaches the image sensor at 1/30 second as at 1/60 second. Shutter speed is also related to:

▶ The ability to handhold the camera and get sharp images, particularly in low light. The general rule for handholding a non-image stabilized lens is that you need a minimum shutter speed that is the reciprocal of the focal length, or 1 over the focal length. For example, if you're shooting at 200mm, then the slowest shutter speed at which you can handhold the lens and get a sharp image is 1/200 second.

▶ The ability to freeze motion or show it as blurred in a picture. For example, you can set a fast shutter speed to show a basketball player's jump in midair with no blur. As a general rule, set the

9.8 A fast shutter speed stopped the motion of the wine pouring into the glass and the bubble inside the glass. Exposure: ISO 200, f/9, 1/100 second using a +2/3-stop Exposure Compensation.

shutter speed to 1/125 second or faster to stop motion. Or set a slow shutter speed to show the motion of water cascading over a waterfall as a silky blur. To show motion as a blur, use a 1/30 second or slower shutter speed and use a tripod.

You can control the shutter speed in Tv or M shooting mode. In Tv shooting mode, you set the shutter speed, and the camera automatically sets the correct aperture. In M shooting mode, you set both the shutter speed and the aperture based on the reading from the camera's light meter and the ISO. The light meter is displayed in the viewfinder as a scale — the Exposure Level Indicator — and it shows over-, under-, and correct exposure based on the shutter speed, aperture, and ISO.

Equivalent Exposures

As you have seen, after the camera meters the light and factors in the selected ISO, the two remaining factors determine the exposure — the aperture and the shutter speed. And just as with filling the glass with water, you can fill it slowly over a longer time, quickly, or any variation between.

Likewise, many combinations of aperture (f-stop) and shutter speed produce exactly the same exposure given the same ISO setting. For example, f/22 at 1/4 second is equivalent to f/16 at 1/8 second, as is f/11 at 1/15, f/8 at 1/30, and so on. And this is based on the doubling and halving effect discussed earlier. For example, if you are shooting at f/8 and 1/30 second, and you change the aperture (f-stop) to f/5.6, then you have doubled the amount of light reaching the image sensor, so the time that the shutter stays open must be halved to 1/60 second.

While these exposures are equivalent, the way the image looks and your shooting options change noticeably. An exposure of f/22 at 1/4 second produces extensive depth of field in the image, but the shutter speed is slow, so your ability to handhold the camera and get a sharp image is dubious and a tripod becomes a necessity. But if you switch to an equivalent exposure of f/5.6 at 1/60 second, you are more likely to be able to handhold the camera, but the depth of field will be shallow.

As with all aspects of photography, evaluate the trade-offs as you make changes to the exposure. And again, it all comes back to light. Your creative options for changing the exposure setting are ultimately limited by the amount of light in the scene.

Putting It All Together

ISO, aperture, shutter speed, and the amount of light in a scene are the essential elements of photographic exposure. On a bright, sunny day, you can select from many different f-stops and still get fast shutter speeds to prevent image blur. You have little need to switch to a high ISO for fast shutter speeds at small apertures.

As it begins to get dark, your choice of f-stops becomes limited at ISO 100 or 200. You need to use wide apertures, such as f/4 or wider, to get a fast shutter speed. Otherwise, your images will show some blur from camera shake or subject movement. Switch to ISO 400 or higher, however, and your options increase and you can select narrow apertures, such as f/8 or f/11, for greater depth of field. The higher ISO enables you to shoot at faster shutter speeds to reduce the risk of blurred images, but it also increases the chances of digital noise.

Approaches to Composition

The technical aspects of photography are unquestionably important, and until now, that's been the primary concentration of this book. But technical competence alone doesn't create memorable images. Among the qualities that make images memorable are artful composition and compelling content. I will leave the content of images to your imagination, but I will discuss some widely used approaches to composition.

While composition guidelines will help you design an image, the challenge and the joy of photography is combining your visual, intellectual, and emotional perceptions of a scene from the objective point of view of the camera. Composition guidelines are helpful, but your personal aesthetic is the final judge. After all, for every rule of composition, there are galleries filled with pictures that break the rules and succeed famously.

 As you think about composition, remember that if you're in doubt about how to compose an image, keep it simple. Simple compositions clearly and unambiguously identify the subject, and they are visually easy to read.

Subdividing the photographic frame

One of the first tasks in making a picture is to decide how to divide the photographic frame. Since antiquity, artists, builders, and engineers have looked to nature and mathematics to find ways to portion spaces that create a harmonious balance of the parts to the whole space.

From the fifth century BCE, builders, sculptors, and mathematicians applied what is now known as the Divine Proportion. Euclid, the Greek mathematician, was the first to express the Divine Proportion in mathematical language. The Divine Proportion is expressed as the Greek symbol Phi where Phi is equal to 1/2(1 + square root of 5) = 1.618033989. This proportion divides a line in such a way that the ratio of the whole to the larger part of the line is the same as the larger part is to the smaller part. This proportion produced such pleasing balance and symmetry that it was applied in building

the pyramids of Egypt; the Parthenon in Athens, Greece; and Europe's Gothic cathedrals. The proportion also made its way into art. Over time, harmonious balance was expressed as the Golden Section, or the Golden Rectangle. The 35mm photographic frame, although being slightly deeper and having a ratio of 3:2, is very similar to the Golden Rectangle. The Golden Rectangle provided a map for artists to balance color, movement, and content within the confines of a canvas.

However, unlike painters, photographers don't begin with a blank canvas but with a scene that often presents itself ready-made. Even with a ready-made scene, photographers have a variety of creative guidelines at their disposal to structure the photographic frame. A popular device is the Rule of Thirds. This rule divides the photographic frame into thirds, much like superimposing a tic-tac-toe grid on the frame. To create visually dynamic compositions, place the subject or the point of interest on one of the points of intersection, or along one of the lines on the grid.

The rule is, of course, approximate because not all scenes conform to the grid placement. But the Rule of Thirds provides a good starting point for subdividing the frame and for placing the subject within the subdivisions. For example, if you're taking a portrait, you

9.9 This image, with a Rule of Thirds grid superimposed, places the dog's right eye roughly at the top-left point of intersection. Exposure: ISO 100, f/22, 1/125 second.

might place a subject's eyes at the upper-left intersection point of the grid. In a landscape scene, you can place the horizon along the top or bottom line of the grid depending on what you want to emphasize.

Balance and symmetry

Balance is a sense of "rightness" or harmony in a photo. A balanced photo appears to be neither too heavy (lopsided) nor too off-center. To create balance in a scene, evaluate the visual "weight" of colors and tones (dark is heavier than light), the shape of objects (larger objects appear heavier than smaller objects), and their placement (objects placed toward an edge appear heavier than objects placed at the center of the frame).

The eye seeks balance in an image. Whether it is in tones, colors, or objects, the human eye seeks equal parts, equal weight, and resolved tension. Static balance begins with a single subject in the center of the frame with other elements emanating from the center point to create equal visual weight. Variations on this balance include two identical subjects at equal distances from each other, or several subjects arranged at the center of the frame. Conversely, dynamic balance is created when tones, colors, or weights are asymmetrical, or unequally balanced, creating visual tension.

Because the human eye seeks balance and symmetry, should compositions be perfectly balanced? Perfectly symmetrical compositions create a sense of balance and stability. And while symmetry is a defining charac-

9.10 This image shows balance between the artist and her painting. Exposure: ISO 100, f/4, 1/320 second.

teristic in nature, if all images were perfectly balanced and symmetrical, they would tend to become boring. While the human eye seeks symmetry and balance, once it finds it, the interest in the image quickly diminishes.

In real-world shooting, the choice of creating perfect balance or leaving tension in the composition is your choice. If you choose perfect symmetry, then it must be perfect, for the eye will immediately scan the image and light on any deviation in symmetry. In dynamic balance, the viewer must work to find balance, and that work can be part of the satisfaction in viewing the image.

Tone and color

At the most fundamental level, contrast is the difference between light and dark tones in an image. But in a larger context, contrast includes differences in colors, forms, and shapes, and it is at the heart of composition. In photography, contrast not only defines the subject but also renders the shape, depth, and form of the subject and establishes the mood and the subject's relationship to other elements in the image.

Related to tones are colors used in composition. Depending on how colors are used in a photo, they can create a sense of harmony, or visual contrasts. In very basic terms, colors are either complementary or harmonizing. Complementary colors are opposite each other on a color wheel — for example, green and red, and blue and yellow. Harmonizing colors are adjacent to each other on the color wheel, such as green and yellow, yellow and orange, and so on, and offer no visual conflict.

If you want a picture with strong visual punch, use complementary colors of approximately equal intensity in the composition. If you want a picture that conveys peace and tranquility, use harmonizing colors.

The more that the color of an object contrasts with its surroundings, the more likely it is that the object will become the main point of interest. Conversely, the more uniform the overall color of the image, the more likely that the color will dictate the overall mood of the image.

The type and intensity of light also strongly affect the intensity of colors, and, consequently, the composition. Overcast weather conditions, such as haze, mist, and fog, reduce the vibrancy of colors. These conditions are ideal for creating pictures with harmonizing, subtle colors. Conversely, on a bright, sunny day, color is intensified and is ideal for composing pictures with bold, strong color statements.

While a full discussion of tone and color are beyond the scope of this book, knowing some characteristics of tone and color will help you make decisions about photographic compositions.

▶ The viewer's eye is drawn to the lightest part of an image. If highlights in an image fall somewhere other than on the subject, the highlights will draw the viewer's eye away from the subject.

▶ Overall image brightness sets the mood of the image. In addition, the predominance of tones determines the key. Images with primarily bright tones are said to be *high key*, while images with predominately dark tones are *low key*.

▶ Colors, like tones, advance and recede; they have symbolic, cultural meanings; and they elicit emotional responses from viewers. For example, red advances and is associated with energy, vitality, and strength as well as with passion and danger. Conversely, blue recedes and tends to be dark. It is widely associated with nature and water.

When speaking of color and when working with images in editing programs, keep these definitions in mind. Hue is the color, or the name of the color. For example, blue is a hue. Saturation is the intensity or purity of a hue. Brightness determines if the hue is light or dark.

Lines and direction

Because lines have symbolic significance, you can use them to bolster communication, to direct focus, and to organize visual elements. For example, you can place a subject's arms in ways that direct attention to the face. In an outdoor scene, you can use a gently winding river to guide the viewer's eye through the scene. You can use a strong diagonal beam in an architecture shot to bolster the sense of the building's strength. When planning the composition, keep in mind that images have both real and implied lines. Examples of implied lines include the bend of a leaf or a person's hand. Ideally, lines will also lead the viewer's eye toward the subject, rather than away from it or out of the frame.

Lines traditionally convey these meanings:

9.11 The strong lines in this image lead the viewer's eye through the line of booths and back to the bicycle hanging from the ceiling. Exposure: ISO 400, f/2.8, 1/80 second. Leaving space in the frame can reinforce a sense of direction. For example, leaving space in the direction that the subject is looking or moving provides visual space to look or move into.

▶ Horizontal lines imply stability and peacefulness.

▶ Diagonal lines create strength and dynamic tension.

▶ Vertical lines imply motion and strength.

▶ Curved lines symbolize grace.

▶ Zigzag lines convey a sense of action.

▶ Wavy lines indicate peaceful movement.

▶ Jagged lines create tension.

Fill the frame

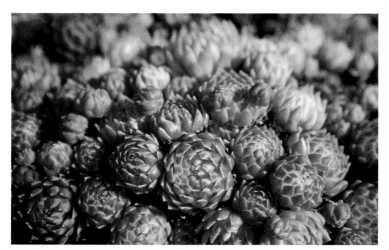

9.12 For this shot, I wanted to fill the frame with the plants while bringing the front plants visually forward in the image. Filling the frame and using a shallow depth of field accomplished the goals. Exposure: ISO 100, f/4.5, 1/125 second.

Just as an artist would not leave part of a canvas blank or filled with extraneous details, you should try to fill the full image frame with the subject and elements that support the subject and the message of the image. Try to include elements that reveal more about the subject.

Create a clean background

In any picture, the elements behind and around the subject become as much a part of the photograph as the subject, and occasionally more so because the lens tends to compress visual elements. As you compose the picture, check all areas in the view-finder or LCD for background and surrounding objects that will, in the final image, seem to merge with the subject, or that compete with or distract from the subject.

A classic example of failing to use this technique is the picture of a person who appears to have a telephone pole or tree growing out of the back of his or her head. To avoid this type of background distraction, you can change your shooting position or, in some cases, move the subject.

Frame the subject

Photographers often borrow techniques from painters — and putting a subject within a naturally occurring frame, such as a window or an archway, is one such technique. The frame may or may not be in focus, but to be most effective, it should add context and visual interest to the image.

Control the focus and depth of field

Sharp focus establishes the relative importance of the elements within the image. And because the human eye is drawn first to the sharpest point in the photo, be sure that the point of sharpest focus is on the part of the subject that you want to emphasize; for example, in a portrait, the point of sharpest focus should be on the subject's eyes.

Differential focusing controls the depth of field, or the zone (or area) of the image that is acceptably sharp. In a nutshell, differential focusing works like this: The longer the focal length (in other words, a telephoto lens or zoom setting) and the wider the aperture (the smaller the f-stop number), the shallower the depth of field is (or the softer the background). Conversely, the shorter the focal length and the narrower the aperture, the greater the depth of field.

You can use this principle to control what the viewer focuses on in a picture. For example, in a picture with a shallow depth of field, the subject stands in sharp focus against a blurred background. The viewer's eyes take in the blurred background, but they return quickly to the much sharper area of the subject. To control depth of field, you can use the techniques in Table 9.1 separately or in combination with each other.

Table 9.1: Depth of Field

To Decrease the Depth of Field (Soften the Background Details)	To Increase the Depth of Field (Sharpen the Background Details)
Choose a telephoto lens or zoom setting	Choose a wide-angle lens or zoom setting
Choose a wide aperture from f/1.4 to f/5.6	Choose a narrow aperture from f/8 to f/22
Move closer to the subject and move the subject farther from the background	Move farther away from the subject

Defining space and perspective

Some ways to control the perception of space in pictures include changing the distance from the camera to the subject, selecting a telephoto or wide-angle lens or zoom setting, changing the position of the light in a studio or changing the subject

position in an outdoor setting, and changing the camera position. For example, camera-to-subject distance creates a sense of perspective and dimension so that when the camera is close to a foreground object, background elements in the image appear smaller and farther apart. A wide-angle lens also makes foreground objects seem proportionally larger than midground and background objects.

While knowing the rules provides a good grounding for well-composed pictures, Henri Cartier-Bresson summed it up best when he said, "Composition must be one of our constant preoccupations, but at the moment of shooting it can stem only from our intuition, for we are out to capture the fugitive moment, and all the interrelationships involved are on the move. In applying the Golden Rule, the only pair of compasses at the photographer's disposal is his own pair of eyes." (From *The Mind's Eye: Writings on Photography and Photographers* by Henri Cartier-Bresson [Aperture, 2005].)

As you can see from this chapter, a combination of technical exposure considerations combined with your creative vision and composition form the foundation for all the images you make. While it seems like a lot to learn, you can approach learning by choosing one aspect of exposure and composition at a time. Practice until you are comfortable with that aspect, and then move to the next aspect.

Event and Action Photography

With a burst rate of 34 JPEG shots, the EOS T2i/550D is capable of keeping up with the action. Combined with continuous focusing, you're positioned to get great action and event shots.

The category of event and action photography covers everything from festivals, corporate gatherings, and weddings to sports and other competitive events such as car and motocross racing. Opportunities abound for one-of-a-kind images that capture the emotion and thrill of the event.

Central to capturing the decisive moments is having a camera that not only responds with quick focusing and a fast response, but also that can record a succession of images during critical moments in the event or peak moments of competitive action.

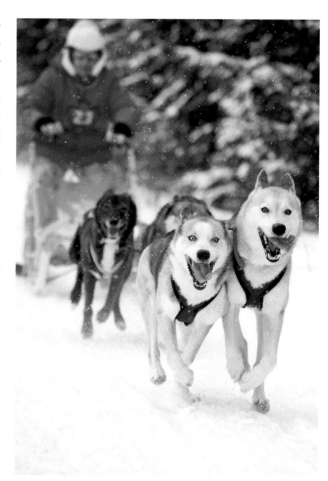

© Peter Burian

An EF 70-200mm f/4L IS USM lens set to 200mm allowed Peter to bring this action in close to the viewer. Exposure: ISO 400, f/5.6, 1/800 second with –1/3-stop of Exposure Compensation.

Setting up for Event and Action Photography

With a generous burst rate and reasonable performance at higher ISO settings, the T2i/550D is especially well-suited for shooting events and action whether that means sports events and races, or concerts, carnivals, festivals, receptions, and parties. And whether you're an advanced photographer, or you're just starting with event photography, the opportunities for both making great images and perhaps earning income from your photography make these areas of photography attractive.

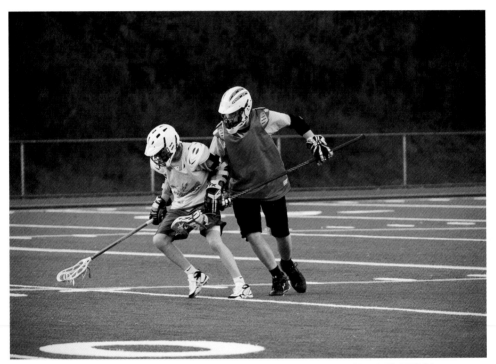

10.1 For these Lacrosse tryouts, I used the Canon EF 70-200mm f/2.8L IS USM lens zoomed to a focal length of 135mm. Exposure: ISO 400, f/3.2, 1/250 second.

Regardless of the subject, the objective is to show the energy and emotion of the event as well as capture the decisive moments, and at 3.7 fps with up to 34 Large/ JPEG shots per burst, the T2i/550D can keep up with the action.

Packing the gear bag

One of the characteristics of event and action shooting is that you have only one opportunity to capture the images. Whether the event is a wedding or athletic competition, if you don't get the shot, there are no do-overs. With that in mind, it is important to have what you need in the gear bag, including backup gear should you need it.

The gear that you pack in the camera bag is directly related to the scene and subjects that you're going to shoot, as well as other factors including your distance from the action, the lighting, weather, length of the event, how much you're willing to carry.

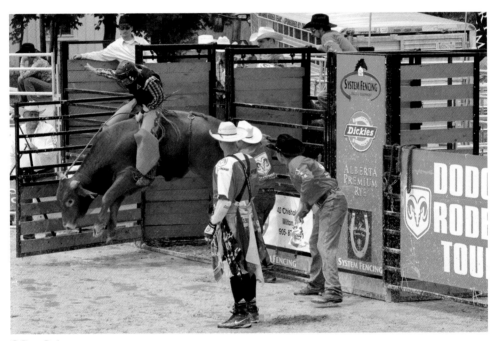

© Peter Burian

10.2 While the goal is to get clean backgrounds for action shots, it isn't always possible. Here Peter kept the signage to a minimum by tightly framing the action coming out of the gate. Exposure: ISO 400, f/8, 1/640 second with a +2/3-stop of Exposure Compensation. Peter used an EF 70-300m f/4.2 USM lens zoomed to 104mm.

As you look at these suggestions, consider them a starting point for your planning:

▶ **The T2i/550D and a backup camera body.** Many events are once in a lifetime situations, so if anything goes wrong with the T2i/550D, you need a backup T2i/550D or other EOS camera body so that you can continue shooting without a hiccup. At the very least, have a point-and-shoot camera such as the Canon PowerShot G11 on hand as backup.

▶ **One or more wide-angle and telephoto zoom lenses.** I've found the 24-70mm f/2.8L USM lens and the 70-200mm f/2.8L IS USM lens to be a versatile combination depending, of course, on the shooting proximity to the players or participants. In good light, you can make good use of the Extender EF 1.4x II or Extender EF 2x II to get more reach with compatible telephoto lenses. (See Chapter 9 for details on which lenses work with extenders.)

Other good telephoto lens choices are the EF 18-200mm f/3.5-5.6 IS USM, or the EF 70-300mm f/4.5-5.6 IS USM lens. For low-light events such as concerts, a fast lens such as the EF 50mm f/1.4 USM will practically shoot in the dark. For outdoor events such as motocross or events where dirt and wind collide, be sure to have lens-cleaning cloths handy as well.

▶ **Monopod or tripod.** If the event continues through sunset and evening hours, then you'll be glad to have the solid support of a tripod. I carry the TrekPod GO that includes fold-out legs to almost all events.

▶ **Spare media cards and charged batteries.** Any event that features action means that you'll take a lot of images. If you have multiple media cards, be sure that you have a system for keeping used cards separate from empty cards. And depending on how many cards you have, consider offloading images to a laptop or handheld storage unit during lulls in the action. Certainly you want a minimum of one or two spare charged batteries, depending on the duration of the event.

▶ **Weatherproof sleeves and camera cover.** If it rains or if you're shooting in fog or mist, having a weatherproof camera jacket and lens sleeve is good insurance against camera damage and malfunctions.

Choosing settings

The more time you spend setting up the camera before you leave for the event, the less time you'll spend futzing with settings when you arrive.

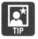 Be sure to arrive at the event early enough to scout out shooting positions and to secure close-in seating, if possible.

Here are some suggestions for camera and Custom Function settings for action and event photography. Modify them as appropriate for your needs.

▶ **RAW+JPEG image quality.** Many photographers shoot events and sell the images to players and family. They post the event images to a Web site where players can order prints. If you do this or are considering doing it, then the RAW+JPEG image quality option comes in handy. The JPEG images enable you

to immediately post images to the Web site while the RAW images give you the option to process exceptional shots for maximum potential or tweak shots that need more attention. Using this option depends on the event you're photographing, of course. Because the burst rate is only 3 shots per second, this option is not an option for shooting fast-moving action.

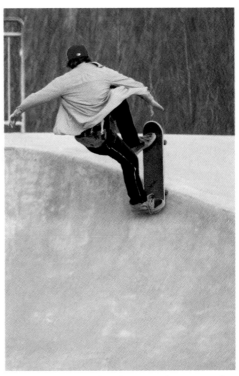

10.3 Action shooting is a good opportunity to capture seemingly impossible positions of athletes. Exposure: ISO 200, f/3.2, 1/400 second using an EF 70-200m f/2.8L IS USM lens.

▶ **Tv shooting mode.** This mode gives you control over the shutter speed so that you can freeze action of the players or participants and get sharp focus. Just remember that for non-IS lenses, the handholding guideline is 1/[focal length]. So for a 300mm lens, you need at least a 1/300 second shutter speed to be able to handhold the camera and lens and get a sharp image. If you can't get a fast enough shutter speed to freeze subject motion or to handhold the camera and lens that you're using, then you can increase the ISO setting.

▶ **AI Servo AF mode and manual or automatic AF-point selection.** AI Servo AF mode is designed for action shooting by tracking subject motion. You can choose the starting AF point for subject focus tracking or let the camera choose it.

Again, depending on the type of event, you can alternately use AI Focus AF that starts out in One-shot AF and automatically switches to AI Servo AF if the subject starts moving, or One-shot AF where you choose the focus with no focus tracking from the camera.

▶ **High-speed Continuous drive mode.** High-speed continuous shooting (3.7 fps) allows a succession of shots up to 34 Large Fine JPEGs. When the internal camera buffer is full, you will be able to continue shooting as images are offloaded to the media card. Also, if you see FuLL CF in the viewfinder, wait until the red

access lamp goes out to replace the card. The camera displays a warning if you open the media card door while images are being recorded.

 If your T2i/550D burst rate seems to be too slow, check to see if you have enabled C.Fn II-5, High ISO speed noise reduction, which can reduce the burst rate depending on the option chosen.

▶ **Evaluative metering mode.** With the T2i/550D's improved metering linked to the AF points, Evaluative metering performs well in a variety of different lighting situations.

▶ **Picture Style.** The Standard Picture Style is a good choice, particularly if you've previously tested it and examined the prints.

▶ **Custom Functions.** For action and events, consider using C.Fn I-1, Exposure level increments, and choosing Option 1: 1/2-stop. This enables larger ISO changes instead of the default 1/3 stop increment. You can consider enabling ISO expansion, C.Fn I-2, but you should test the H (12800) setting for digital noise level before using it.

Taking Event and Action Images

The T2i/550D offers versatility in shooting a broad range of events and games with a seriously fast shutter action and excellent burst depth. Couple that with shutter speeds ranging from 1/4000 to 30 seconds (and Bulb), and you have ample opportunity to freeze or show motion, and to create interesting panned images. Action photography and the techniques used for it are by no means limited to sports. Any event — from a football game to a carnival or concert — is an opportunity to use action-shooting techniques.

Add a Sense of Motion with Panning

If you've wondered how photographers capture images where the subject is in focus but the background details appear as colorful streaks, wonder no more. The technique they use is called panning, and it involves focusing on the subject, and then moving the camera with the motion of the subject while using a slow shutter speed. Here is how the technique works:

1. **Find a shooting location where the background will be attractive when it is rendered as long streaks of color.**

2. **Set the T2i/550D to Tv mode, and set a shutter speed that is slow enough to allow you to record movement with the camera.** I typically use shutter speeds slower of 1/30 sec. or slower. Sometimes 1/30 sec. is not long enough to get good follow through motion with the camera while the shutter is open. I usually set 1/25 to 1/8 sec.

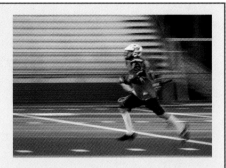

3. **When the subject enters the frame, move the camera to start following the subject's motion and when the subject hits the spot where you pre-focused, press the Shutter button completely to make the picture** *and* **continue moving the camera with the subject as the subject leaves the scene.**

This technique is much easier to accomplish if you are using a tripod. The tripod keeps the scene level and frees you to concentrate on a smooth panning motion. But it's also possible to pan while you are handholding the camera.

A classic action approach is to show the motion of the athlete or participant in mid-whatever — midjump, midrun, middrop — with tack-sharp focus and no motion blur. Stopping action requires fast shutter speeds and fast shutter speeds require ample light, or an increased ISO sensitivity setting. The shutter speed that you need to stop motion depends on the subject's direction in relation to the camera. Table 10.1 provides some common action situations and the shutter speeds needed to stop motion and to pan with the motion of the subject.

Table. 10.1: Recommended Shutter Speeds for Action Shooting

Subject direction in relation to camera	Shutter speeds in seconds
Subject is moving toward camera	1/250
Subject is moving side-to-side or up-and-down	1/500 to 1/2000
Panning with the motion of the subject	1/25 to 1/8

Depending on the light and the speed of the lens that you're using, getting a fast shutter speed often means increasing the ISO sensitivity setting. In previous chapters, I recommended shooting test shots at the higher ISO settings, and then evaluating the images for digital noise at 100 percent enlargement on the computer.

You also should print the images and view them at a standard 1-foot viewing distance to evaluate digital noise and at what ISO setting it becomes objectionable. I shoot at the lowest ISO possible to get the shutter speed that I need to stop subject motion. I use ISO 1600 when the light is too low to allow shooting at ISO 800 or 400.

Getting accurate and visually pleasing color is important as well. For outdoor events and games, the preset white balance settings such as Daylight, Cloudy, and so on are excellent.

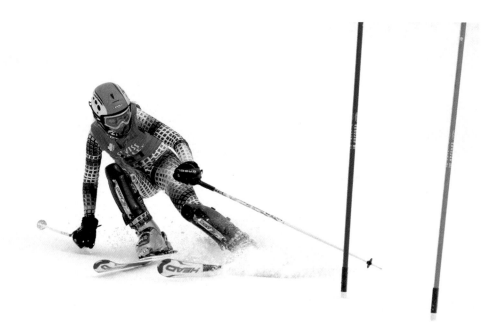

© Peter Burian

10.4 For action shooting, timing the shutter release is everything. Here Peter captured a great spray of snow coming off the skis as the skier approaches the gates. Exposure: ISO 200, f/7.1, 1/1000 second with -1/3 stop Exposure Compensation using an EF 300mm f/4L IS USM lens.

Because I shoot RAW for all but fast action events, I carry a small gray card with me (like the one found at the back of the book) and take a picture of it in the event light. If the light changes, I shoot a new picture of the gray card. Then I open the images taken under the same light as a group with the picture of the gray card in a RAW conversion program. I can select all the images, click the gray card, and color balance the entire image series. Other photographers prefer using the ExpoDisc, a calibrated 18 percent gray lens filter.

While stopping subject motion is what you most often see in event and action images, there are also countless scenes where a slow shutter speed creates a rich display of motion whether it's the blurred lights of a Ferris wheel or the crash of a waterfall where the water is transformed to a silky blur. And the range of subjects is almost limitless. Even everyday occurrences such as a dog coming out of a lake after a swim present opportunities to explore the effect of motion against motion or motion against a still backdrop. The same is true for music concerts, athletic events, and some events during weddings.

10.5 This image of a Ferris wheel in motion was shot with a monopod that I stabilized by wedging it between the back and seat sections of a bench, and then pushing the monopod forward with one hand to stabilize it. Exposure: ISO 400, f/18, 1.6 seconds with -1/3-stop of Exposure Compensation using an EF 24-70mm f/2.8L USM lens.

If you combine a flash with a slow shutter, you open new doors for creative renderings that add the dynamic aspect of motion to event and action images. One technique that

is popular with wedding photography is called *dragging the shutter*, and while it can be used with or without a flash, it's very often used in combination with flash. This technique has several components. First, the flash suspends subject motion for a sharply focused subject; second, a slow shutter speed allows the existing light to fully register during the exposure; and, third, panning the camera creates blur that adds the dynamic sense of motion to the image.

You can set the built-in flash or an accessory Speedlite to second-curtain sync so that the flash fires at the end of the exposure rather than at the beginning so that the motion is recorded and the subject motion is frozen at the end of the exposure with the pop of flash. During the long exposure, you can pan the camera with or against the direction of the subject motion. Or you can turn the camera to create a circular background blur, or you can zoom the lens during the exposure.

Of course, the subject should be sharply focused, so the usual lens handholding guidelines apply.

Event and Action Photography Tips

Beyond the point of selecting the correct shutter speed to capture the action, the biggest challenges of action shooting are timing shots and composing images. The first challenge is to anticipate the moments of high emotion and the decisive moment. And when the mirror flips up, you hold your breath during the blackout hoping that you captured the critical moment. Because the subject is in constant motion, there is limited time to compose the image as you react to the subject's motion.

In many scenarios, action shooting often means getting a handful of keepers from 50 to 100 exposures. You can use a few approaches to increase your ability to get good action images.

- ▶ **In a venue with spotty lighting, find an area with good light.** Prefocus on the area, and then wait for the action to come to that spot. For example, you can prefocus on an important area such as the goal line. Then wait for the action to come to that area and begin shooting.

- ▶ **Keep exposure changes to a minimum for as long as the light allows.** This allows you to concentrate on capturing the important moments and composing images. The more time you spend adjusting controls, the more action you're likely to miss.

▶ **Zoom in.** Action and event shots have far more impact when the subjects are large within the frame. If you don't have a telephoto lens that's long enough to bring the action close, consider using an extender if your lens is compatible with an extender.

▶ **Keep the background clean.** Many sports stadiums are plastered with advertising on the walls. And at events, people and equipment or props in the background can be very distracting. See if you can find a shooting position that avoids background distractions. Sometimes you can avoid them by shooting from a high position. Alternately, switch to Av shooting mode and set a wide aperture such as f/5.6 or wider to blur background distractions.

▶ **Anticipate the action.** Whether the event is a football game or a child's graduation, knowing what is likely to happen next means that you can set up for the next shooting sequence before the subject gets to the area.

10.6 As dusk settled in on this open-air concert, I increased the ISO to 400 to maintain a motion-stopping shutter speed of 1/400 second. Exposure: ISO 400, f/2.8, 1/400 second using an EF 70-200mm f/2.8L IS USM lens.

10.7 Not all action ends well, and when I captured this shot, I knew that it would not end well for the athlete. Exposure: ISO 400, f/2.8, 1/400 second using an EF 70-200mm f/2.8L IS USM lens.

▶ **Shoot just before the critical moment of high action.** Because there is a moment in which the shutter opens to make the exposure, you need to anticipate that camera function and shoot just before the critical moment of action — and that's the moment that the shutter fires to make the exposure. And in Continuous shooting mode, you're more likely to capture those critical moments as the camera fires off a series of shots.

▶ **Keep an eye on the media card capacity.** It is very frustrating for critical moments to occur just as the media card presents a "Card full" message on the LCD. Watch to see how many remaining shots you have, and change the card out before it is full and certainly before decisive moments in the action begin.

10.8 A high shooting position enabled me to keep the background foliage out of the frame. The second athlete provides context for the skate park setting. Exposure: ISO 200, f/3.2, 1/200 second using an EF 70-200mm f/2.8L IS USM lens.

▶ **Tell the story of the event.** The best images are those that tell the story of an athlete, the event, or an aspect of the event such as the dedicated fans. If you're shooting a student's graduation, begin shooting early in the day and include the "getting ready" phase, greeting friends, the ceremony, and the after party.

▶ **Try switching between lenses.** Use a telephoto lens to photograph action and a wide-angle lens to capture establishing shots of the overall venue, the audience, and crowd reactions. These are the shots that help create the full story and spirit of the event.

▶ **Take lots of images.** Don't assume that you have the shots you need and stop shooting. Rather, keep shooting. You won't know for certain that the shots are pristine until you view them on the computer, and then it's too late to go back and capture the moment you missed.

Nature and Landscape Photography

By now, you know that the EOS T2i/550D gives you full creative control. When you combine that with your creative vision, you are ready to make stunning nature and landscape images.

Making stunning images is the unconscious and instinctive blending of the technical and creative aspects of photography. As you acquire experience with your camera and shooting, the technical and creative components become a synergistic and fluid process, each complimenting the other. This chapter looks at approaches to shooting nature and landscape images.

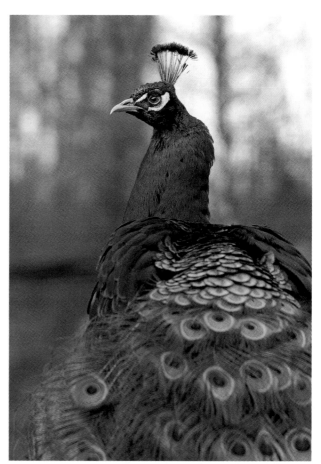

The regal look and rich colors of this peacock drew my eye immediately. Exposure: ISO 200, f/4, 1/125 second.

Setting up for Nature and Landscape Shooting

It is a rare photographer who does not heed the call of photographing the singular beauty of this world. It's that call that lures photographers to travel the globe and shoot in all kinds of weather, simply to capture the vast array of natural wonders. While this chapter is titled "Nature and Landscape Photography," these broad categories also encompass travel, fine-art landscape, seascapes, flora, fauna, wildlife, and birds, as well as close-ups of the smallest structures in the natural world.

These photography categories share commonality in the diversity of light, the visual rhythm of the scenes and subjects, and in the photographer's desire to creatively interpret scenes and subjects in very personal and exciting ways.

 Many of the techniques used for nature and landscape photography can also be applied to shooting skyscapes, cityscapes, and, in part, outdoor architectural photography.

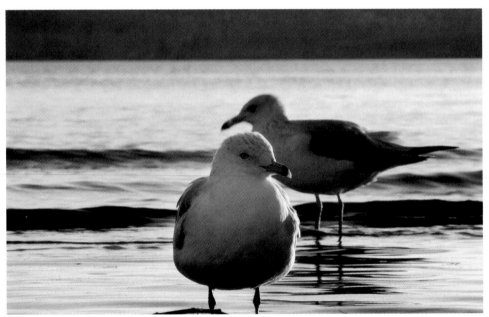

11.1 While shooting in early sunset light, I noticed the rim light — light that outlines the edge of a subject — on one side of this seagull and although the aperture was narrower than I would have liked, I grabbed a quick shot before the bird flew off. Exposure: ISO 200, f/29, 1/40 second with a -2/3-stop of Exposure Compensation.

Packing the gear bag

Shooting nature and landscape images begins by being prepared for what you think you'll shoot, and being prepared for the photo opportunities that you don't expect to encounter. You don't have to have a bag full of lenses, and certainly you can get good shots with a single lens. But if you have multiple lenses, then think through which lenses will serve you best.

Here are some lenses and lens accessories that will cover a variety of scenes and subjects.

▶ **Wide-angle lenses.** To capture truly sweeping landscapes with the T2i/550D, you need a wide-angle and ultrawide-angle lens. The EF-S 18-55mm IS kit lens provides the wide view needed for landscape shots. Other lenses to consider are the EF 16-35mm f/2.8L II USM, EF-S 10-22mm f/3.5-4.5 USM, or the EF 17-40mm f/4L USM lens. If you don't have a wide-angle lens, you can use the widest zoom lens that you have and shoot a panorama of images. Then you can use the PhotoStitch program that Canon provides on the EOS Digital Solution Disk to stitch the images together.

 If you shoot panoramas, it's a good idea to have a monopod or a tripod to keep the image series level. Keeping the images level makes stitching images together easier and more precise.

▶ **Short telephoto lenses.** If the area has wildlife or you'll be shooting distant subjects, then bring a telephoto lens. In general, a telephoto lens in the 70-200mm range is a good choice. If you have the Canon Extender EF 2x II or the Extender EF 1.4x II, you can double the focal length or multiply the focal length by 1.4X, respectively.

 Lens extenders can be used with all prime (single focal-length) lenses of 135mm and longer, except the 135mm f/2.8 Softfocus lens. Extenders can also be used with many telephoto lenses. An extender reduces the maximum effective aperture, meaning that you lose an f-stop or more of light. The 1.4X extender reduces the maximum effective aperture by 1 f-stop, and the 2X extender reduces it by 2 f-stops.

▶ **Macro lenses.** Also I seldom go anywhere without a macro lens. For macro work where you can't or don't want to get close to the subject, the EF 180mm f/3.5L Macro USM lens is ideal. For flowers and plants, either the EF-S 60mm f/2.8 Macro USM or the EF 100mm f/2.8L Macro IS USM lens is an excellent choice.

▶ **Filters.** Standard filters for outdoor shooting include a high-quality circular polarizer, and graduated neutral density filters.

Handy Filters

The most useful filters in outdoor photography include the circular polarizer, neutral density and variable neutral density filters, and warm-up filters. Here is a brief overview of each type of filter.

▶ **Polarizer.** Polarizers deepen blue skies, reduce glare on surfaces to increase color saturation, and help remove spectral reflections from water and other reflective surfaces. A circular polarizer attaches to the lens, and you rotate it to reduce glare and increase saturation. Maximum polarization occurs when the lens is at a right angle to the sun. With wide-angle lenses, uneven polarization can occur, causing part of the sky to be darker than the sky closest to the sun. You can use a 1- to 2-stop neutral density (ND) graduation filter to tone down the lighter area of the sky by carefully positioning the grad-ND filter. If you use an ultrawide-angle lens, be sure to get the thin polarizing filter to help avoid vignetting that can happen when thicker filters are used at small apertures. Both B+W and Heliopan offer thin polarizing filters.

▶ **Variable neutral density filters.** Singh-Ray's Vari-ND variable neutral density filter (www.singh-ray.com/varind.html) allows you to continuously control the amount of light passing through your lens up to 8 stops, making it possible to use narrow apertures and slow shutter speeds, even in brightly lit scenes. Thus you can show the motion of a waterfall, clouds, or flying birds. The filter is pricey, but it is a good addition to your gear bag.

▶ **Graduated neutral density filters.** These filters allow you to hold back the brightness in the sky from 1 to 3 f-stops to balance a darker foreground with a brighter sky. Filters are available in hard or soft-stop types and in different densities: 0.3 (1 stop), 0.45 (1.5 stops), 0.6 (2 stops), and 0.9 (3 stops). With this filter, you can darken the sky without changing its color, thus making the brightness of the sky similar to that of the landscape.

▶ **Weatherproof camera and lens sleeves.** The EOS T2i/550D isn't built to withstand the elements of nature including rain, other moisture, dust, and sand. And these kinds of elements can play havoc with your Rebel. Also if you use non-L-series lenses, they do not have extensive weather sealing. As a result, carrying along a water-repellant bag is good insurance against moisture, dust, and sand that can put a camera out of commission. You can buy a wide variety of weatherproof camera protectors from Storm Jacket, Pelican, Aquatec, and Op-Tech. I always also have several quart-size plastic bags in my camera bag that I can use to protect accessories during an unexpected shower. Most newer camera bags are water repellent and have overlapping protectors around zippers to keep moisture and dust out of the bag.

▶ **Additional gear.** Because conditions can change quickly, and depending on the time of day and the focal length of your telephoto lenses, you will need a sturdy tripod or a monopod. Also bring spare CF cards, charged camera batteries, cell phone, plastic bags, florist's wire (to steady plants), silver reflectors, GPS locator, and water and snacks as necessary.

While the T2i/550D is a great camera and Canon lenses are among the best on the market, the camera and lens capture only what you see. So in addition to your gear, bring along your sharp and practiced photographic eye as well as your curiosity and passion for shooting.

Choosing settings

Different photography subjects require different camera setups. And now is the time to get the most you can from the T2i/550D's rich features and options that you've read about thus far in this book.

When I get ready to go out shooting, I always think through all of the camera settings that I want to use and set as many options as possible before I leave. Not only does this planning save time when I'm ready to begin shooting, but it also helps avoid oversights that can make a big difference during shooting and in getting the best images. Good pre-planning also means that I can get in position and concentrate on evaluating the scene, the light, and the composition instead of setting up the camera on location.

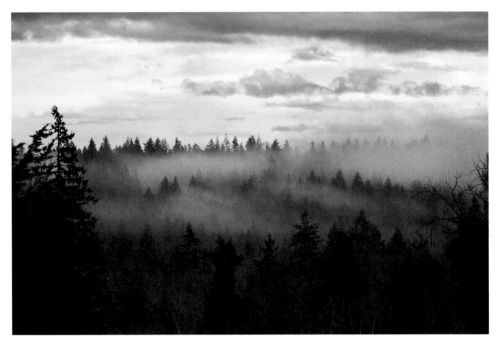

11.2 For this shot of the Cascade Mountains, I was handholding the camera with the EF 100-400mm f/4.5-5.6L IS USM lens zoomed to 100mm. Exposure: ISO 200, f/4.5, 1/125 second.

Here is a checklist of camera settings that you can set in advance.

▶ **Av shooting mode.** In most outdoor and nature scenes, a primary goal is to control the depth of field. For that reason, many photographers use Av shooting mode because with one adjustment, they can set the aperture while the camera automatically adjusts the shutter speed. If you use Av shooting mode and you're handholding the camera, be sure to continually check the shutter speed. If the shutter speed is too slow, you run the risk of getting an out-of-focus image.

▶ **One-shot AF mode with manual AF-point selection.** I use One-shot AF mode with manual AF-point selection because I always want to control where the point/plane of sharpest focus is in the image. But if you're shooting birds or wildlife, then you may prefer using AF Focus AF, which automatically switches to automatic focus tracking (AI Servo AF mode) if the subject begins to move.

▶ **Single or a Continuous Drive mode.** The drive mode you choose depends on the scene or subject you're shooting. If I'm shooting in areas where birds and wildlife are common, then I use Continuous Drive mode. But if I'm shooting landscapes or other non-moving subjects, then I use Single Drive mode. If the light is low and/or if you are making a long exposure, you can ensure rock-solid shooting

by using a tripod combined with a Self-timer mode. Using the Self-timer mode avoids any blur due to the motion of you pressing the Shutter button.

 You can also use Mirror Lockup to avoid any blur in the image from the reflex mirror flipping up at the start of the exposure. You can turn on Mirror Lockup using C.Fn III-8.

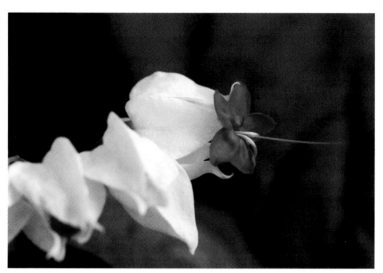

11.3 In scenes such as this, the T2i/550D produces very good exposures. However, to keep good detail in the brightest highlights, I used a -2/3-stop exposure compensation. Exposure: ISO 200, f/5.6, 1/200 second.

▶ **Evaluative or Spot Metering mode.** Evaluative metering gives good exposure results in a majority of scenes. You can also use Spot metering mode to meter on midtone area in the scene, as described in the Advanced Exposure Technique section of this chapter.

▶ **Picture Style.** Because I always edit my images on the computer before displaying them on the Web or printing them, I use my modified Neutral Picture Style for shooting outdoors. This style offers ample room for interpreting the color and contrast during image editing, and the colors are very true to the scene. However, you may prefer the Landscape Picture Style with its more vivid greens and blues. If you don't edit images on the computer before printing them, then the Standard Picture Style also produces good prints from the camera.

For more information on modifying Picture Styles, see Chapter 3.

▶ **Custom Functions.** My choices depend on the scene and subject, but in general, here are some T2i/550D Custom Functions that are helpful for nature and landscape shooting. If you want to make larger or smaller changes in aperture and shutter speed, then you can set exposure level increments, C.Fn I-1, to 1/2 stop instead of the default 1/3 stop increment. Long exposure and High ISO noise reduction (C.Fn II: 4 and 5) are good choices if you are shooting low light at a high ISO setting and/or using long exposures. Finally, you can set C.Fn III-8 to lock up the reflex mirror to prevent blur when you are making long exposures or macro shots, or using a long lens.

Shooting Mode Considerations

There are different opinions about which shooting mode is best for outdoor and nature scenes. Here is a synopsis of when and why photographers use Av, Tv, and M shooting modes for landscape and nature shooting.

▶ Av mode seems like the logical choice since it enables control over the depth of field with a minimum of adjustments. And this mode works well as long as you keep an eye on the shutter speed to ensure it is fast enough to get a sharp image if you are handholding the camera.

▶ Some photographers prefer to use Tv shooting mode. This school of thought argues that the ability to control depth of field is useful only so long as the image has sharp focus. And to get sharp focus when you're handholding the camera, controlling the shutter speed is more important than controlling the aperture. Using Tv mode, you can lock in a shutter speed that is fast enough to handhold the camera (provided that there is enough light in the scene to get a fast enough shutter speed, of course). And if there is potential subject movement, Tv mode enables you to quickly set a fast enough shutter speed to freeze subject motion.

▶ For photographers who determine exposure settings by metering from a gray card or from a midtone in the scene, M (Manual) mode is best because it is necessary to manually set the aperture and the shutter speed based on the midtone meter reading. You can meter a middle tone in Tv or Av mode using AE Lock as well, but the lock on exposure settings are temporary.

Taking Nature and Landscape Images

One of the most important things you can learn early in your shooting with the Rebel T2i/550D is that good exposures should happen in the camera, not on the computer.

Doubtless, many image problems can be improved with skillful editing in both a RAW conversion program and in Photoshop. But your goal should be to get the best in-camera exposure that the T2i/550D is capable of delivering.

With landscape images in particular, making a good exposure is challenging because scenes often have very bright skies and much darker foregrounds, and it's difficult for the camera to maintain both highlight and shadow detail in these scenes. Other scenes may include large expanses of snow or white sand, or dark expanses of water.

To get the best exposure, you can take one of two techniques: the basic technique that uses Evaluative metering mode and enables you to make exposure modifications as needed, or the advanced technique that has a long history with landscape and nature photographers.

> **NOTE** At first glance, the advanced exposure approach may seem too complex or too much trouble. In that case, use the basic exposure technique knowing that the T2i/550D will give you consistently good exposures. As you gain experience, you can try using the advanced exposure technique.

The basic exposure method, described next, is a popular exposure technique that is bolstered by the T2i/550D's new metering sensor.

11.4 This is a scene in which the onboard light meter and the camera's recommended exposure produces excellent results. Exposure: ISO 200, f/5.6, at 1/640 second.

Basic exposure technique

The basic exposure technique uses Av shooting mode with Evaluative metering mode. As you may recall, Evaluative metering mode evaluates light throughout the scene biasing the exposure toward the active AF point. Evaluative metering is dependable and accurate for a majority of scenes and subjects, and it produces good exposures even for difficult subjects such as those that are backlit. There are some scenes in which you may need to tweak the exposure, but the T2i/550D offers a number of ways to modify the exposure when necessary.

The following guidelines can be applied to shooting any nature and landscape subject, although I use the example of shooting a landscape image here.

▶ **Decide what aperture (f-stop) that you want to use.** If you're shooting a landscape, then the classic approach is to set a narrow aperture ranging from f/8 to f/22 to keep as much of the scene in acceptably sharp focus as possible. In Av shooting mode, set the aperture you want.

▶ **Set the ISO sensitivity setting.** I recommend setting the lowest ISO possible given the light in the scene. To determine the ISO setting to use, select the AF point that you want to use, and then compose the scene in the viewfinder as you want to shoot it. Press the Shutter button halfway and check the shutter speed to ensure that it's fast enough to handhold the camera. If you're using a non-Image Stabilized lens, then you can handhold the camera and get a sharp image at 1 over the focal length. So, if you're shooting with the lens set to 200mm, then you need a 1/200 sec. to get a sharp handheld image. If the shutter speed is too slow to handhold the camera at the current focal length, then you can:

- Increase the ISO to get a faster shutter speed

- Use a wider aperture; unless, of course, the lens is already at its widest, or maximum, aperture

- Use a monopod or tripod.

▶ **Compose the image in the viewfinder, focus on the subject, and then make the picture using the camera's recommended settings.**

▶ **Evaluate the image and the histogram to see if exposure modifications are needed.** For example, if there are blown highlights within the subject, then set negative exposure compensation. The amount of compensation depends on the scene or subject, but setting -1/3- to 2/3-stop of compensation is a good starting point. Then make the picture again and evaluate the histogram to see if more or less compensation is needed. In some scenes, you may have to live with some blown highlights in non-subject-critical areas.

 When you set Exposure Compensation in Av shooting mode, the camera changes the shutter speed to achieve the compensation. So always monitor the shutter speed, and use a tripod if the shutter speed is too slow for handholding the camera and lens.

This example assumed that you are shooting a still subject such as a landscape or a garden. However, if you are shooting a waterfall or a fountain in a garden, then you'll want to modify the general steps to use Tv shooting mode and set a slow shutter speed to show the motion of the water as a silky blur. To show motion as a blur, set a shutter speed of 1/2 second to 3 seconds.

In some scenes, a large area of bright tones such as a bright sky or white background behind the subject can cause the camera to reduce the exposure (underexpose the image). If this happens, you can use AE Lock to meter and lock the exposure on the subject. Just zoom in on the subject, press the Shutter button halfway to meter on the subject, and then press the AE Lock button on the back of the camera to lock the exposure. Then zoom out, compose the image, focus and shoot.

11.5 To show the motion of water flowing in this water wheel, I used a slow shutter speed of 1/6 second. Exposure: ISO 200, f/18, 1/60 second.

 You may want to use Tv shooting mode rather than Av mode in scenes where you want to set and maintain a shutter speed that it is fast enough to handhold the camera.

Exposing Challenging Scenes

Scenes with large expanses of light tones such as snow scenes and white sand beaches and scenes with large expanses of dark tones such as scenes with large expanses of dark water can throw off exposures. The camera expects that all tones

will average to 18 percent reflectance. But light-toned subjects reflect 36 percent of the light while dark-toned subjects reflect only 9 percent of the light. As a result, if you use the basic exposure technique, you need to adjust for the different reflectivity of light and dark subjects by using exposure compensation. If you don't make exposure adjustments, then a white snow scene will be underexposed with a grayish look, while a dark lake scene will be overexposed with a dark grayish look.

Generally, a +1 or +2 exposure compensation for scenes with a predominance of light tones, or -1 to -2 compensation for scenes with a predominance of dark tones produces true whites and blacks. Be sure, however, to check the histogram to ensure that highlights are not blown or the shadows are not blocked. You may need to experiment a bit to find the ideal amount of compensation for the scene.

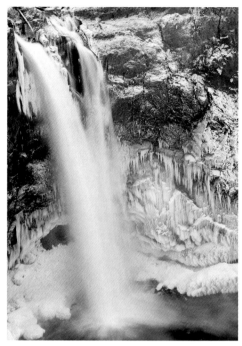

11.6 To keep the ice and water as truly white, I used +1 1/3 Exposure Compensation for this shot of Snoqualmie Falls. Exposure: ISO 100, f/11, 1/6 second.

NOTE If you're using Partial, Spot, or Center-weighted Average metering modes, AE Lock is set at the center AF point only, and this is also true if you turn the switch on the lens to MF (Manual Focus). So in these metering modes, be sure to point the center AF point over the area where you want to meter.

NOTE With any exposure approach, you may not see any difference in images where you make exposure changes if you have Auto Lighting Optimizer on the Shooting 2 menu set to any setting except Disable. Auto Lighting Optimizer automatically brightens pictures that it detects as being too dark and corrects low contrast. If you are using exposure modification, then turn off Auto Lighting Optimizer so that you can see the effect that the modifications make.

Dealing with High Dynamic Range scenes

You have likely taken images where the sky blows out to white and the landscape is properly exposed, or where the landscape is too dark while the sky is properly exposed. These scenes have a wide range from light to dark tones — as measured in f-stops — that are beyond the capability of the camera's image sensor to handle. They are called High Dynamic Range scenes. In most High Dynamic Range scenes, the camera sacrifices the highlights, resulting in blown highlights, although the shadows may also be blocked or go to black too quickly. If you're shooting a High Dynamic Range scene, then you have several choices. You can:

▶ Properly expose the subject and let the rest of the scene go overexposed or underexposed.

▶ Shoot a series of five to eight images that are bracketed by shutter speed. Then combine all of the bracketed images in a High Dynamic Range-imaging program so that the final image retains good detail in all areas of the image.

▶ Shoot a single RAW image, and then process the RAW file three times — once each to maximize highlight, midtones, and shadows. The RAW file is processed and saved as a TIFF with a different file name each time. Then all three files are combined and manipulated to reveal the best of each file in an image-editing program.

Advanced exposure technique

The classic exposure approach to exposing landscape and nature scenes is to set the exposure based on a meter reading taken on a gray card or on a middle tone area in the scene. This approach takes advantage of knowing that the camera's built-in reflective light meter expects that when all of the tones in the scene are averaged, they will be middle gray, or 18 percent reflectance. Thus if the middle tones in the scene are properly exposed, then all the tonal values will be properly exposed. The caveat is that if you meter from a gray card, the card must be in the same light as the subject.

The challenge of this technique is that you often cannot put a gray card in the same light as the subject you're photographing. For example, if you're standing in a shady area as you shoot a distant mountain range with a telephoto lens, you won't be able to put the gray card in the same light as the mountains. As a result, you have to train your eye to identify an area in the scene that has the same brightness value as middle gray as shown in figure 11.7. With experience, you'll learn to identify middle tone areas in the scene. Objects that are close to middle gray include green grass, tree bark, or a blue sky.

11.7 In this abbreviated tonal scale, middle gray is the fourth gray square from the left. The far right is a section of a photographic gray card, a copy of which you can find in the back of this book.

To use this exposure technique, follow these steps.

- **Switch to M (Manual) shooting mode and switch to Spot metering mode.**

- **Set the ISO to the setting you want.**

- **Set the aperture you want by holding the AV button as you turn the Main dial until the aperture you want is displayed in the viewfinder.** If shutter speed is a critical factor for your exposure, you can set it first by turning the Main dial without holding the AV button.

- **Identify a middle-toned area in the scene, or place the photographic gray card in the same light as the subject.**

- **Point the lens so that the center AF point is over the middle gray area or point it over the photographic gray card.** If you use a gray card (there is one included in the back of this book), hold the camera about 6 inches from the card and ensure that there are no shadows, glare, or hotspots on the card, and that the center spot meter circle shown in the viewfinder is filled with the gray card.

- **Press the Shutter button halfway, and then set the shutter speed by turning the Main dial until the tick mark is in the center of the Exposure Level Index that's displayed at the bottom of the viewfinder.** If you're handholding the camera, be sure that the shutter speed is fast enough to get a sharp image. If not, you can increase the ISO. If you already set the shutter speed, then set the aperture at this point by holding the AV button and turning the Main dial.

- **Manually select the AF point you want to use.** Press the AF-point selection/ Magnify button on the top back of the camera, and then turn the Main dial until the AF point you want to use is displayed.

- **Focus on the subject, and press the Shutter button completely to make the picture.**

You may need to make trade-offs in the aperture, shutter speed, or ISO depending on the light to get the depth of field or shutter speed you need. As long as the light doesn't change and you don't change subjects, you can continue to use the exposure settings.

11.8 For this Lake Washington sunset image, I metered on a middle tonal value in the line of blue water near the horizon to determine the exposure. Exposure: ISO 200, f/8, 1/125 second using an EF 70-200mm f/2.8L IS USM lens.

Landscape and Nature Photography Tips

In my experience, all the tips in the world cannot make great images if the photographer doesn't constantly practice seeing and appreciating everything in nature. I've irritated many other drivers because I routinely slow down to appreciate a stunning mountain lit by that rare and incomparable light that happens only occasionally. Slowing down is a good approach overall, and it will help you get great landscape and nature shots.

▶ **Look for the light.** Light, especially beautiful light, is transitory and fleeting, but this is the light you desire. Maybe the light illuminates a mountainside forest with gold and purple hues, or maybe a small shaft of light pierces through the forest trees to spotlight a tiny frog or wild mushroom; just look with an acute eye for the stunning light. And be ready to shoot, regardless of whether or not the right lens is on the camera. Don't let stunning light opportunities pass you by.

11.9 A local farm keeps a variety of birds and animals on-site, and that's where I found this peacock. Exposure: ISO 200, f/.8, 1/100 second.

▶ **Keep your eye in practice.** Photography is like any other skill: The more you practice it, the more finely tuned your eye becomes and the more you will look for unique and unusual scenes and approaches. For example, when I spend long stretches writing at the computer, and then go out shooting, it takes a while to see with a practiced eye again.

11.10 When I'm photographing animals, I try to capture them interacting with other animals, the environment, or with me. This turkey's distrust of me and my camera is evident in this shot. Exposure: ISO 200, f/2.8, 1/320 second.

▶ **Image composition is very important.** Many books have been written on composition, but you'll do well to study nature itself. For me, nature is the ultimate field guide to good composition.

▶ **Give yourself room and time to learn.** Many new photographers get frustrated when images don't come out as they want or expect, or they forget to set something on the camera. Snafus and slightly "off" shots are all part of the learning process, and they provide incentive to do better the next time. There are a lot of things to remember as you are shooting, and it takes time for them to become second nature. And never stop learning. Part of the challenge and joy of photography is that there is *always* more to learn.

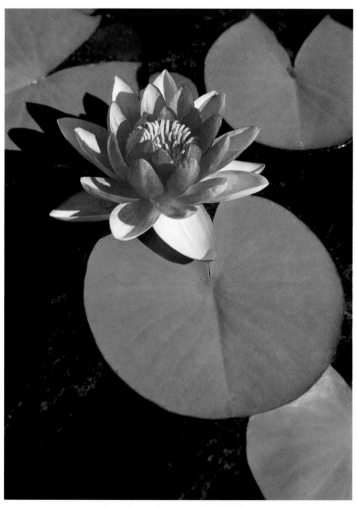

11.11 For this water lily, I used the basic exposure technique and metered on the bright center structures of the flower. Exposure: ISO 100, f/5.6, 1/400 second.

Portrait Photography

One of the most rewarding and challenging areas of photography is people photography. There is a never-ending source of great subjects, and you can unleash your creative ideas for locations, sets, lighting, clothing, and subject action and position.

But even better than the creative opportunities is the opportunity to work with people — to get to know them, to coax out the best in them, and to make images that both they and you will enjoy for years to come.

The Rebel T2i/550D makes excellent portraits with either the kit lens or a short telephoto lens in the 80mm to 100mm range. For women and children, the Portrait Picture Style renders skin tones acurately and beautifully. But, whatever settings you choose, you can count on making portraits that you will treasure.

©Cricket Krengel

Taken using midafternoon window light and a bounced flash, this little one was captured looking rather pensive. Exposure: ISO 400, f/4.5, 1/40 second using a 70-300mm f/4.0 lens and a 430 EX II Speedlite.

Setting up for Portraits

With most portrait sessions, the most important work you can do is to establish and maintain rapport with the person or people you're photographing. Establishing rapport and trust takes time — sometimes a lot of time. Unlike nature and landscape shooting, where you can set the pace and face snafus with equanimity, people photography, whether it's a structured portrait session or street shooting, demands more of your time and patience.

©Cricket Krengel

12.1 This napping baby was photographed using the natural light from a nearby window. Exposure: ISO 200, f/5.6, 1/4 second using an EF 24-70mm, f/2.8L USM lens.

When you photograph people, you have to maintain an ongoing conversation, provide direction, change lenses, and, in some portrait sessions, you also have to coordinate clothing, lighting, and background changes. Given these demands, the last thing that you have time to worry about is the camera's performance, and with the T2i/550D, you can depend on the camera to perform when you need it to. And if you plan carefully for session, your odds of having a problem-free session are greatly increased.

Planning includes having the camera, lenses, and accessories that you want within easy reach. For example, you want to plan in advance the range of setups including

backgrounds or locations that you want, and what type of lighting you'll use, whether it's studio strobes, flash units, reflectors, or supplementing outdoor light.

Selecting gear

The type and amount of gear that you use for photographing people depends on where you shoot, whether it's in your studio or home or outdoors. In local shooting scenarios, your gear will be conveniently close by, but if you have to travel, then you may want to take less gear. Another aspect that influences gear selection is whether you're photographing a single person or a group, and, if a group, how large the group is.

Consider the following additions and accessories, and then make adjustments according to your specific portrait session.

▶ **A T2i/550Ds and a backup camera.** In almost all shooting situations, having a backup camera is important for all the reasons mentioned in previous chapters. At the very least, I recommend having a point-and-shoot camera to fall back on if something unexpected happens to the Rebel.

▶ **One or more fast wide-angle and short telephoto lenses.** For portraits, I most often use the EF 24-70mm f/2.8L USM, the EF 70-200mm f/2.8 IS USM, and the EF 50mm f/1.4 USM lens. In particular, the 24-70mm is very versatile — you can shoot individual subjects at the 70mm focal length or at a wider focal length for groups of up to five or six people.

I also recommend the EF 50mm f/1.4 USM lens, which is the great focal length for portraits. It is affordable, offers excellent sharpness and contrast, offers very wide apertures, and is lightweight. As you build up your lens system, try to buy the highest quality lens that you can afford. The high resolution of the T2i/550D requires a lot from lenses, and the higher the quality of the lens, the better the images will be. I also recommend the EF 70-200mm f/2.8L IS USM, or the lighter-weight but slower EF 70-200mm f/4L IS USM as good lenses that will increase background softness, particularly at wide apertures.

▶ **Reflectors.** I can't imagine shooting a portrait session indoors or outdoors without using one, two, or more silver, white, or gold reflectors. Reflectors are small, lightweight, collapsible, and indispensable for everything, from redirecting the main light or filling shadow areas to adding catchlights to the subject's eyes. Reflectors are easier to manipulate than flash (and much less expensive), and silver and white reflectors retain the natural color of the ambient light. A gold reflector adds appealing warmth to skin tones.

▶ **EX-series flashes, light stands, umbrellas or softboxes.** You can create a nice portrait with a single flash unit mounted off-camera on a flash bracket. But you'll have a lot more creative control if you use one or more Speedlites mounted on stands with either umbrellas or softboxes, and fired wirelessly from the T2i/550D. The Speedlites can be placed around the set to replicate almost any classic lighting pattern. Best of all, a Speedlite system is portable and lightweight. You can, of course, use the built-in flash, but I've found that the built-in flash creates unattractive pinpoint size catchlights in the eyes and increases the incidence of red-eye, so I opt to use a Speedlite when possible.

▶ **Tripod, monopod, CF cards, and spare batteries.** These are obvious items to have on hand, but they bear mentioning.

▶ **Brushes, combs, cosmetic blotters, lip gloss, concealer, safety pins, and everything else you can think of.** The subject will likely forget to bring one of these items, a garment will tear, or a button will pop off. Have a small emergency kit at the ready. The kit will often contain just what you need to keep the session going with minimal stress and interruption.

Setting up the T2i/550D for portrait shooting

One of the first instincts you may have when shooting portraits is to switch to the automatic Portrait mode. While this mode provides the classic settings used for portraits, the disadvantages to it are that you cannot control where the camera sets the focus, the flash fires automatically, and the ISO is often increased to levels higher than are necessary for the existing light. At a minimum, a successful portrait must have sharp focus on the subject's eye, and the way to guarantee the sharp focus on the eyes is by using Av shooting mode and selecting the AF point manually.

With that as background, here are suggestions for setting up the T2i/550D for portrait shooting.

▶ **Av shooting mode.** Av shooting mode is a good choice because it offers quick control over the depth of field by changing the aperture. If you use Av shooting mode, *always* keep an eye on the shutter speed to ensure it's fast enough to handhold the camera.

I don't recommend riding the edge of handholding shutter speeds. With portraits, you have to consider the potential that the people or person you're photographing may move during the exposure. So if you err, err on the side of getting a faster rather than a slower shutter speed.

As a rule of thumb, the minimum shutter speed at which you can handhold a non-IS lens is the reciprocal of the focal length. Thus, if your lens is set to 100mm, the minimum shutter speed at which you can handhold the camera and get a sharp image is 1/100 second. That's the *minimum* shutter speed. But I also factor in the potential that the subject may move, so a safer shutter speed is 1/200 second or faster.

▶ **One-shot AF mode, and manual AF-point selection.** Unless the portrait subject is a young child who moves unexpectedly, One-shot AF mode is a good choice. If you are photographing a young child, then you may want to use AI Focus AF. In AI Focus AF mode, you can focus on the child and if the child begins to move, the T2i/550D switches to automatically track focus on the child. In addition, I also always use manual AF-point selection. A portrait isn't successful if the point of sharpest focus is anywhere except on the subject's eyes — specifically, the eye that is closet to the lens — and the best way to ensure sharp focus on the eyes is to manually set the AF point.

©Peter Burian

12.2 Events such as fashion shows are a great place to practice your portrait shooting skills. Exposure: ISO 400, f/5, 1/60 second using an EF 70-200mm, f/4L IS USM lens.

▶ **Evaluative metering mode.** Evaluative metering is both fast and accurate for portraits. However, you may want to switch to Spot metering mode to take a meter reading from a gray card. As you begin shooting, make one or two test shots, examine the images and histograms on the LCD, and then modify the exposure as necessary.

▶ **Picture Style.** The Portrait Picture Style produces lovely skin tones and renders colors faithfully and with subdued saturation, which is appropriate for portraits. I also use a modified Neutral Picture Style. If you are shooting where the lighting

is flat, then Standard produces a more vibrant rendering. Be sure to test these Picture Styles well before the session and evaluate the prints so that you know which style works best for the lighting and the printer that you'll use.

▶ **Custom Functions.** For flash portraits, consider whether you want to use a fixed 1/200-second sync speed to make flash the primary illumination, or to sync at shutter speeds slower than 1/200 second to allow more of the ambient light to figure into the exposure. If you're shooting informal family images in a room with low light, then the 1/200 sec. (fixed) option will ensure no motion blur, but there will be dark shadows behind the subjects. To help avoid the shadows, move the people away from the background if possible. If you're shooting scenes with bright tones, such as a bride in a white dress, you can enable C.Fn II-6, Highlight tone priority, to help maintain image detail and texture in bright highlights.

Making Portraits

The goal of any portrait is to capture the spirit of the subject. When you capture the spirit of the person, the subject's eyes are vibrant and sparkling, and that draws the viewer into the image. No amount of skillful lighting, posing, or post-capture editing can substitute for this. Likewise, if the subject is smiling, the eyes should also be "smiling." And that's why establishing rapport is so important.

Other factors to consider include background, lighting, posting, and providing direction to the subject or subjects, and, of course, getting excellent exposures.

Backgrounds

In all portraits, the subject is the center of attention, and that's why it's important to choose a non-distracting background. Even if you have trouble finding

12.3 For this portrait, I used light from a door to light the subject. To help blur the wall texture, I moved her away from the background wall and used a telephoto lens set to a wide aperture. Exposure: ISO 100, f/2.8, 1/13 second using an EF 70-200mm f/2.8L IS USM lens.

a good background, you can de-emphasize the background by using a wide aperture such as f/4 or f/2.8 and by moving the subject well away from the background. Conversely, some portraits benefit by having more background context. For example, when taking high school senior portraits, backgrounds and props that help show the student's areas of interest are popular. Having a more extensive depth of field by using a narrow f/8 or f/11 aperture is the ticket for showing a star football player in the context of a football field.

Lighting

Lighting differs for portraits of men and women. For men and boys, strong, directional daylight can be used to emphasize strong masculine facial features. For women and girls, soft, diffuse light from a nearby window or the light on an overcast day is flattering. To determine exposure, take a meter reading from the subject's face, use Auto Exposure Lock, and then recompose, focus, and take the picture.

NOTE The Rebel T2i/500D doesn't have a PC terminal to connect a studio strobe system directly to the camera, but you can buy hot-shoe adapters for this purpose. Ensure that the voltage of the strobe system is safe to use with the T2i/500D — the recommended voltage is usually 6 volts. Consider Safe-Sync adapters that regulate voltage to protect camera circuitry.

There are many times during the day, and many types of outdoor light, that provide lovely portrait light. With that said, I can think of no one who is flattered in bright, overhead, unmodified midday sunlight. Nor can I think of any subject who is comfortable looking into the sun. So if you have a portrait session outside on a sunny afternoon and you can't reschedule, then move the subject to an area that is shaded from the top, such as by a roof, an awning, or a tree. Or in an open area with overhead sunlight, use a *scrim* — fabric or other material stretched over a frame — and hold it over the subject to diffuse the strong sunlight. If the subject is in the shade, use a reflector to direct light onto the front of the face. Then you can move the subject and use reflectors to create and control shadow areas.

The most desired outdoor portrait light is during and just after sunrise, just before and during sunset, and, if you use reflectors or fill flash skillfully, the light of an overcast day.

In any type of outdoor light, watch how the shadows fall on the face. If unflattering shadows form under the eyes, nose, and chin, then you can use a silver or gold reflector to bounce fill light into those areas. If you're shooting a head-and-shoulders portrait, you can ask the subject to hold a reflector at waist level, and ask the subject to

tilt the reflector in various positions. Watch to find the position that best fills in facial and chin shadow areas. Also ensure that catchlights appear in the subject's eyes. In overcast light, in particular, you may need to use a reflector to create the catchlights. The ideal positions for catchlights are at the 10 and 2 o'clock positions.

To get the best color in overcast or cloudy light, use a custom white balance. At sunrise or sunset, you can use either the Daylight or Cloudy white balance setting. Or if you're shooting RAW, you can shoot a gray card in one frame and use that image to color-correct images as a batch during RAW image conversion, as described in Chapter 4. If you don't want a completely neutral color — and, generally, you don't want perfectly neutral color — then adjust the temperature and tint controls during RAW image conversion to warm up or cool down the color.

Without question, window light is one of the most beautiful of all natural light options for portraits, and it offers exceptional versatility. If the light is too bright, you can simply move the subject farther from the window or put a fabric over the window. Window

12.4 Regardless of where I'm shooting, I take advantage of making people pictures with almost anyone who agrees to let me photograph them. I couldn't pass up the opportunity to photograph this vendor at a local fair. The tent helped diffuse the bright outdoor light. Exposure: ISO 100, f/3.5, 1/1000 second with -2 Exposure Compensation using an EF 24-70mm, f/2.8L USM lens.

light provides ample light to bounce into the shadow side of the subject using a reflector. For window-light portraits, try to shoot when the sun is at a mid to low angle above the horizon. However, strong midday sunlight can also be quite usable if you cover the window with a lightweight fabric, such as a sheer curtain.

A good starting point for window-light portraits is to place the subject so that one side of his face is lit and the other side is in shadow. Then position a silver or white reflector so that it bounces light into the shadow side of the face.

Posing

Entire books are written on posing techniques for portraits. But you won't go wrong with one essential guideline — the best pose is the one that makes the subject look comfortable, relaxed, and natural. In practice, this doesn't mean that the subject slouches on a chair; it means letting the subject find a comfortable position, and then tweaking it to ensure that the subject lines and appearance are crisp and attractive. Key lines are the structural lines that form the portrait. You can also use diagonal and triangular lines formed by the legs, arms, and shoulders to create more dynamic portraits.

12.5 Late afternoon window light lit these subjects. Exposure: ISO 100, f/2.8, 1/30 second using an EF 70-200mm f/2.8L IS USM lens.

Placing the subject's body at an angle to the camera is more flattering and dynamic than a static pose with the subject's head and shoulders squared off to the camera. Watch that objects in the background do not intersect behind the subject's head to avoid having the proverbial telephone pole seeming to grow out of the subject's head.

Rapport and direction

Even if you light and pose the subject perfectly, a portrait will fail if you haven't connected with the subject. Your connection with the subject is mirrored in the subject's eyes. Every minute that you spend building a good relationship with the subject pays big dividends in the final images. Keep in mind that even the most sparking personalities can freeze when the lens is pointed in their direction. To ease their anxiety, you have to be a consummate director, calming the subject, gently guiding him or her into the spirit of the session, and providing encouraging feedback.

Exposure approaches

For portrait shooting, you can often get excellent exposures using Evaluative metering with no exposure modifications. However, if there are hot spots on the subject's skin

that you can't eliminate with lighting modifications, or if there are blocked shadows, you can use Auto Exposure Lock or Exposure Compensation, detailed in Chapter 2 to retain detail in the highlights.

Also in regard to exposure, my preference for portraits is to ensure very fine detail and the lowest level of digital noise possible in the images. For me, that means shooting between ISO 100 and 400, 99 percent of the time.

If you're shooting in very low-light scenes, increasing the ISO to 800 provides good prints; however, there is nothing that spoils an otherwise beautiful portrait more quickly than seeing a colorful scattering of digital noise in facial shadows and in skin areas. If you have to shoot at a high ISO, be sure to turn on noise reduction using C.Fn II-5.

To control depth of field, some photographers rely solely on f-stop changes. Certainly, aperture changes render the background differently, and wide apertures from f/5.6 to f/1.4 are common in portraiture. However, you can use the additional factors that affect depth of field:

- ▶ **Lens.** A telephoto lens has an inherently shallow depth of field, and a wide-angle lens has an inherently extensive depth of field.

- ▶ **Camera-to-subject distance.** The closer you are to the subject, the shallower the depth of field, and vice versa.

- ▶ **Subject-to-background distance.** The farther the subject is from the background, the softer the background details, and vice versa.

12.6 This portrait was made with studio strobes. Exposure: ISO 100, f/18, 1/125 second using an EF 24-70mm, f/2.8L USM lens.

This chapter provides a lot of information, and it may seem overwhelming. If you're new to using the Rebel, then use this condensed checklist for making portraits.

 This checklist assumes that you have set up the lighting and that the subject is already sitting or standing in that light.

▸ **Set the metering mode to Evaluative.**

▸ **Set the Autofocus mode to either One-shot or to AI Focus AF.** If you're shooting children, I recommend AI Focus AF because if the child begins to move, the camera tracks focus on the child as he or she moves.

▸ **Set the T2i/550D to Av shooting mode, and then turn the Main dial and set the aperture to f/5.6, f/4, or f/2.8.** The apertures you can choose depend on the lens you're using. These wide apertures help to soften background details to prevent them from distracting from the subject. Also move the subject several feet or more from the background.

▸ **Set the ISO.** The lower the ISO, the better the image quality. Try to keep the ISO at 100 to 400.

▸ **Check the shutter speed.** If the shutter speed is too slow to handhold the camera or to prevent blur if the subject moves, increase the ISO, use an accessory Speedlite, or add more light to the scene.

▸ **Set the white balance to match the light in the scene or set a custom white balance.** For details on setting the white balance, see Chapter 3.

▸ **Select a single AF point manually.** Manually select the one AF point that is on top of the subject's eye that is closest to the lens. Chapter 2 details how to manually select an AF point.

▸ **Compose the image so that the subject's eyes are in the top half of the frame, and position the subject at a dynamic angle to the camera.** Chapter 9 offers composition tips.

▸ **Chat with the subject to elicit the expression that you want.**

▸ **Focus on the eye nearest the lens by having the selected AF point on top of the eye nearest the lens, and then make the picture.**

▸ **Enlarge the image on the LCD and verify that the focus is tack-sharp on the subject's eye.** Never assume that the focus is sharp — it takes only a moment to verify it on the LCD.

▸ **Check the image exposure by evaluating the histogram, and then reshoot if there are any blown highlights within the subject.** If there are blown highlights, you can use AE Lock or negative Exposure Compensation.

Portraits with a One-Light Setup

If you're just starting to build a studio lighting system, it is important to know that you can make great portraits with a single light and an umbrella or softbox, combined with silver reflectors. For example, set up the single light on a stand shooting into an umbrella or fitted with a softbox. Then place the light at a 45-degree angle to the right of the camera with the light pointed slightly down onto the subject. This creates a shadow under the subject's nose and lip. Now place a silver reflector to the left of the camera and adjust its position to soften the shadow created by the light.

For classic loop lighting, the nose shadow should follow the lower curve of the cheek on the opposite side of the light. The shadow from the light should cover the unlit side of the nose without the shadow extending onto the subject's cheek. Also ensure that the eyebrows and the top of the eyelids are well lit. You can also adjust the height of the key light to change the curve under the cheekbone.

Portrait Photography Tips

A library of books has been written on portrait and people photography. If you want to specialize in people photography, read the books, practice the classic techniques, and keep practicing until they become second nature.

But when the time comes to start shooting, relax and keep it simple. At a minimum, here are the basic guidelines that I keep in mind for every portrait session.

12.7 Portraits aren't restricted to people. Pets make excellent portrait subjects as well. Exposure: ISO 100, f/14, 1/125 second using an EF 85mm, f/1.2L II USM lens.

▶ **Connect with the person, couple, or group.** Engage your subject in conversation about his or her interests. When you find a topic that lights up his or her eyes, start shooting and keep talking with the subject.

▶ **Bring a mirror.** Portrait subjects, especially women, know how they want to appear in a portrait. I often bring a full-length mirror so the subject can see what she looks like in a certain position or pose. The mirror significantly reduces the amount of coaching I have to give the subject.

▶ **Focus on the eye that is closest to the camera.** If the eyes are not in tack-sharp focus, reshoot.

▶ **Keep the subject's eyes in the top third of the frame.**

▶ **The best pose is the pose in which the subject feels comfortable and relaxed.**

▶ **Be prepared.** Be unflappable. Back up everything.

▶ **Check the histogram and focus as you shoot.** If you wait to do periodic checks of the exposure by evaluating the histogram and of the focus, then it will be too late to reshoot. There's nothing that substitutes for on-scene verification of the images. To check the histogram, press the Playback button, and then press the Display button one or more times until the histogram is displayed. To check the focus, go to Single image display by pressing the Display button until the large preview of the image is displayed, and then press the AF-point selection/Magnify button multiple times to enlarge the preview. Then press the cross keys to scroll to the subject's eye to ensure tack-sharp focus.

▶ **The best shots happen at the end of the session.** After shooting a session, the wind-down period is often when adult subjects finally feel they can relax, and, predictably, that's when you will get the most natural-looking shots. So use the last minutes of your session to your advantage.

▶ **Preview the images with the subject.** One of the best ways to coach a subject is to show them a preview image on the camera's LCD and discuss how you both can improve on it by making specific changes. Never make the subject feel they are not performing well, so cast suggestions in a positive light, such as indicating they are just "tweaks" or "slight changes."

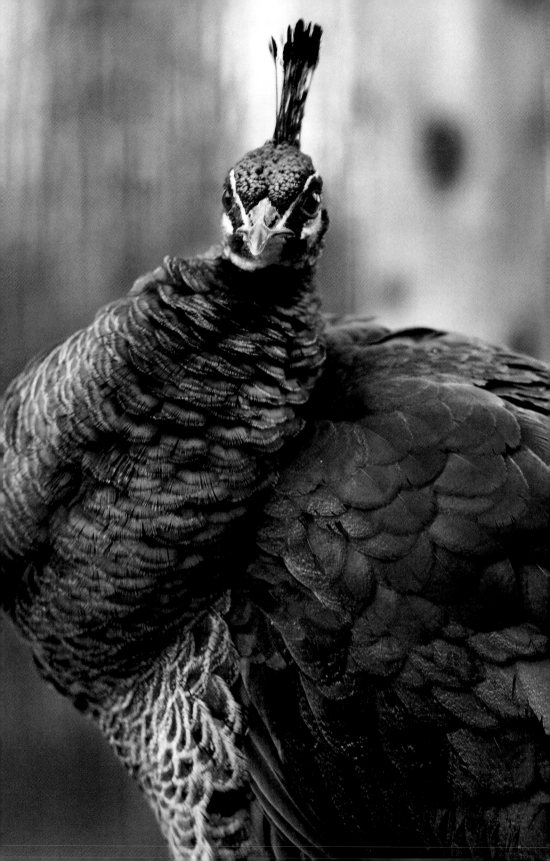

Exploring RAW Capture

If you want to get the highest quality images from the EOS T2i/550D, then choosing to capture RAW images is the way to get them. In addition, you have the opportunity to determine how the image data from the camera is interpreted as you convert, or process, the RAW images. While RAW capture offers significant advantages, it isn't for everyone. If you prefer images that are ready to print straight out of the camera, then JPEG capture is the best option. However, if you enjoy working with images on the computer and having creative control over the quality and appearance of the image, then RAW is the best option.

This appendix provides an overview of RAW capture, as well as a brief walk-through on converting RAW image data into a final image.

Learning about RAW Capture

One way to understand RAW capture is by comparing it to JPEG capture, which most photographers are familiar with already. When you shoot JPEG images, the camera edits or processes the images before storing them on the media card. This processing includes converting images from 14-bit files to 8-bit files, setting the color, saturation, and contrast, and generally giving you a file that is finished. Very often, JPEG images can be printed with no editing. But in other cases, you may encounter images where you want more control over how the image is rendered — for example, you may want to recover blown highlights, to tone down high-contrast images, or to correct the color of an image.

Of course, you can edit JPEG images in an editing program and make some corrections, but the amount of latitude for editing is limited. With JPEG images, large amounts of image data are discarded when the images are converted to 8-bit mode in the camera, and then the image data is further reduced when JPEG algorithms compress image files to reduce the size. As a result, the image leaves little, if any, wiggle

room to correct the tonal range, white balance, contrast, and saturation during image editing. Ultimately, this means that if the highlights in an image are overexposed, or blown, then they're blown for good.

If the shadows are blocked up (meaning they lack detail), then they will likely stay blocked up. It is possible to make improvements in Photoshop, but the edits make the final image susceptible to posterization or banding that occurs when the tonal range is stretched and gaps appear between tonal levels. This stretching makes the tonal range on the histogram look like a comb.

By contrast, RAW capture allows you to work with the data that comes off the image sensor with virtually no internal camera processing. The only camera settings that the camera applies to a RAW image are ISO, shutter speed, and aperture. And because many of the key camera settings have been noted but not applied in the camera, you have the opportunity to make changes to settings, including image brightness, white balance, contrast, and saturation, when you convert the RAW image data into a final image using a conversion program such as Canon's Digital Photo Professional, Adobe Camera Raw, Adobe Lightroom, or Apple Aperture.

An important characteristic of RAW capture is that it offers more latitude and stability in editing converted RAW files than JPEG files offer. RAW images have rich data depth and provide significantly more image data to work with during conversion and subsequent image editing. In addition, RAW files are more forgiving if you need to recover overexposed highlight detail during conversion of the RAW file. These differences in data richness translate directly to editing leeway. And maximum editing leeway is important because after the image is converted, all the edits you make in an editing program are destructive. Another advantage of RAW conversion is that as conversion programs improve, you can go back to older RAW image files and convert them again using the improved features and capabilities of the conversion program.

Proper exposure is important with any image, and it is no less so with RAW images. With RAW images, proper exposure provides a file that captures rich tonal data that withstands conversion and editing well. For example, during conversion, image brightness levels must be mapped so that the levels look more like what you see with your eyes — a process called *gamma encoding*. In addition, you will also likely adjust the contrast and midtones and move the endpoints on the histogram. For an image to withstand these conversions and changes, a correctly exposed and data-rich file is critical.

Proper exposure is also critical, considering that digital capture devotes the lion's share of tonal levels to highlights while devoting far fewer levels to shadows. In fact, half of all the tonal levels in the image are assigned to the first f-stop of brightness. Half of the rest of the tonal levels account for the second f-stop, and half into the next f-stop, and so on.

> **NOTE** With digital cameras, dynamic range depends on the sensor. The brightest f-stop is a function of the brightest highlight in the scene that the sensor can capture, or the point at which the sensor element is saturated with photons. The darkest tone is determined by the point at which the noise in the system is greater than the comparatively weak signal generated by the photons hitting the sensor element.

Clearly, capturing the first f-stop of image data is critical because fully half of the image data is devoted to that f-stop. If an image is underexposed, not only is important image data sacrificed, but the file is also more likely to have digital noise in the shadow areas.

Underexposure also means that during image conversion, the fewer captured levels must be stretched across the entire tonal range. Stretching tonal levels creates gaps between levels that reduce the continuous gradation between levels.

The general guideline when shooting RAW capture is to expose with a bias to the right so that the highlight pixels just touch the right side of the histogram. Thus, when tonal mapping is applied during conversion, the file has significantly more bits that can be redistributed to the midtones and darker tones where the human eye is most sensitive to changes.

If you've always shot JPEG capture, the exposing-to-the-right approach may seem just wrong. When shooting JPEG images, the guideline is to expose so that the highlights are not blown out because if detail is not captured in the highlights, it's gone for good. This guideline is good for JPEG images where the tonal levels are encoded and the image is essentially pre-edited inside the camera. However, with RAW capture, gamma encoding and other contrast adjustments are made during conversion with a good bit of latitude. And if highlights are overexposed, conversion programs such as Adobe Camera Raw or Digital Photo Professional can recover varying amounts of highlight detail.

In summary, RAW capture produces files with the most image data that the camera can deliver, and you get a great deal of creative control over how the RAW data is converted into a final image. Most important, you get strong, data and color-rich files that withstand image editing and can be used to create lovely prints.

However, if you decide to shoot RAW images, you also sign on for another step in the process from capturing images to getting finished images, and that step is RAW conversion. With RAW capture, the overall workflow is to capture the images, convert the RAW data in a RAW-conversion program, edit images in an image-editing program, and then print them. You may decide that you want to shoot in RAW+JPEG so that you have JPEGs that require no conversion, but you have the option to convert exceptional or problem images from the RAW files with more creative control and latitude.

Canon's RAW Conversion Program

Unlike JPEG images, RAW images are stored in proprietary format, and they cannot be viewed on some computers or opened in some image-editing programs without first converting the files to a more universal file format such as TIFF, PSD, or JPEG. Canon includes a free program, Digital Photo Professional, on the EOS Digital Solution Disk that you can use to convert T2i/550D RAW files, and then save them as TIFF or JPEG files.

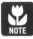

Images captured in RAW mode have a .CR2 file name extension.

Digital Photo Professional (DPP) is noticeably different from traditional image-editing programs. It focuses on image conversion tasks, including correcting, tweaking, or adjusting white balance, brightness, shadow areas, contrast, saturation, sharpness, noise reduction, and so on. It doesn't include some familiar image-editing tools, nor does it offer the ability to work with layers.

Sample RAW Image Conversion

Although RAW image conversion adds a step to image processing, this important step is well worth the time. To illustrate the overall process, here is a high-level workflow for converting an EOS T2i/550D RAW image using Canon's DPP.

Be sure to install the Digital Photo Professional application provided on the EOS Digital Solution Disk before following this task sequence.

1. **Start Digital Photo Professional (DPP).** The program opens. If no images are displayed, you can select a directory and folder from the Folder panel.

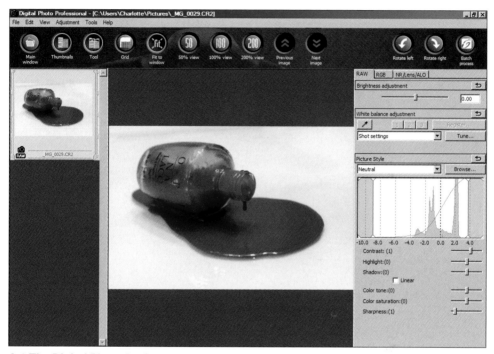

A.1 The Digital Photo Professional editing window

2. **Double-click the image you want to process.** The image preview opens with the RAW image tool palette displayed with the RAW tab selected. If the Tool palette isn't displayed, click View ➟ Tool palette. In the editing mode, you can:

 • **Drag the Brightness adjustment slider to the left to darken the image or to the right to lighten it.** To quickly return to the original brightness setting, click the curved arrow above and to the right of the slider.

 • **Use the White Balance adjustment control to adjust color.** You can click the Eyedropper tool, and then click an area that is white or gray in the image to quickly set white balance, choose one of the preset White Balance settings from the Shot Settings drop-down menu, or click Tune to adjust the white balance using a color wheel. After you correct the color you can click Register to save the setting and then use it to correct other images.

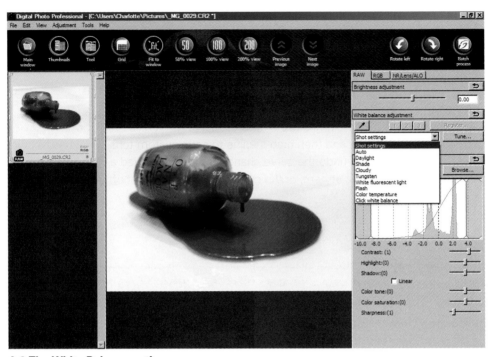

A.2 The White Balance options

- **Change the Picture Style by clicking the down arrow next to the currently listed Picture Style and selecting a different Picture Style from the list.** The Picture Styles offered in DPP are the same as those offered on the menu on the T2i/550D. When you change the Picture Style in DPP, the image preview updates to show the change. If you don't like the results, you can click the curved arrow to the right of Picture Style to switch back to the original Picture Style.

- **Adjust the tonal curve.** Sliders enable you to target the image contrast, highlights, and shadows for adjustments. You can also adjust the black-and-white points on the image histogram by dragging the bars at the far left and right of the histogram toward the center. Then you can also adjust the color, saturation, and sharpness.

- **Adjust the Color tone, Color saturation, and Sharpness by dragging the sliders.** Dragging the Color tone slider to the right increases the green tone, and dragging it to the left increases the magenta tone. Dragging the Color saturation slider to the right increases the saturation, and vice versa. Dragging the Sharpness slider to the right increases the sharpness, and vice versa.

3. **Click the RGB tab.** Here you can apply an RGB curve and also apply separate curves in each of the three color channels: Red, Green, and Blue. You can also adjust the following:

- Click one of the tonal curve options to the right of Tone curve assist to set a classic S-curve without changing the black-and-white points. If you want to increase the curve, click the Tone curve assist button marked with a plus (+) sign one or more times to increase the curve. Or you can click the linear line on the histogram, and then drag the line to set a custom tonal adjustment curve. If you want to undo the curve changes, click the curved arrow to the right of Tone curve adjustment, or the curved arrow to the right of Tone curve assist.

- Click the R, G, or B buttons next to RGB to make changes to a single color channel. Working with an individual color channel is helpful when you need to reduce an overall colorcast in an image.

- Drag the Brightness slider to the left to darken the image or to the right to brighten the image. The changes you make are shown on the RGB histogram as you make them.

- Drag the Contrast slider to the left to decrease contrast or to the right to increase contrast.

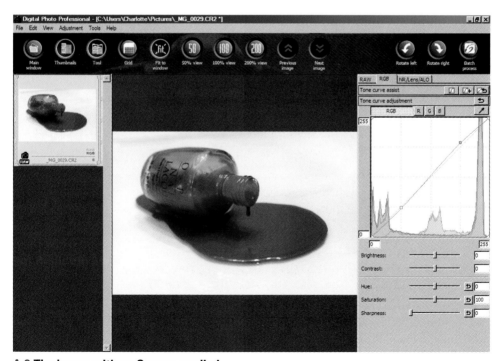

A.3 The image with an S curve applied

4. **Click the NR/Lens/ALO tab.** Control on this tab enables you to:

- **Set Auto Lighting Optimizer.** Auto Lighting Optimizer automatically corrects overexposed images and images with flat contrast. This option can be applied automatically to JPEG images in the camera, but the only way to apply it to RAW images is in Digital Photo Professional. You can choose Low, Standard, or Strong settings, or turn off Auto Lighting Optimizer by clicking the check box.

- **Control digital noise if it is problematic in the image.** There are controls for both RAW and TIFF/JPEG images. Be sure to enlarge the preview image to 100 percent and scroll to a shadow area to set noise reduction for Luminance and/or Chrominance.

- **Correct Lens aberration.** Click the Tune button to display another dialog box where you can view and adjust the Shooting distance information, correct vignetting using Peripheral illumination, Distortion, chromatic aberration, and Color blur.

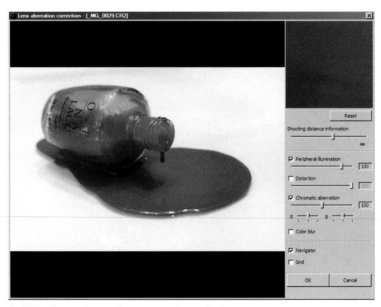

A.4 The Lens aberration correction window

5. **In the image preview window, choose File→ Convert and save.** The Convert and save dialog box appears. In the dialog box, you can specify the file type and bit depth at which you want to save the image. Just click the down arrow next to Kind of file and choose one of the options, such as TIFF 16-bit. Then you can set the Image Quality setting if you are saving in JPEG or TIFF plus JPEG format, set the Output resolution, choose to embed the color profile, or resize the image.

 The Edit menu also enables you to save or copy the current image's conversion settings as a recipe. Then you can apply the recipe to other images in the folder.

6. **Click Save.** DPP displays the Digital Photo Professional dialog box until the file is converted. DPP saves the image in the location and format that you choose.

This is a very brief introduction to RAW capture and processing. If you think that RAW is a good option for you, then I encourage you to explore more about RAW capture in books and Web tutorials that are available.

How to Use the Gray Card and Color Checker

Have you ever wondered how some photographers are able to consistently produce photos with such accurate color and exposure? It's often because they use gray cards and color checkers. Knowing how to use these tools helps you take some of the guesswork out of capturing photos with great color and correct exposures every time.

The Gray Card

Because the color of light changes depending on the light source, what you might decide is neutral in your photograph, isn't neutral at all. This is where a gray card comes in very handy. A gray card is designed to reflect the color spectrum neutrally in all sorts of lighting conditions, providing a standard from which to measure for later color corrections or to set a custom white balance.

By taking a test shot that includes the gray card, you guarantee that you have a neutral item to adjust colors against later if you need to. Make sure that the card is placed in the same light that the subject is for the first photo, and then remove the gray card and continue shooting.

 When taking a photo of a gray card, de-focus your lens a little; this ensures that you capture a more even color.

Because many software programs enable you to address color correction issues by choosing something that should be white or neutral in an image, having the gray card in the first of a series of photos allows you to select the gray card as the neutral point. Your software resets red, green, and blue to be the same value, creating a neutral midtone. Depending on the capabilities of your software, you might be able to save the adjustment you've made and apply it to all other photos shot in the same series.

If you'd prefer to made adjustments on the spot, for example, and if the lighting conditions will remain mostly consistent while you shoot a large number of images, it is

advisable to use the gray card to set a custom white balance in your camera. You can do this by taking a photo of the gray card filling as much of the frame as possible. Then, use that photo to set the custom white balance.

The Color Checker

A color checker contains 24 swatches which represent colors found in everyday scenes, including skin tones, sky, foliage, etc. It also contains red, green, blue, cyan, magenta, and yellow, which are used in all printing devices. Finally, and perhaps most importantly, it has six shades of gray.

Using a color checker is a very similar process to using a gray card. You place it in the scene so that it is illuminated in the same way as the subject. Photograph the scene once with the reference in place, then remove it and continue shooting. You should create a reference photo each time you shoot in a new lighting environment.

Later on in software, open the image containing the color checker. Measure the values of the gray, black, and white swatches. The red, green, and blue values in the gray swatch should each measure around 128, in the black swatch around 10, and in the white swatch around 245. If your camera's white balance was set correctly for the scene, your measurements should fall into the range (and deviate by no more than 7 either way) and you can rest easy knowing your colors are true.

If your readings are more than 7 points out of range either way, use software to correct it. But now you also have black and white reference points to help. Use the levels adjustment tool to bring the known values back to where they should be measuring (gray around 128, black around 10, and white around 245).

If your camera offers any kind of custom styles, you can also use the color checker to set or adjust any of the custom styles by taking a sample photo and evaluating it using the on-screen histogram, preferably the RGB histogram if your camera offers one. You can then choose that custom style for your shoot, perhaps even adjusting that custom style to better match your expectations for color.

Glossary

720p/1080i/1080p High-definition video recording standards that refer to the vertical resolution (the number of horizontal lines on the screen) — either 720 or 1080 lines. Seven hundred twenty horizontal lines translate to a width of 1280 pixels, and 1080 lines translate to 1920 pixels of horizontal resolution. The p stands for progressive scan, which displays the video frame all at once. The i stands for interlaced, an analog compression scheme that allows 60 frames per second (fps) to be transmitted in the same bandwidth as 30 fps by displaying 50 percent of the video frame at a time.

AE Automatic exposure.

AE Lock (Automatic Exposure Lock) A camera control that enables the photographer to decouple exposure from autofocusing by locking the exposure at a point in the scene other than where the focus is set. AE Lock enables the photographer to set the exposure for a critical area in the scene.

angle of view The amount or area seen by a lens or viewfinder, measured in degrees. Shorter or wide-angle lenses and zoom settings have a wider angle of view. Longer or telephoto lenses and zoom settings have a narrower angle of view.

aperture The lens opening through which light passes. Aperture size is adjusted by opening or closing the lens diaphragm. Aperture is expressed in f-numbers such as f/8, f/5.6, and so on.

artifact An unintentional or unwanted element in an image caused by an imaging device (such as color flecks and digital noise), or as a byproduct of software processing such as compression.

artificial light The light from an electric light or flash unit. This is the opposite of natural light.

autofocus A function where the camera focuses on the subject using the selected autofocus point or points. Pressing the Shutter button halfway down activates autofocus. This is the opposite of manual focus.

automatic exposure (AE) A function where the camera sets all or some of the exposure elements automatically. In automatic shooting modes, the camera sets all exposure settings. In semiautomatic modes, the photographer sets the ISO and either the aperture (Av mode) or the shutter speed (Tv mode), and the camera automatically sets the shutter speed or aperture, respectively.

available light The natural or artificial light within a scene. This is also called existing light.

axial chromatic aberration A lens phenomenon that bends different-colored light rays at different angles, thereby focusing them on different planes, which results in color blur or flare.

barrel distortion A lens aberration resulting in a bowing of straight lines outward from the center.

bit depth The number of bits used to represent each pixel in an image.

blocked up A description of shadow areas that lack detail.

blooming Bright edges or halos in digital images around light sources, and bright reflections caused by an oversaturation of image sensor photosites.

bokeh The shape and illumination characteristics of the out-of-focus area in an image.

bounce light Light that is directed toward an object, such as a wall or ceiling, so that it reflects (or bounces) light back onto the subject.

brightness The perception of the light reflected or emitted by a source; the lightness of an object or image. See also *luminance*.

buffer Temporary storage for data in a camera or computer.

bulb A shutter speed setting that keeps the shutter open as long as the Shutter button is fully depressed.

cable release An accessory that connects to the camera and allows you to trip the shutter using the cable instead of by pressing the Shutter button.

chroma noise Extraneous, unwanted color artifacts in an image.

chromatic aberration A lens phenomenon that bends different-colored light rays at different angles, thereby focusing them on different planes. Two types of chromatic aberration exist: axial and chromatic difference of magnification. The effect of chromatic aberration increases at longer focal lengths. See also *axial chromatic aberration* and *chromatic difference of magnification*.

chromatic difference of magnification A lens phenomenon that bends different-colored light rays at different angles, thereby focusing them on different planes; this appears as color fringing where high-contrast edges show a line of color along their borders.

CMOS (complementary metal-oxide semiconductor) The type of imaging sensor used in the T2i/550D to record images. CMOS sensors are chips that use power more efficiently than other types of recording media.

color balance The color reproduction fidelity of a digital camera's image sensor and of the lens. In a digital camera, color balance is achieved by setting the white balance to match the scene's primary light source or by setting a custom white balance. You can adjust color balance in image-editing programs.

color/light temperature A numerical description of the color of light measured in Kelvin. Warm, late-day light has a lower color temperature. Cool, early-day light has a higher temperature. Midday light is often considered to be white light (5000K). Flash units are often calibrated to 5000K.

color space In the spectrum of colors, a subset of colors that is encompassed by a particular space. Different color spaces include more or fewer colors. See also *RGB* and *sRGB*.

compression A means of reducing file size. Lossy compression permanently discards information from the original file. Lossless compression does not discard information from the original file and allows you to re-create an exact copy of the original file without any data loss. See also *lossless* and *lossy*.

contrast The range of tones from light to dark in an image or scene.

contrasty A term used to describe a scene or image with great differences in brightness between light and dark areas.

crop To trim or discard one or more edges of an image. You can crop when taking a picture by moving closer to the subject to exclude parts of a scene, by zooming in with a zoom lens, or via an image-editing program.

daylight balance A general term used to describe the color of light at approximately 5000K, such as midday sunlight or an electronic flash. A white balance setting on the camera calibrated to give accurate colors in daylight.

depth of field The zone of acceptable sharpness in a photo extending in front of and behind the plane of sharp focus.

diaphragm Adjustable blades inside the lens that open and close to determine the lens aperture.

diffuser Material such as fabric or paper that is placed over the light source to soften the light.

dpi (dots per inch) A measure of printing resolution.

dynamic range The difference between the lightest and darkest values in a scene as measured by f-stops. A camera that can hold detail in both highlight and shadow areas over a broad range of f-stops is said to have a High Dynamic Range.

exposure The amount of light reaching the image sensor. At a given ISO, exposure is the result of the intensity of light multiplied by the length of time the light strikes the sensor.

exposure meter A general term referring to the built-in light meter that measures the light reflected from the subject back to the camera. EOS cameras use reflective meters. The exposure is shown in the viewfinder and on the LCD panel as a scale, with a tick mark under the scale that indicates ideal exposure, overexposure, and underexposure.

extender An attachment that fits between the camera body and the lens to increase the focal length of the lens.

extension tube A hollow ring attached between the camera lens mount and the lens, that increases distance between the optical center of the lens and the sensor, and decreases minimum focusing distance.

fast A term that refers to film, ISO settings, and photographic paper that have high sensitivity to light. This also refers to lenses that offer a wide aperture, such as f/2.8 or f/1.4, and to a short shutter speed.

filter A piece of glass or plastic that is usually attached to the front of the lens to alter the color, intensity, or quality of the light. Filters are also used to alter the rendition of tones, reduce haze and glare, and create special effects such as soft focus and star effects.

flare Unwanted light reflecting and scattering inside the lens, causing a loss of contrast and sharpness, and/or artifacts in the image.

flat A term that describes a scene, light, photograph, or negative that displays little difference between dark and light tones. This is the opposite of contrasty.

f-number A number representing the maximum light-gathering ability of a lens, or the aperture setting at which a photo is taken. It is calculated by dividing the focal length of the lens by its diameter. Wide apertures are designated with small numbers, such as f/2.8. Narrow apertures are designated with large numbers, such as f/22. See also *aperture*.

fps (frames per second) In still shooting, fps refers to the number of frames either in One-shot or Continuous shooting modes. In video film recording, the digital standard is 30 fps.

focal length The distance from the optical center of the lens to the focal plane when the lens is focused on infinity. The longer the focal length is, the greater the magnification.

focal point The point in an image where rays of light intersect after reflecting from a single point on a subject.

focus The point at which light rays from the lens converge to form a sharp image. This is also the sharpest point in an image achieved by adjusting the distance between the lens and image.

frame A term used to indicate a single exposure or image. This also refers to the edges around the image.

f-stop See *aperture*.

ghosting A type of flare that causes a clearly defined reflection to appear in the image symmetrically opposite to the light source, creating a ghost-like appearance. Ghosting is caused when the sun or a strong light source is included in the scene, and a complex series of reflections occur among the lens surfaces.

gigabyte The usual measure of the capacity of digital mass storage devices; a gigabyte is slightly more than 1 billion bytes.

grain See *noise*.

gray-balanced The property of a color model or color profile where equal values of red, green, and blue correspond to a neutral gray value.

gray card A card that reflects a known percentage of the light that falls on it. Typical gray cards reflect 18 percent of the light. Gray cards are standard for taking accurate exposure-meter readings and for providing a consistent target for color balancing during the color-correction process using an image-editing program.

grayscale A scale that shows the progression from black to white using tones of gray. This also refers to rendering a digital image in black, white, and tones of gray. It is also known as monochrome.

highlight A term describing a light or bright area in a scene, or the lightest area in a scene.

histogram A graph that shows the distribution of tones or colors in an image.

hue The color of a pixel defined by the measure of degrees on the color wheel, starting at 0 for red, depending on the color system and controls.

HDV and AVCHD High Definition Video and Advanced Video Codec High Definition refer to video compression and decompression standards.

infinity The farthest position on the distance scale of a lens (approximately 50 feet and beyond).

ISO (International Organization for Standardization) A rating that describes the sensitivity to light of film or an image sensor. ISO in digital cameras refers to the amplification of the signal at the photosites. ISO is expressed in numbers such as ISO 100. The ISO rating doubles as the sensitivity to light doubles. For example, ISO 200 is twice as sensitive to light as ISO 100.

JPEG (Joint Photographic Experts Group) A lossy file format that compresses data by discarding information from the original file to create small image file sizes.

Kelvin A scale for measuring temperature based around absolute zero. The scale is used in photography to quantify the color temperature of light.

LCD (liquid crystal display) The image screen on digital cameras that displays menus and images during playback and Live View shooting.

lightness A measure of the amount of light reflected or emitted. See also *brightness* and *luminance*.

linear A relationship where doubling the intensity of light produces double the response, as in digital images. The human eye does not respond to light in a linear fashion. See also *nonlinear*.

lossless A term that refers to file compression that discards no image data. TIFF is a lossless file format.

lossy A term that refers to compression algorithms that discard image data, often in the process of compressing image data to a smaller size. The higher the compression rate, the more data that is discarded and the lower the image quality. JPEG is a lossy file format.

luminance The light reflected or produced by an area of the subject in a specific direction and measurable by a reflected light meter. See also *brightness*.

megabyte Slightly more than 1 million bytes.

megapixel One million pixels. This is used as a measure of the capacity of a digital image sensor.

memory card In digital photography, removable media that stores digital images, such as the Secure Digital media card used to store T2i/550D images.

metadata Data about data, or more specifically, information about a file. This information, which is embedded in image files by the camera, includes aperture, shutter speed, ISO, focal length, date of capture, and other technical information. Photographers can add additional metadata in image-editing programs, including name, address, copyright, and so on.

middle gray A shade of gray that has 18 percent reflectance.

midtone An area of medium brightness; a medium-gray tone in a photographic print. A midtone is neither a dark shadow nor a bright highlight.

neutral density filter A filter attached to the lens or light source to reduce the required exposure.

noise Extraneous visible artifacts that degrade digital image quality. In digital images, noise appears as multicolored flecks and as grain that is similar to grain seen in film. Both types of noise are most visible in high-speed digital images captured at high ISO settings.

nonlinear A relationship where a change in stimulus does not always produce a corresponding change in response. For example, if the light in a room is doubled, the room is not perceived as being twice as bright. See also *linear*.

normal lens or zoom setting A lens or zoom setting whose focal length is approximately the same as the diagonal measurement of the film or image sensor used. In full-frame 35mm format, a

50 to 60mm lens is considered to be a normal lens. On the T2i/550D, normal is about 28mm. A normal lens more closely represents the perspective of normal human vision.

open up To switch to a lower f-stop, which increases the size of the diaphragm opening.

overexposure Giving an image sensor more light than is required to make an acceptable exposure. The resulting picture is too light.

panning A technique of moving the camera horizontally to follow a moving subject, which keeps the subject sharp but blurs and/or streaks background details.

photosite The place on the image sensor that captures and stores the brightness value for one pixel in the image.

pincushion distortion A lens aberration causing straight lines to bow inward toward the center of the image.

pixel The smallest unit of information in a digital image. Pixels contain tone and color that can be modified. The human eye merges very small pixels so that they appear as continuous tones.

plane of critical focus The most sharply focused part of a scene. This is also referred to as the point or plane of sharpest focus.

polarizing filter A filter that reduces glare from reflective surfaces such as glass or water at certain angles.

ppi (pixels per inch) The number of pixels per linear inch on a monitor or image file that are used to describe overall display quality or resolution. See also *resolution.*

RAW A proprietary image file in which the image has little or no in-camera processing. Because image data has not been processed, you can change key camera settings, including brightness and white balance, in a conversion program (such as Canon DPP or Adobe Camera Raw) after the picture is taken.

reflective light meter A device — usually a built-in camera meter — that measures light emitted by a photographic subject back to the camera.

reflector A surface used to redirect light into shadow areas of a scene or subject.

resolution The number of pixels in a linear inch. Resolution is the amount of data used to represent detail in a digital image. Also, the resolution of a lens that indicates the capacity of reproduction. Lens resolution is expressed as a numerical value such as 50 or 100 lines, which indicates the number of lines per millimeter of the smallest black-and-white line pattern that can be clearly recorded.

RGB (Red, Green, Blue) A color model based on additive primary colors of red, green, and blue. This model is used to represent colors based on how much of red, green, and blue is required to produce a given color.

saturation As it pertains to color, a strong, pure hue undiluted by the presence of white, black, or other colors. The higher the color purity is, the more vibrant the color.

sharp The point in an image at which fine detail is clear and well defined.

shutter A mechanism that regulates the amount of time during which light is let into the camera to make an exposure. Shutter time or shutter speed is expressed in seconds and fractions of seconds, such as 1/30 second.

slave A flash unit that is synchronized to and controlled by another flash unit.

slow A reference to film, digital camera settings, and photographic paper that have low sensitivity to light, requiring relatively more light to achieve accurate exposure. This also refers to lenses that have a relatively wide aperture, such as f/3.5 or f/5.6, and to a long shutter speed.

speed The relative sensitivity to light of photographic materials such as film, digital camera sensors, and photographic paper. This also refers to the ISO setting, and the ability of a lens to let in more light by opening to a wider aperture. See also *fast*.

spot meter A device that measures reflected light or brightness from a small portion of a subject.

sRGB A color space that encompasses a typical computer monitor.

stop See *aperture*.

stop down To switch to a higher f-stop, thereby reducing the size of the diaphragm opening.

telephoto A lens or zoom setting with a focal length longer than 50 to 60mm in full-frame 35mm format.

TIFF (Tagged Image File Format) A universal file format that most operating systems and image-editing applications can read. Commonly used for images, TIFF supports 16.8 million colors and offers lossless compression to preserve all the original file information.

tonal range The range from the lightest to the darkest tones in an image.

TTL (Through the Lens) A system that reads the light passing through a lens that strikes an image sensor.

tungsten lighting Common household lighting that uses tungsten filaments. Without filtering or adjusting to the correct white balance settings, pictures taken under tungsten light display a yellow-orange colorcast.

underexposure The effect of exposing an image sensor to less light than is required to make an accurate exposure. The resulting picture is too dark.

viewfinder A viewing system that allows the photographer to see all or part of the scene that will be included in the final picture.

vignetting Darkening of edges on an image that can be caused by lens distortion, using a filter, or using the wrong lens hood. This is also used creatively in image editing to draw the viewer's eye toward the center of the image.

white balance The relative intensity of red, green, and blue in a light source. On a digital camera, white balance compensates for light that is different from daylight to create correct color balance.

wide angle A lens with a focal length shorter than 50 to 60mm in full-frame 35mm format.

INDEX

Guides to go.

Colorful, portable *Digital Field Guides* are packed with essential tips and techniques about your camera equipment. They go where you go; more than books—they're *gear*. Each $19.99.

978-0-470-46714-5

978-0-470-52128-1

978-0-470-52126-7

978-0-470-39236-2

978-0-470-45405-3

978-0-470-53490-8

Also available

Canon EOS Rebel XSi/450D Digital Field Guide • 978-0-470-38087-1
Nikon D40/D40x Digital Field Guide • 978-0-470-17148-6
Sony Alpha DSLR A300/A350 Digital Field Guide • 978-0-470-38627-9
Nikon D90 Digital Field Guide • 978-0-470-44992-9
Nikon D300 Digital Field Guide • 978-0-470-26092-0
Canon 50D Digital Field Guide • 978-0-470-45559-3

Available wherever books are sold.

WILEY
Now you know.

Wiley and the Wiley logo are registered trademarks of John Wiley & Sons, Inc. and/or its affiliates.
All other trademarks are the property of their respective owners.